IMAGES
of America

MANASQUAN
REVISITED

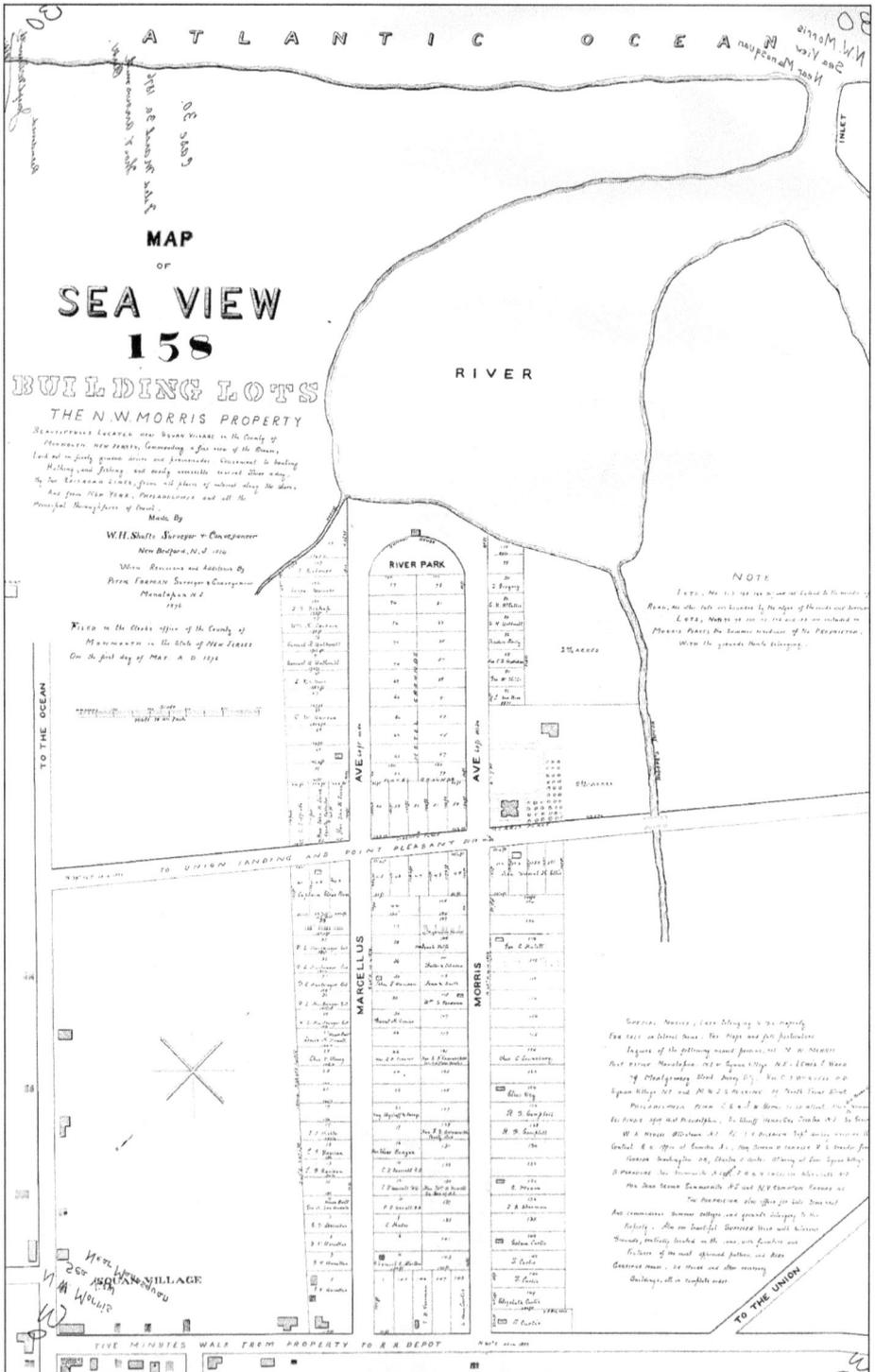

A map of Sea View produced in 1874 details the dream of Nathaniel Wyckoff Morris, one of the earliest real estate developers in Manasquan. Sea View was located adjacent to Squan Village (now Manasquan).

IMAGES
of America

MANASQUAN
REVISITED

Mary A. Birckhead Ware

ARCADIA
PUBLISHING

Published by Arcadia Publishing
Charleston, South Carolina

Library of Congress Catalog Card Number: 00100091

For all general information contact Arcadia Publishing at:
Telephone 843-853-2070
Fax 843-853-0044
E-mail sales@arcadiapublishing.com
For customer service and orders:
Toll-Free 1-888-313-2665

Visit us on the Internet at www.arcadiapublishing.com

For Andrew

CONTENTS

ACKNOWLEDGMENTS

Manasquan Revisited would not have been possible if it were not for how well the first book, *Manasquan*, was received nearly two years ago. Many thanks to all of those who have added *Manasquan* to their book collection.

This second volume on Manasquan would never have been completed without the encouragement and assistance of friends, local writers, and historians. Wesley V. Banse Sr. and his wife, the late Grace Banse, always offered enthusiastic encouragement and welcomed my visits to their home. Wes was the borough historian from 1976 to 1997 and when Toni Marzulla McChesney accepted the position as borough historian, she in turn was always available to answer questions and assist me in locating photographs and information. The help I received from Toni and Wes is invaluable.

Also, fellow Squan Village Historical Society members offered their assistance—in particular, Wayne and Betty Bailey, Don and Nancy Sherman, Betty Anderson, Connie and Bob Watkins, Erma B. Dorrer, Iva Messick, Alice Skokos, James N. Height, Joann Rowe, Raymond Pettit, George Williams, and Frank and Jean Applegate.

Many other local residents generously shared stories, postcards, photographs, and Manasquan memories for the book, including my aunt Grace B. Dickson, Esther Riddle Mills and her family, Holly Peterson, Janice and John Lavance, the William S. Wilkins family, Lea Wight, Barbara and Joe Jackson, Munroe Hawes and the staff at Hawes & McAfee, Bob Wood, Herb Stiefel, Dick Napolitan, L. Warren Randolph, Boyd and Nelda Davis, Shirley Carroll, Herbert Muller, Melinda and Stanley Saminski, Bankston and Hilda Brooman, Steven E. Phillips, Eric Goetz, Carl Mertens, Linda J. Fitzgerald, Arthur Birdsall, Bob and Helen Fitzgerald, Rich and Cass Mueller, Jack Tassini, Howard and Linda McKeon, Carol Raffetto Hill, and Bruce and Jill Seyfried.

Recognition is also extended to all of the area writers, photographers, and historians who took the time to document the events, activities, and changes in landscape that make Manasquan a great place to live. This book could not have been written in such detail without the contributions of those who compiled the *Golden Jubilee* and *Diamond Jubilee* books, and *Manasquan 1887–1987*—all fantastic sources of Manasquan history. Also, the files of the back editions of the *Coast Star*, which have chronicled Manasquan for more than 100 years, are a valuable resource.

Lastly, and most importantly, many thanks to my father and mother, Thomas and Virginia Birckhead, who have encouraged me, answered my many questions, and provided several photographs for this volume. Also, thanks to my husband, Charles Ware, who patiently lived with all of the old photographs, negatives, newspapers, postcards, and papers spread around the house for months. A special thank-you to my son, Andrew, who worked beside me on all aspects of *Manasquan Revisited*.

INTRODUCTION

The sandy shores of Manasquan have been a place many have called home for centuries. The Lenni Lenape Indians, for whom the borough was named, were the first settlers of this area. The Europeans arrived in the late 1600s. On December 30, 1887, Manasquan was incorporated as a borough. Today, nearly 6,000 people call Manasquan home.

Manasquan Revisited is an assortment of images that continues the pictorial history of the borough. Readers are invited to stroll along Main Street and the business district to visit Manasquan's resident baker, pharmacists, clothiers, and woodworkers, to name a few.

After reminiscing through the business district, travel back to a time when the community was home to sea captains, those early settlers who dared the powerful and perilous Atlantic Ocean to make a living in the shipping industry.

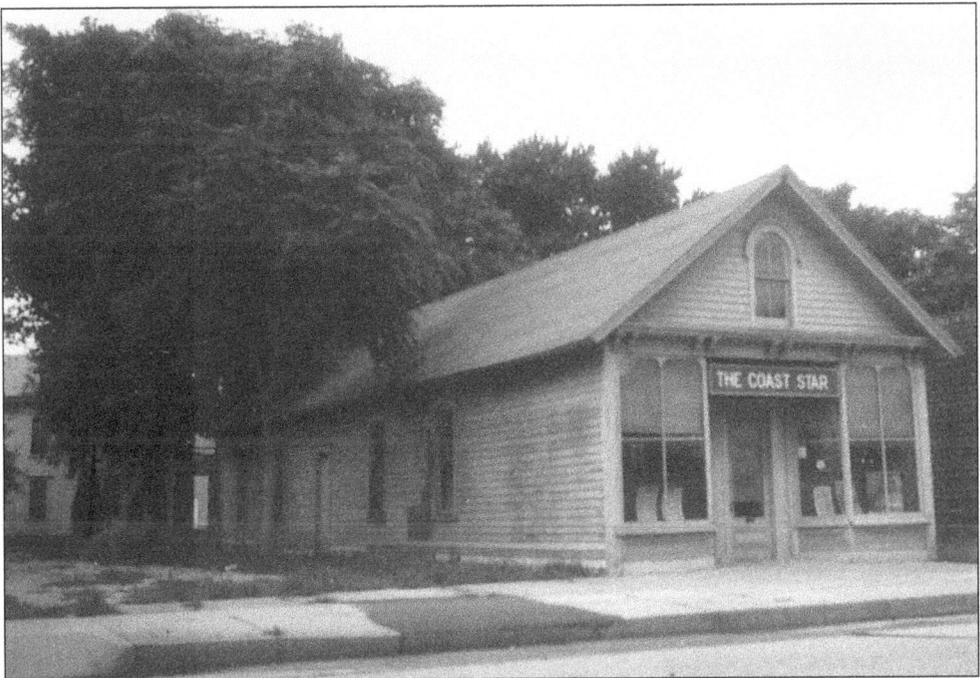

The office of the *Coast Star*, a weekly newspaper, was located at 13 Broad Street c. 1943. (Photograph courtesy of James M. Manser.)

After taking to the high seas with the Baileys, the Pearces, and the Longstreets, see the damage that the mighty seas wrought along the beaches and oceanfront homes in the off-season in Manasquan. From violent northeasters and hurricanes to the warm, sunny summer days in season, the ocean and beaches have played a key role in Manasquan's vitality. In fact, many who enjoyed vacations in the community have found the beachfront borough so attractive that they, too, have joined the clam diggers in making Manasquan home.

The section "Residences . . . Developing Manasquan" depicts the development in the 1920s of the east side of the railroad in the borough. After the first 37 homes were constructed around the business district when it was known as Squan Village and the bungalow colony at the beach was established, development took place in the remaining area between the beach and town.

Traveling around Manasquan one is aware of the community's history. Whether in the town's architecture, its businesses dating back to the 1800s, its streets that bear the names of sea captains, or the many Manasquan descendants of founding families, the town offers today's residents a strong link to the past. I hope that you enjoy this second book of historical pictures, postcards, and other images of Monmouth County's family beach town, Manasquan.

—Mary A. Birckhead Ware
December 30, 1999

One

FAMILIAR FACES AND PLACES AROUND TOWN

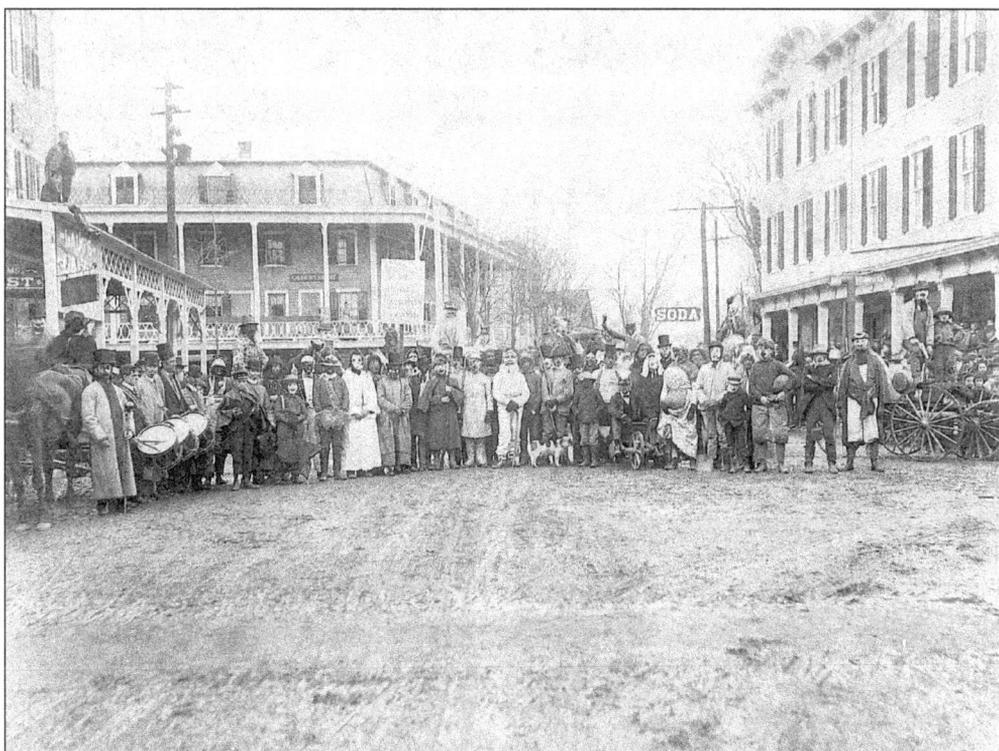

What a treat! This early 1900s Halloween parade photograph shows the charm of a community with real spirit. Notice the Osborn House on the southwest corner of Main and South Streets. Laug's Candy Factory is located in the building on the southeast corner. (Photograph courtesy of Howard and Linda McKeon.)

An official program for the Fourth of July Carnival sponsored by the Volunteer Engine Company *c.* 1900 features a schedule of competitions and prizes, as well as advertisements. The prizes for the 5-mile bicycle event were a gold watch for first place and a gold chain for second place. The prizes for the 2-mile bicycle event were a photograph box for first place and a smoking set for second place. The program cost 5¢.

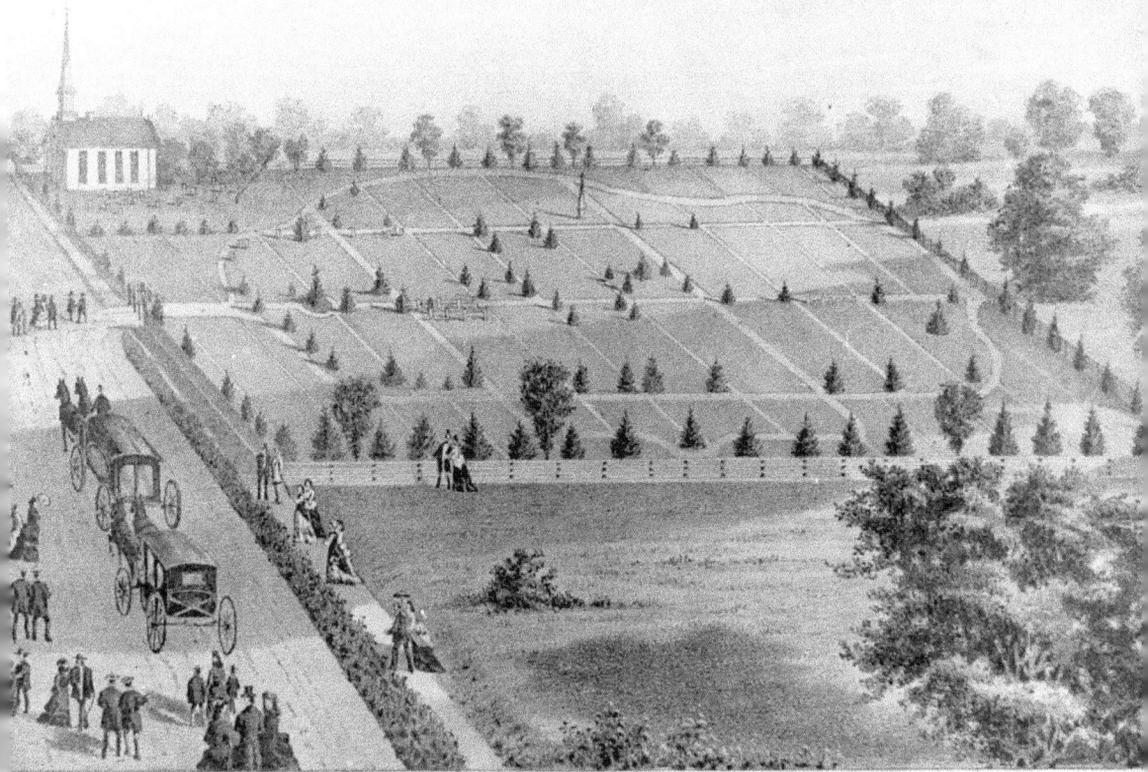

This sketch was included in the *Atlas of the New Jersey Coast*, published by Woolman & Rose in 1878. The Ocean Hill Church, upper left, was built in 1842 and was razed in 1922. The Atlantic View Cemetery occupies the highest piece of land on the north side of Church Street.

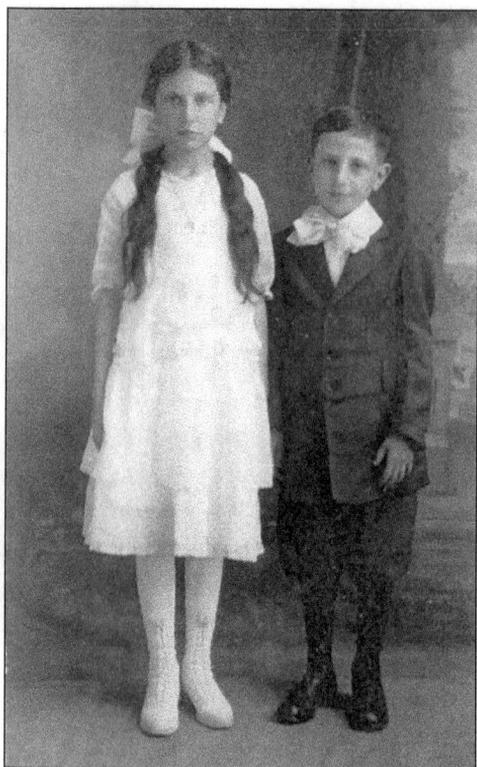

Manasquan residents Theresa and Charles Tassini, sister and brother, wore their Sunday best for the First Holy Communion photograph, taken by the Rogers Studio in Point Pleasant c. 1915. Years later, Dr. Charles Tassini served on Manasquan's Planning Board from its inception in 1959 until 1981, for 20 of those years as chairman of the board. In June 1986, the borough council named a park area on Central Avenue the Dr. Charles Tassini Wildlife Park. Tassini died later that year. (Photograph courtesy of the Tassini family.)

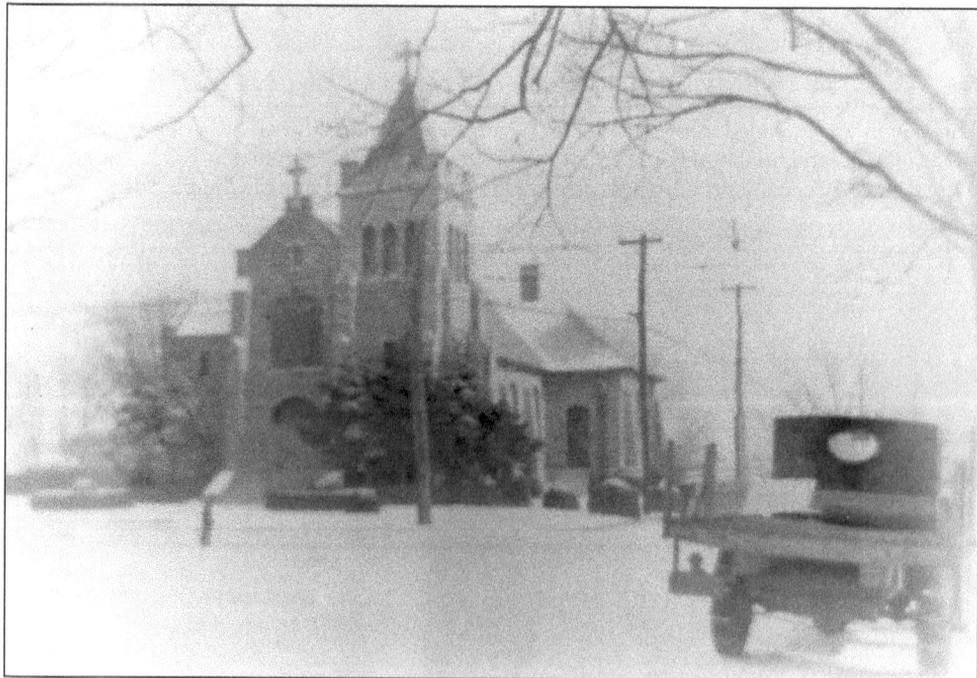

After a snowfall in 1918, this large pickup truck parked on the southwest corner of Route 71 and Virginia Avenue, diagonally across from St. Denis Roman Catholic Church . The first Mass was held in the church in 1911.

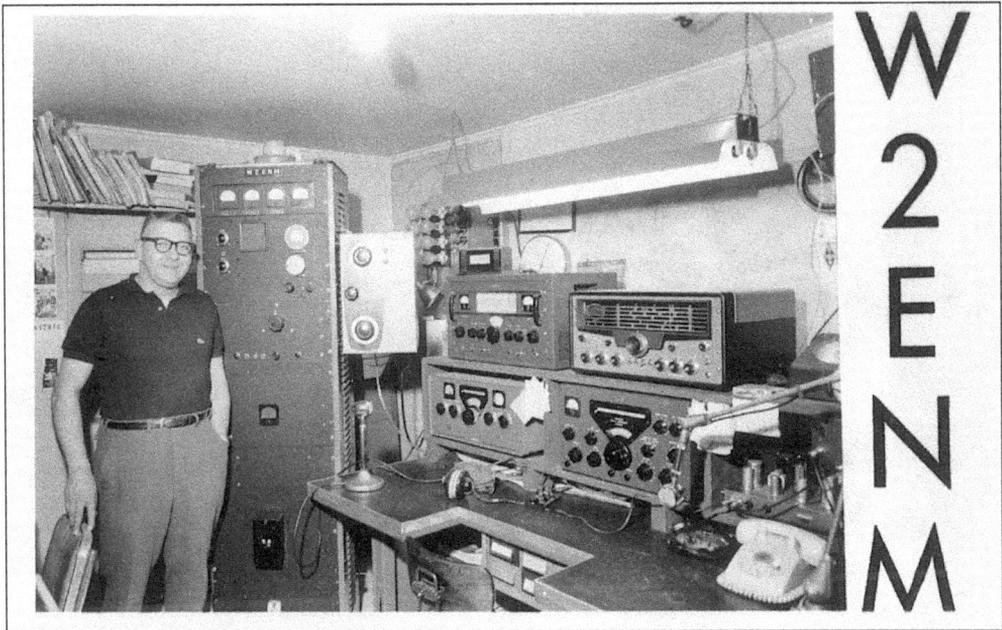

Samuel Yatter, a resident of Manasquan for 70 years, operated his ham radio in the 1940s and 1950s from his home above Sally's, a women's apparel shop, which his wife owned and operated. Yatter received citations for his assistance during World War II. He owned and operated Yatter Laboratories, a dental laboratory, for 20 years before retiring in 1979. He died in July 1999.

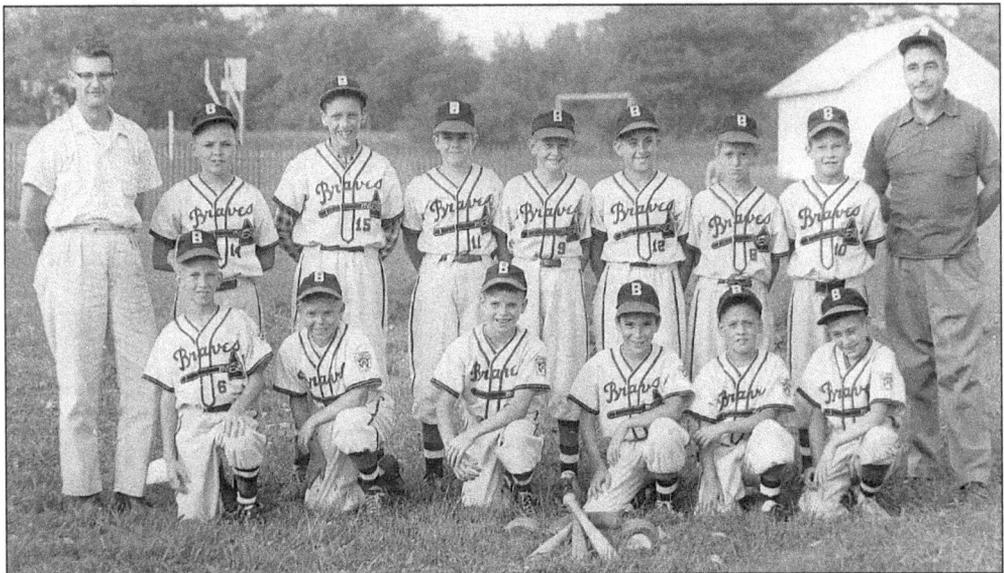

Members of the Braves, one of the Manasquan Little League teams, take time out from play in the summer of 1959 for a team photograph. Seen here, from right to left, are as follows: (front row) John Wolcott, Tom Steen, Jack Tassini, Barry Echardt, Dick Beam, and Bob Lucas; (back row) Coach Jim Coder, John McGovern, Van Height, Sven Miller, Carl Coder, Bob Siegel, Bob Higham, Glen Ditzenberger, and Coach Rudy Echardt. (Photograph courtesy of the Tassini family.)

13

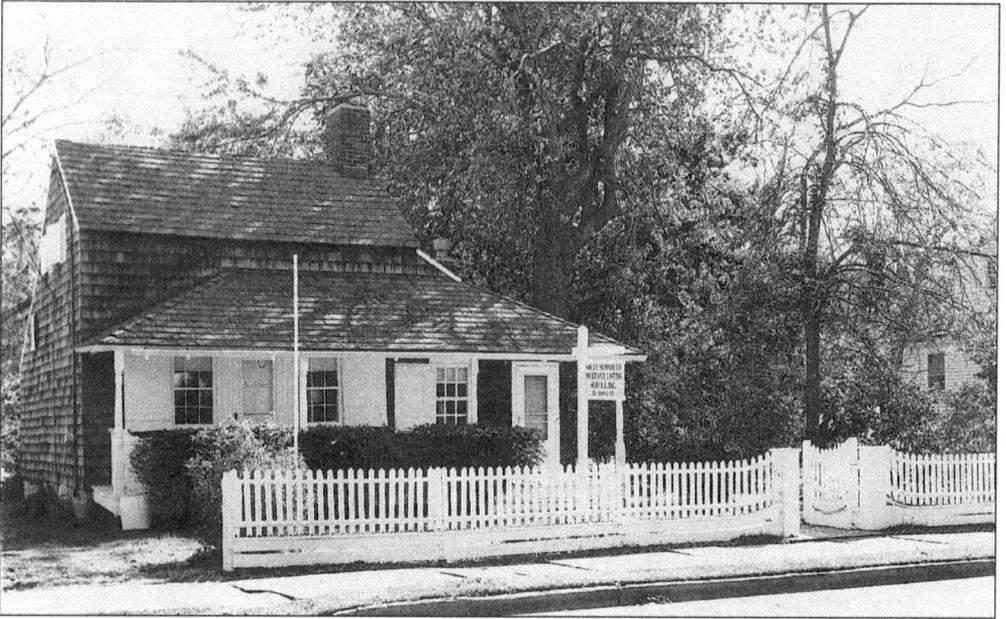

The headquarters of the South Monmouth Board of Realtors, the former Jackson Homestead, was located at 68 Broad Street, on the property adjacent to the W.F. Sherman Millwork Company. At one time, the site also served as the Girl Scout headquarters. Before it was destroyed by fire in the late 1960s, it was one of the oldest houses in the community, dating back to the War of 1812.

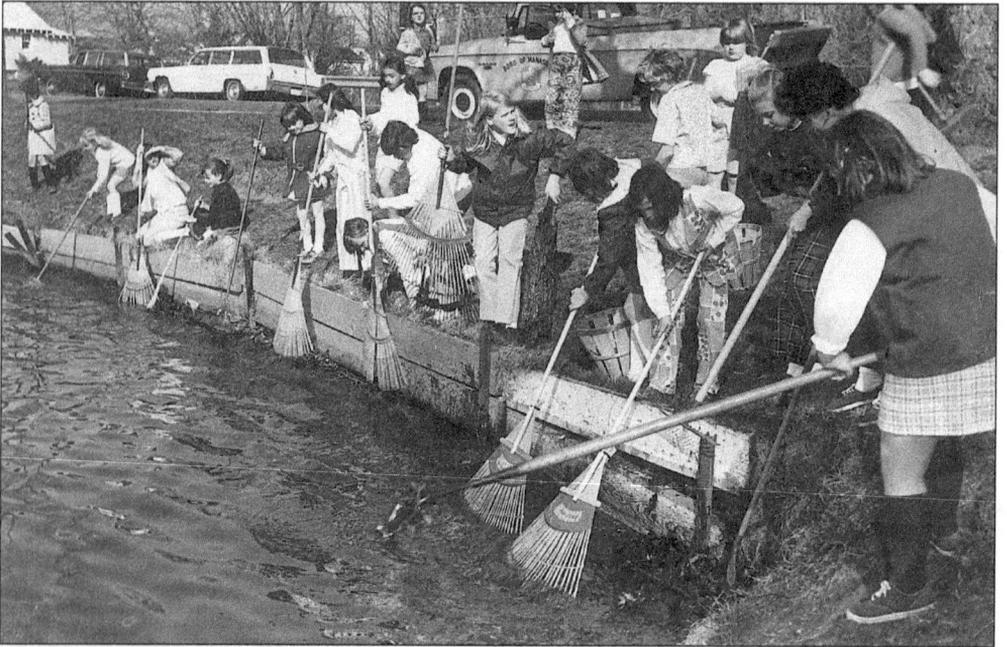

Members of Manasquan's Junior Girl Scout Troop 74 and Brownie Troops 210 and 462 clean Mac's Pond on April 22, 1970, in observance of Earth Day. In this community effort, some of the Scouts provided rakes and shovels for the cleanup; other equipment was loaned by the borough.

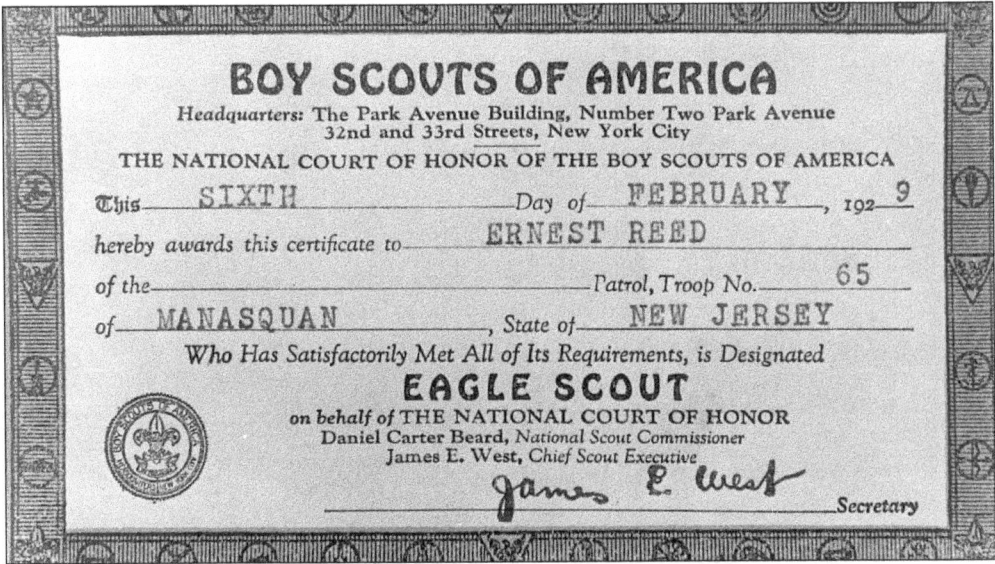

BOY SCOUTS OF AMERICA

Headquarters: The Park Avenue Building, Number Two Park Avenue
32nd and 33rd Streets, New York City

THE NATIONAL COURT OF HONOR OF THE BOY SCOUTS OF AMERICA

This _____SIXTH_____ Day of_____FEBRUARY_____, 192 9

hereby awards this certificate to_____ERNEST REED_____

of the_____Patrol, Troop No.____65____

of____MANASQUAN____, State of____NEW JERSEY____

Who Has Satisfactorily Met All of Its Requirements, is Designated

EAGLE SCOUT

on behalf of THE NATIONAL COURT OF HONOR
Daniel Carter Beard, *National Scout Commissioner*
James E. West, *Chief Scout Executive*

_____Secretary

Manasquan native Ernest Reed became an Eagle Scout on February 6, 1929. Upon his death, his wife fulfilled his wishes by selling the family residence at 105 South Street to the Squan Village Historical Society in July 1997. Today, the home is being restored to its 1812 charm by volunteer members of the society and many others.

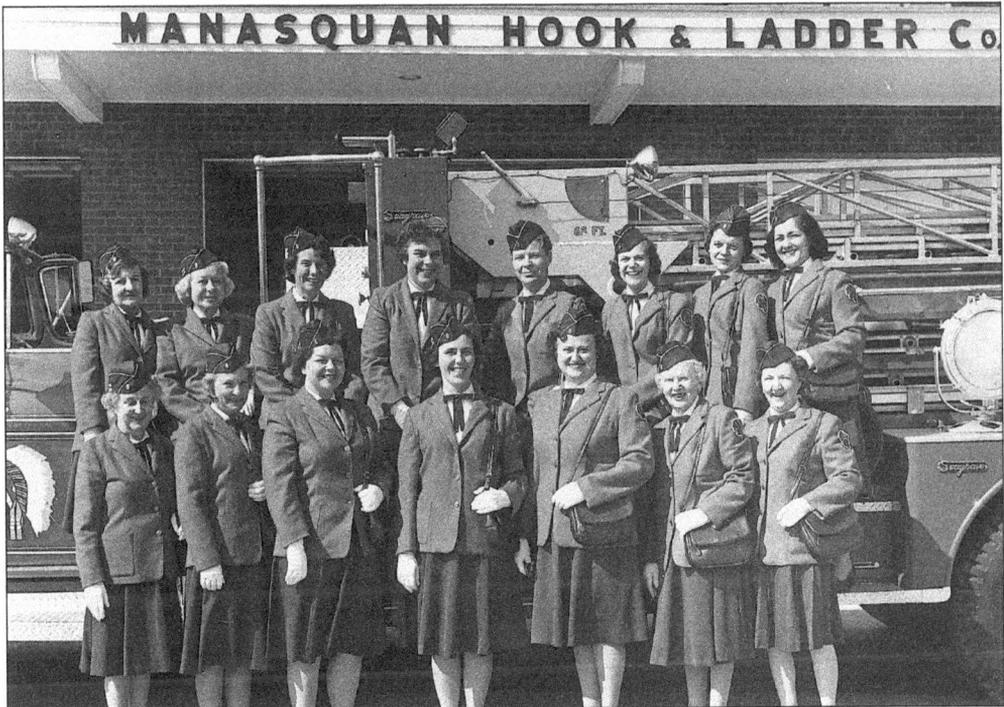

Members of the Ladies Auxiliary of Hook and Ladder Company No. 1 assemble for the 1965 Memorial Day parade. Seen here, from left to right, are as follows: (front row) Mae Seylaz, Alice Throckmorton, Carol Anderson, Jean Heulitt, Mary Morris, Miriam Mount, and Hazel Price; (back row) Lillian Shann, Doris Wright, Betty Sanford, Marion Hooyman, Wanda Darcy, Marilyn Malone, Joan Edick, and Marguerite O'Hare.

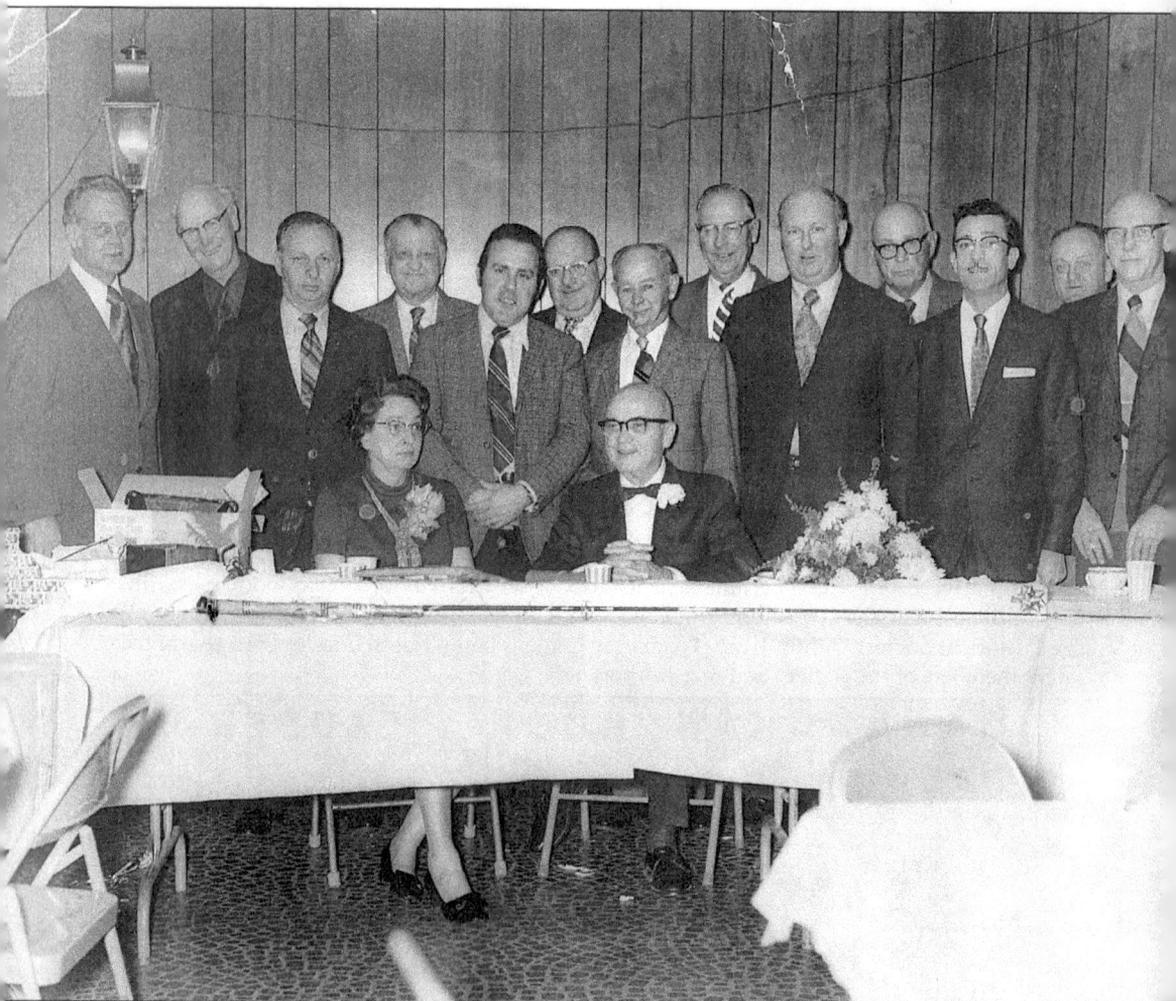

In 1972, some 400 local residents joined together to honor Dr. Joseph C. Jordan and his wife, front, during his retirement dinner held at the Manasquan First Aid Building on Broad Street. Participating in the festivities were, from left to right, Axel B. Carlson, Abram D. Voorhees, William E. Miller, Hans Letsche, George Kleinknecht, Arnold Lane, John Howarth, William A. Morton, Fred Leggett, Willard Nock, Eden B. O'Hare, William Maney, and Roy Hains. Jordan maintained offices on the northwest corner of Main Street and Minerva Avenue. Residents recall his many house calls to their homes.

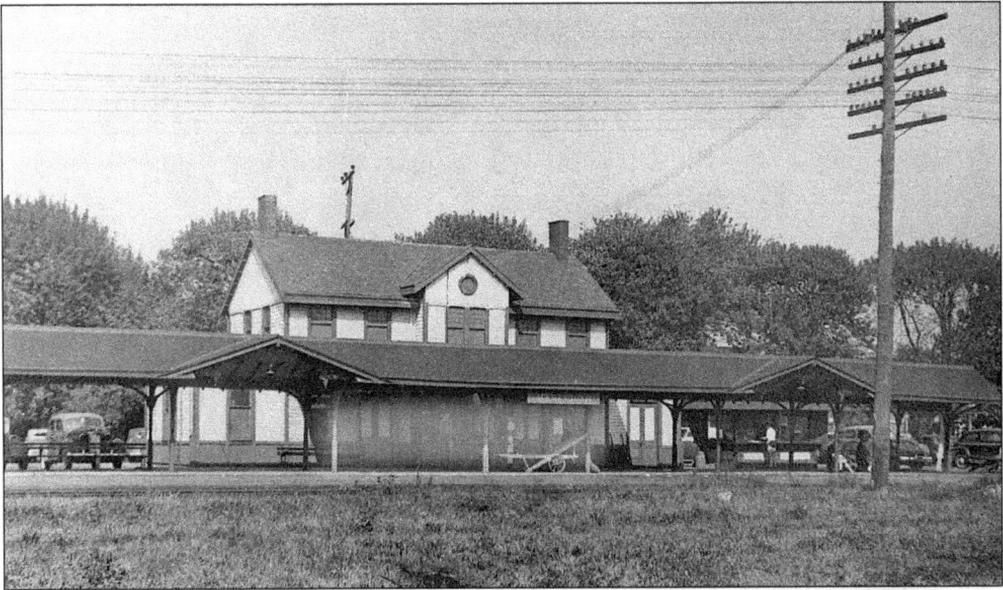

This view of the Manasquan Railroad Station was taken in the 1930s. After years of disrepair, the rail depot was restored to its Victorian splendor in 1987. The structure, originally built in 1887, was relocated from Spring Lake to the borough at the beginning of the 20th century. For a time, the station served as the headquarters and museum of the Squan Village Historical Society. On March 30, 1996, the building caught fire and was subsequently razed.

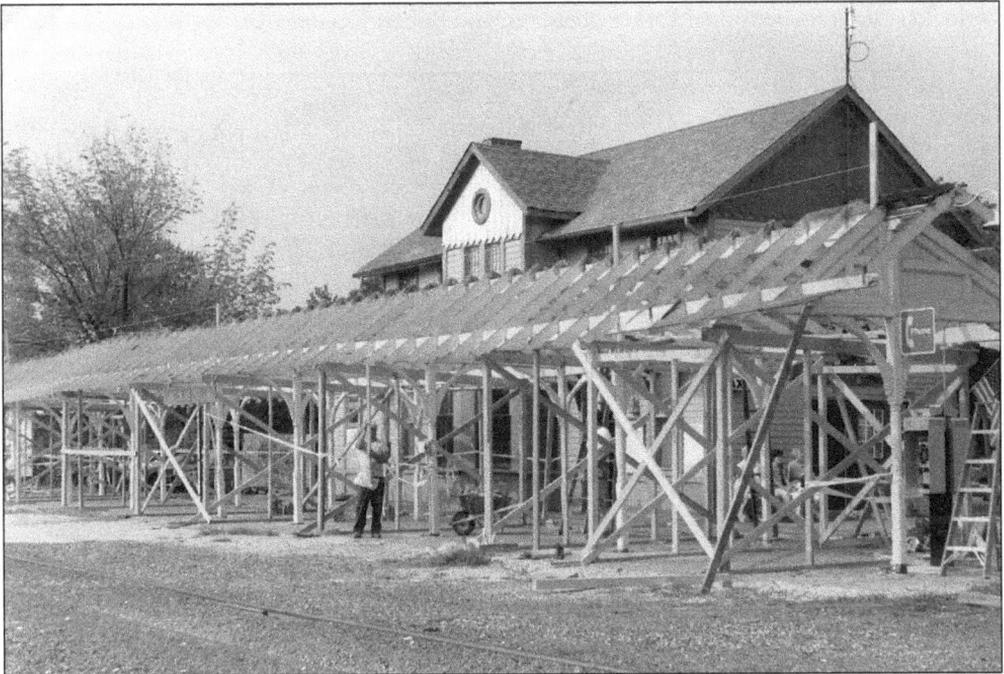

Workmen constructed a canopy for the Manasquan Railroad Station during restoration efforts on the building. Save Our Station (SOS), a volunteer group of local citizens, was established in 1984 and completed all restoration efforts on the building by October 1987. A dedication program was held as part of the Manasquan Centennial festivities that month.

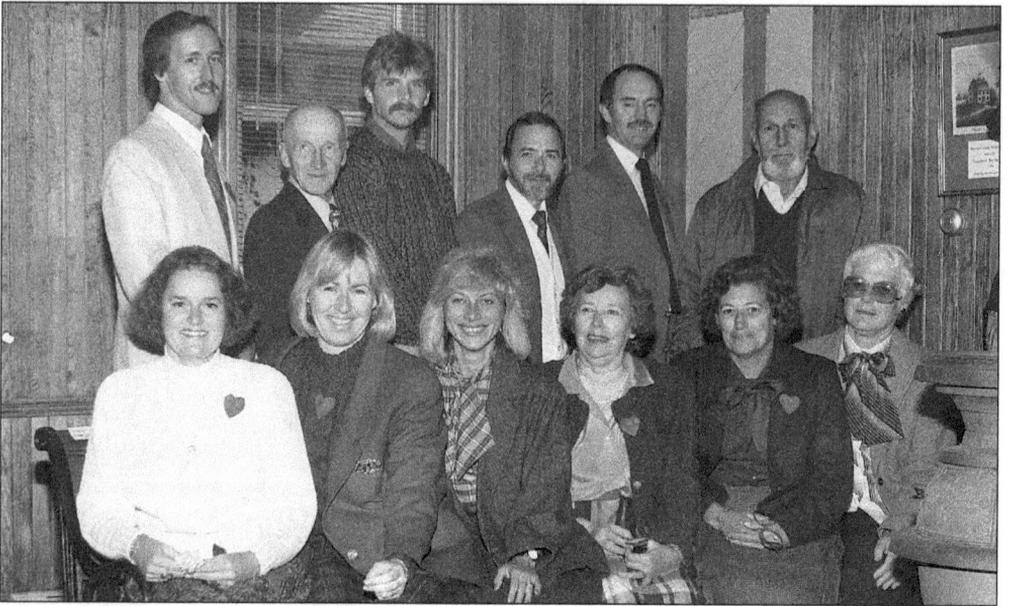

Members of the volunteer group Save Our Station meet in the depot after having successfully restored the Manasquan Railroad Station. They are, from left to right, as follows: (front row) Deborah Thomas; Judi D. Shirley; Melinda Saminski; Jean Lee, president; Virginia B. Birckhead; and Helen Delaney; (back row) Stanley Saminski George W. Williams Jr., Bradford Book, Robert B. Wynne, Richard H. Thomas, and Joseph J. Lee. Other members included Rosemary Borloglou, vice president; Joel Parker, treasurer; and Robert Caemmerer.

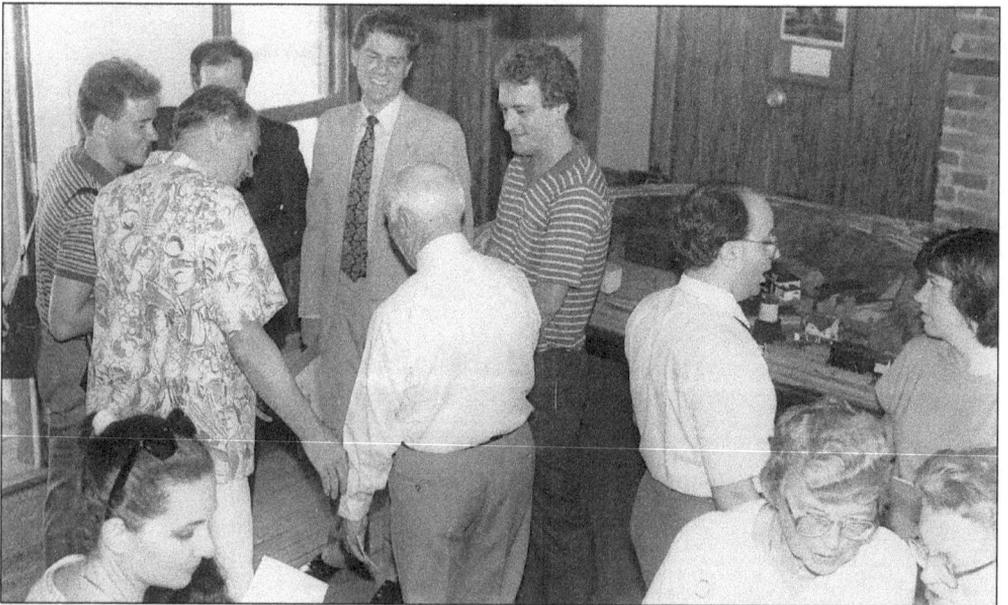

State Sen. Frank Pallone, dressed in a suit, meets with volunteers of Save Our Station and other community members at the open house for the Manasquan Railroad Station, held during borough Centennial festivities on October 3 through 10, 1987. Pallone aided members of SOS in securing grant funds for the canopy on the east side of the structure.

18

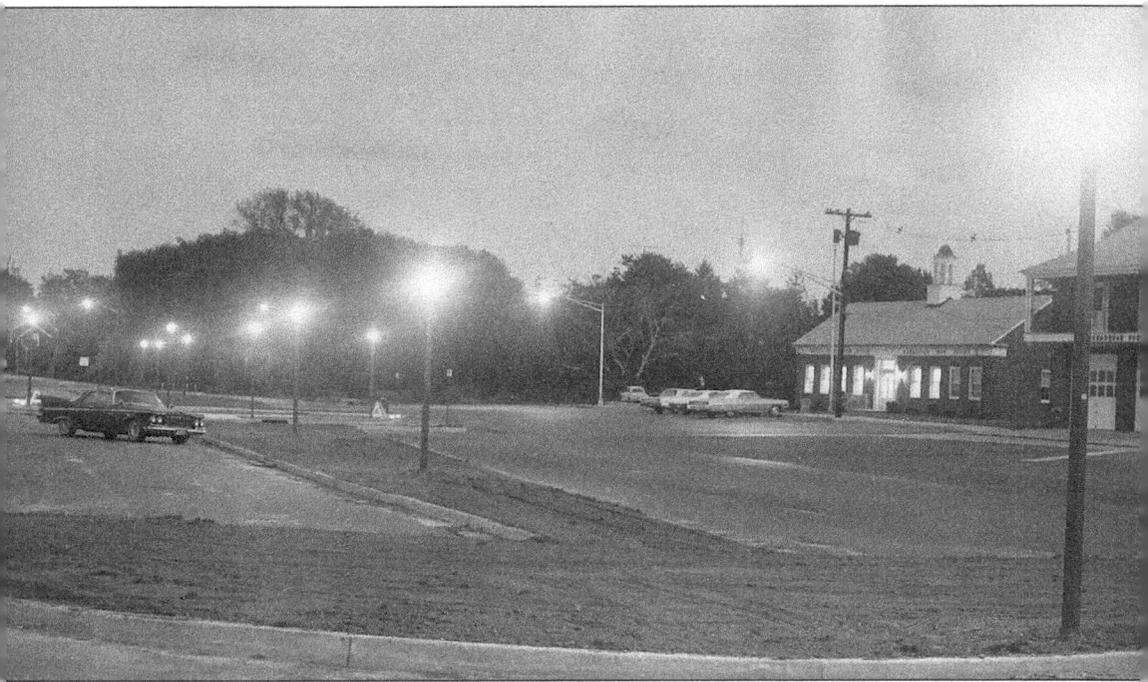

New Colonial-style lamps illuminate Old Squan Plaza in this photograph taken on October 10, 1968. In addition to the lights, new parking space and grassy areas were created during the renovation project in the plaza. The Manasquan Post Office, right, relocated from its Main Street site to the plaza in 1962.

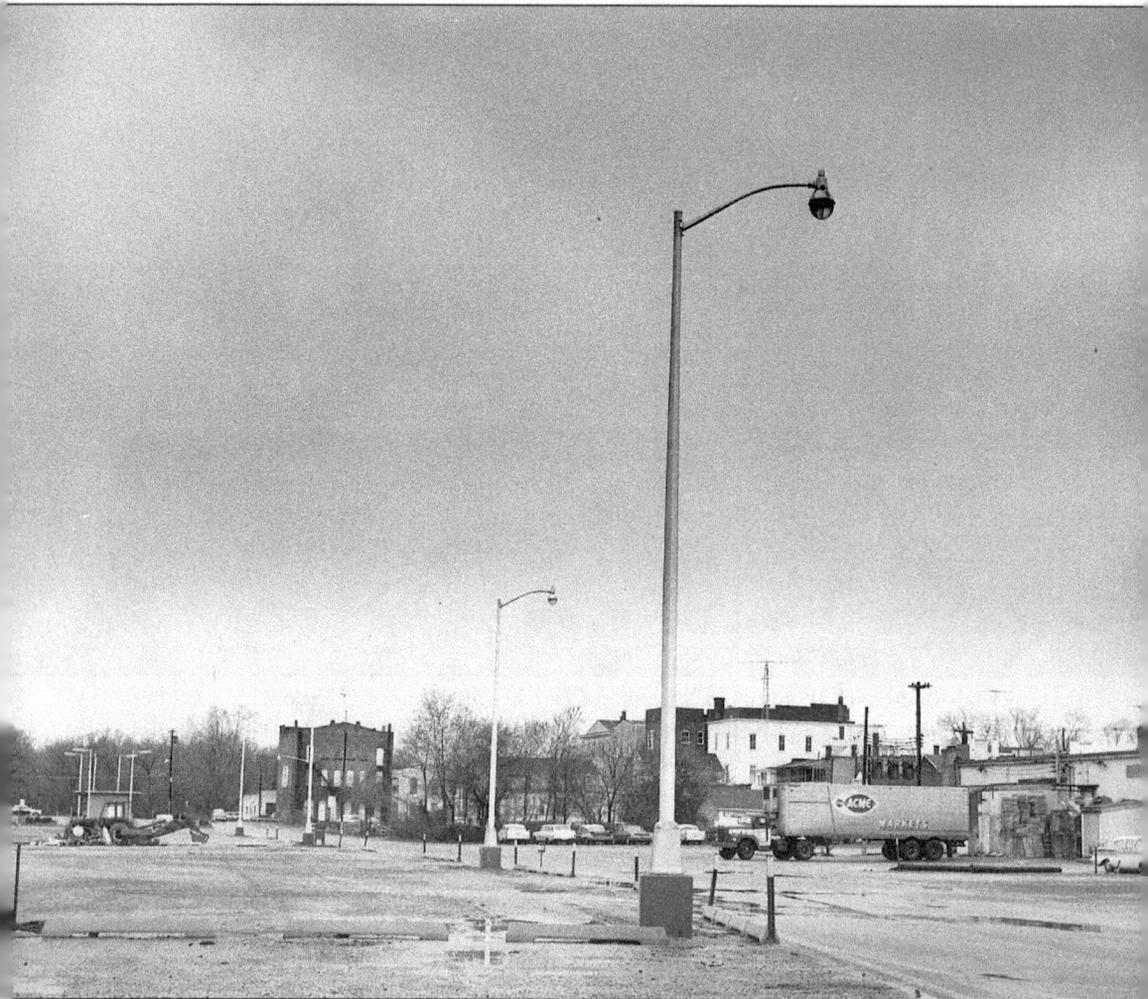

In this view, an Acme Market truck makes a delivery to the food store when it was still located on Main Street in the center of the town. The full development of Old Squan Plaza had not yet occurred when this photograph was taken in 1962.

In 1968, Manasquan residents Joseph Acerra, left, and Robert Reynolds take time to honor servicemen on Veterans Day at the Manasquan War Memorial. At that time, the monument was located adjacent to the Manasquan Elementary School on Broad Street. It lists the names of borough residents who died in WW I and WW II, as well as those who served during WW II.

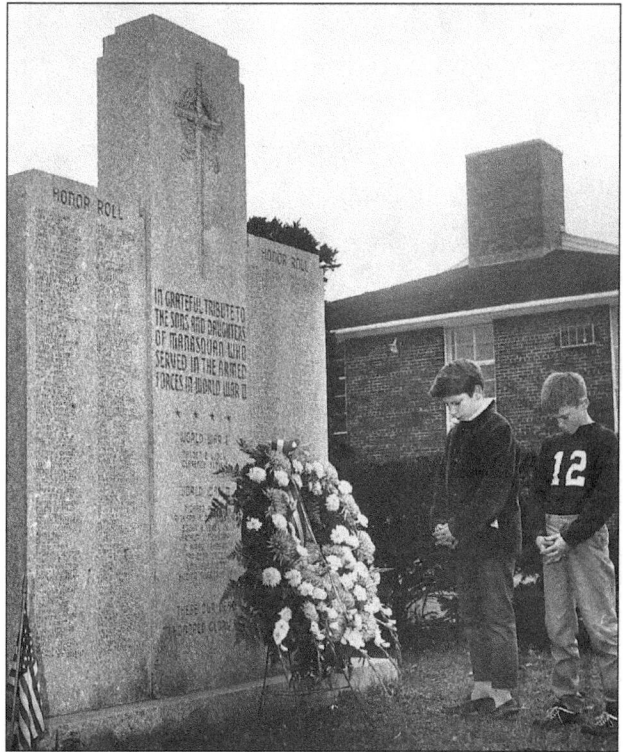

Workmen from H.T. Hall of Manasquan hoist the Manasquan War Memorial onto a truck for its move to a new location. On December 7, 1968, the granite monument was installed at Old Squan Plaza to accommodate the expansion of the Manasquan Elementary School.

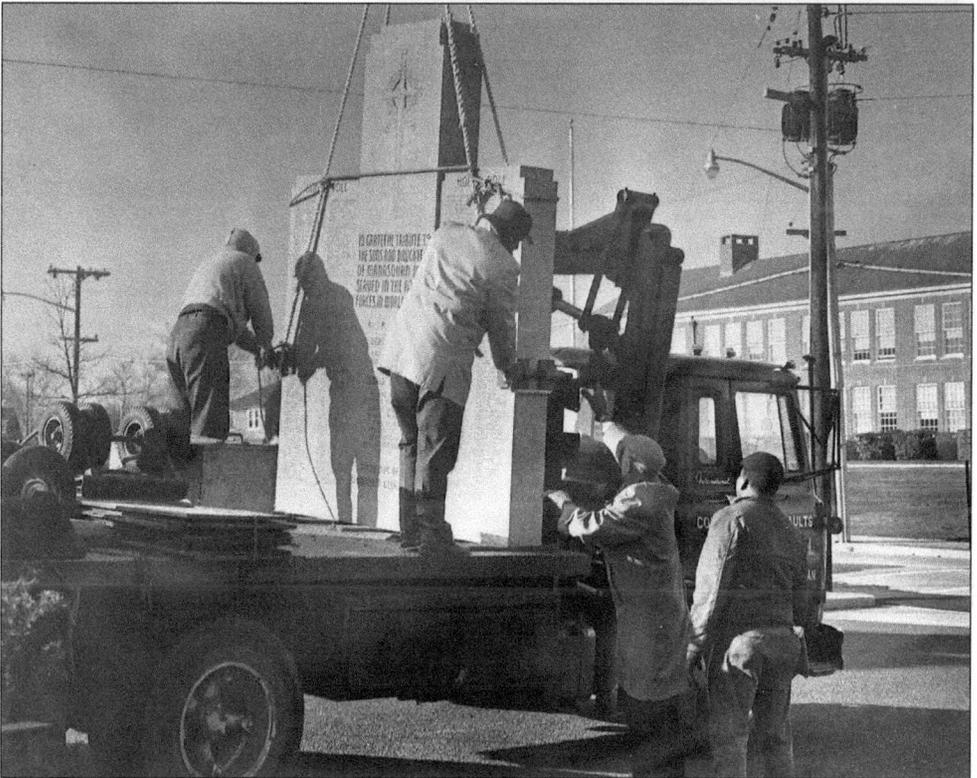

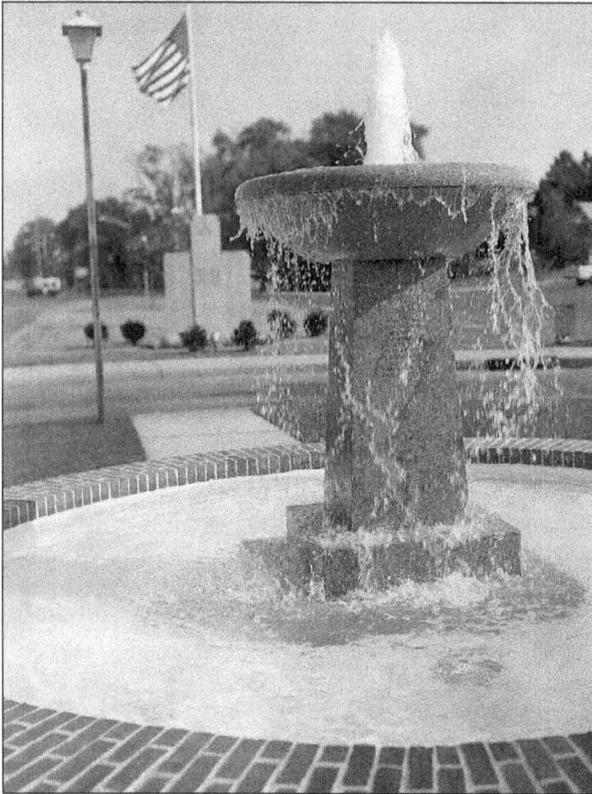

The granite Bicentennial Memorial Fountain in Old Squan Plaza, dedicated in September 1976, has become the focal point of the plaza. The monument was erected to commemorate the 200th anniversary of the United States. Members of the fountain committee were Joel Parker, John D. Wooley, and Harold T. Hall Jr. In 1989, a beautiful garden containing 100 rosebushes was added to surround the fountain.

A monument recognizing outstanding Manasquan First Aid Squad volunteers is located in Old Squan Plaza adjacent to the War Memorial Monument. Carved of red granite, it was originally located at the First Aid headquarters on Broad Street; it was moved to the plaza in 1969.

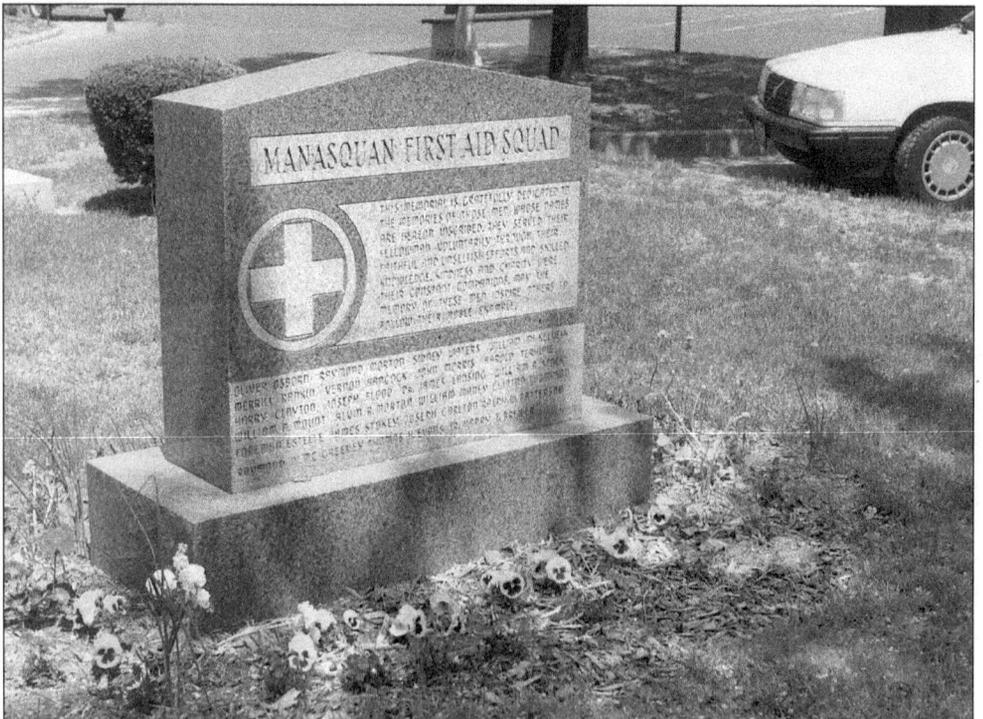

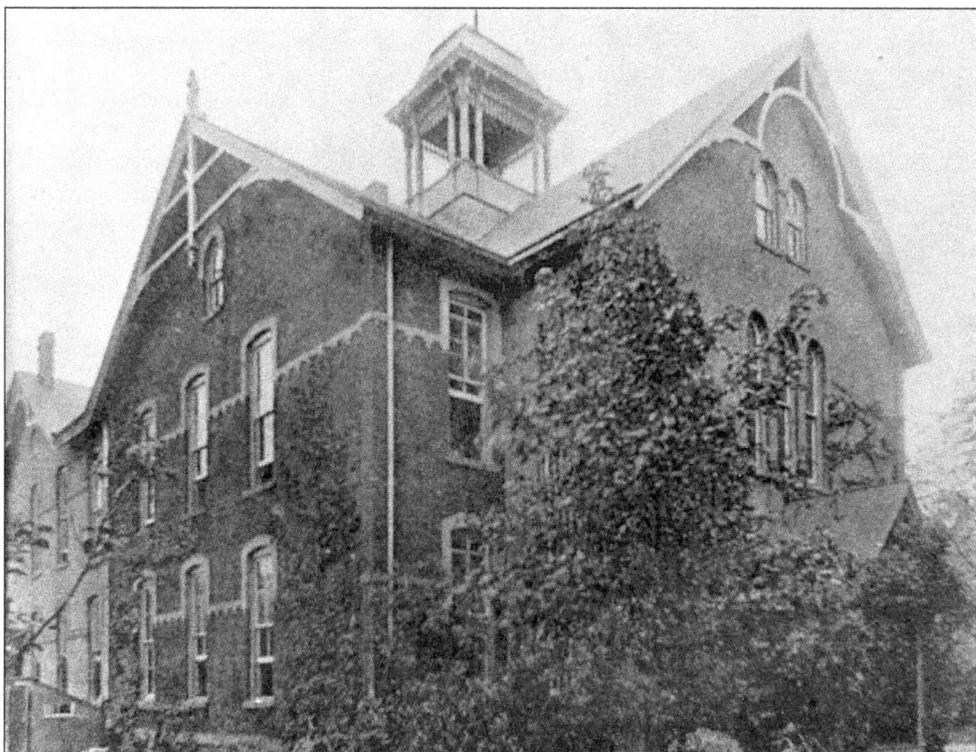

Built during 1879 and 1880, the original Manasquan School on Taylor Avenue (Route 71) opened on April 22, 1880. After several additions to accommodate the school's expanding population, a second school was constructed just north of this one. In 1933, this school was deeded to Manasquan, and today it serves as Manasquan Borough Hall.

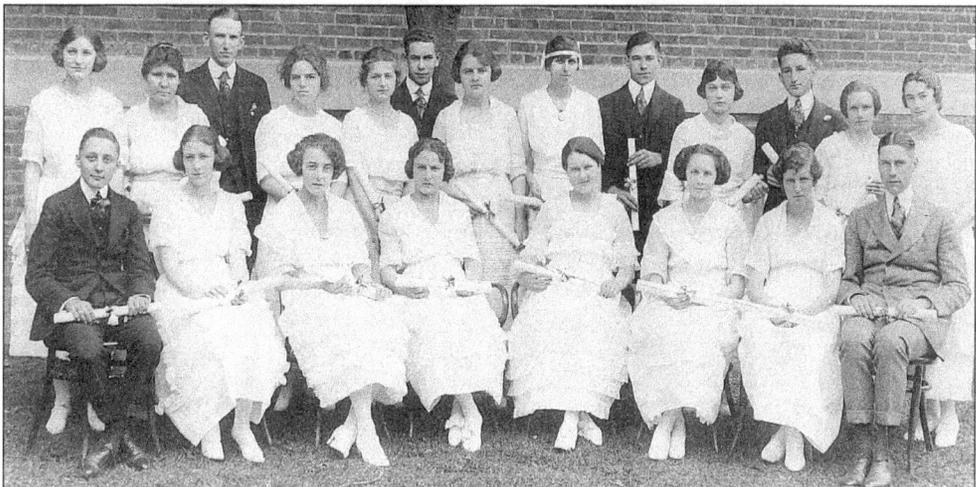

The Class of 1920 proudly displays diplomas in front of the original Manasquan School on Taylor Avenue (Route 71). Seen here, from left to right, are as follows: (front row) Harry Trotter, Helen Parkhurst, Margaret Shier, Emma Eggiman, Elizabeth Walker, Roberta Marks, Anna Love, and William Cranmer; (back row) Ethel Hurley, Pauline Pearce, George Gregory, Jenny Gifford, Florence Meseroll, Myron Brognard, Edna Sherman, Lena Wooley, John McGreevey, Ruth Denninger, Hugh Stomenger, Margaret Newman, and Gertrude Hopper.

23

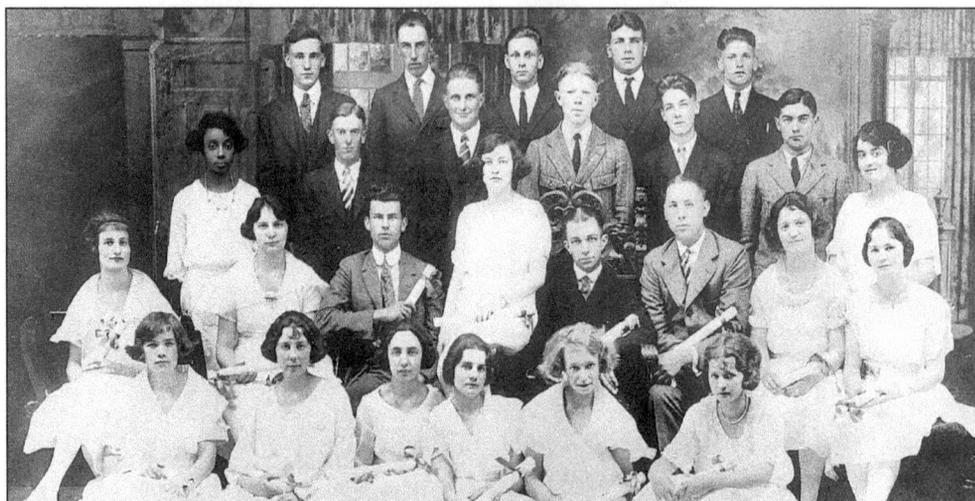

Two years later, the Class of 1922 was larger and had significantly more graduates. Students seen here, from left to right, are as follows: (first row) Frances Heulitt, Lillian Parent, Edith Fluhr, Mary Page, Hazel Rice, and Pauline Wolcott; (second row) Ida Wagmeister, Dora Watts, Marvin White, Dorothy Sprague, Harvey Bush, Paul Cranmer, Ruth Mitchell, and Helen Holloway; (third row) Irene Morgan, Red Rice, Hans Vogel, Stanley Morton, Bill Fluhr, Ralph Patterson, and Aline Allen; (fourth row) Raymond Frazee, Harry Burr, Robert White, John Tassini, and Jack Cornelius.

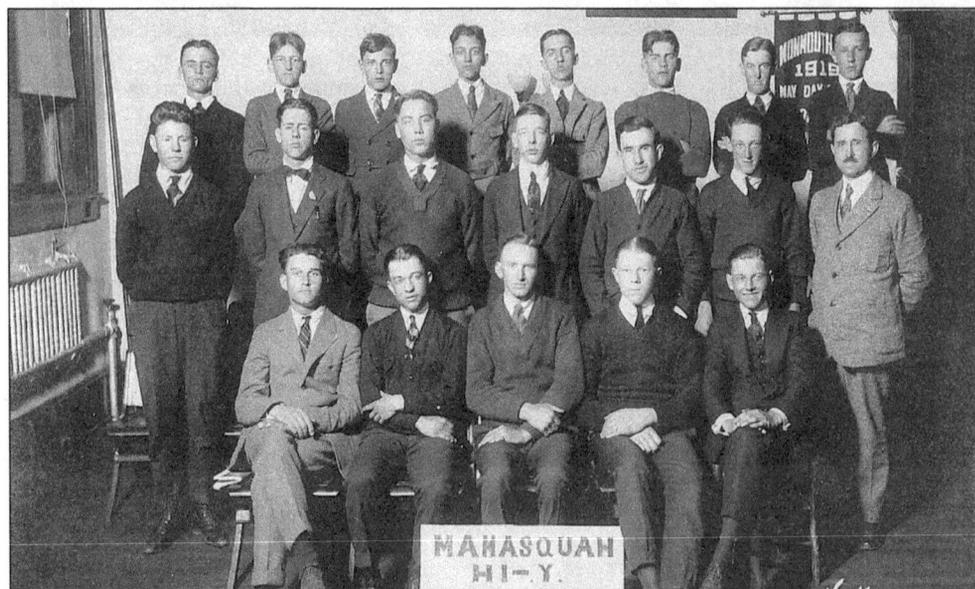

Members of the Manasquan Hi-Y Club (High School YMCA) assemble for this 1921 photograph. They are, from left to right, as follows: (front row) Dick Newman, Harvey Bush, George Gregory, Stanley Morton, and Lester Meseroll; (middle row) Harry Johnson, Lou Green, Paul Cranmer, Morton Pratt, Donald Osborn, Kenneth Van Brunt, and John Hulsart; (back row) Fred Heustis, Philip Meseroll, Harry Mount, adviser James Hulsart, Spencer Norris, Milne Cornelius, Red Rice, and Jay Miller. Under the leadership of Gregory, Osborn, and Green, club members discussed how to lead a good life and to uphold the high standards of Christian character for which the YMCA stands.

24

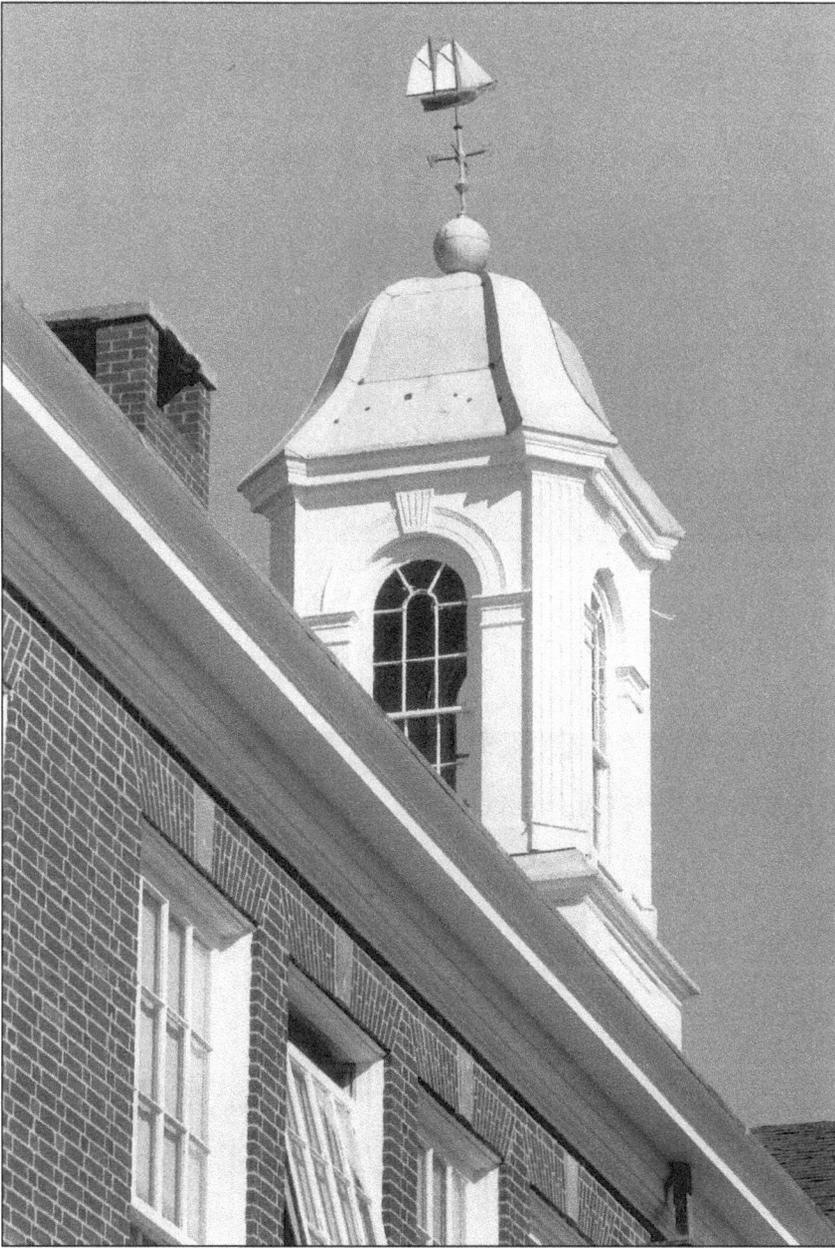

Not unlike many of those on sailing vessels, the clipper ship weather vane atop the cupola on Manasquan High School on Broad Street has endured many storms. According to Willard R. Newman of Manasquan, the decorative weather vane has "caught the wind at least twice" after which it had been repaired. The ship was part of the original design of the building because of the community's seafaring history, according to Newman, Class of 1931 and a former member of the Manasquan Board of Education, who served as board secretary from 1957 to 1975. The ship was broken during a hurricane c. 1990, according to Jeffrey C. Osborn, principal of the high school from 1981 to the present. Members of the Point Pleasant Beach Fire Department kindly returned it to the top of the cupola since Manasquan Hook and Ladder Company No. 1 had no ladder long enough to complete the job, Osborn said.

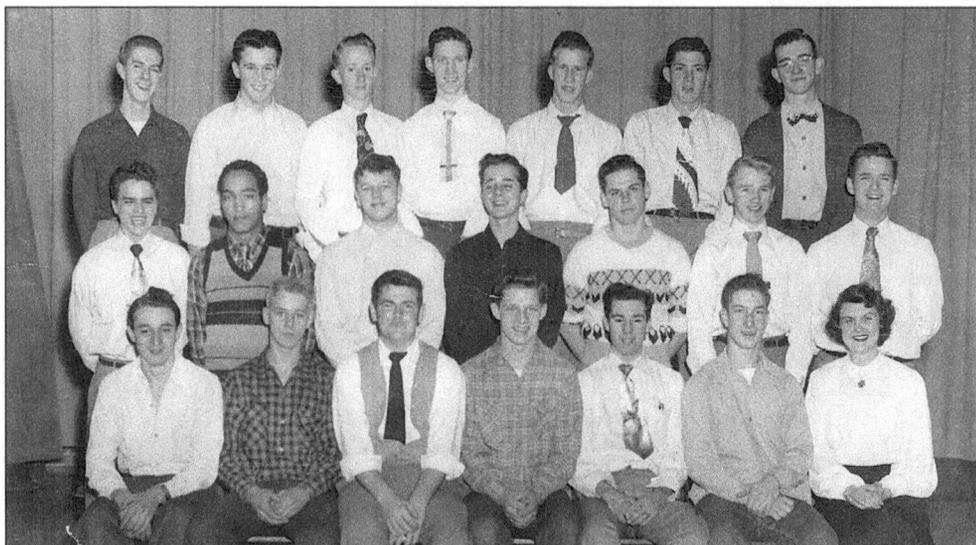

Members of the Manasquan Glee Club assemble for the annual yearbook picture in 1951. Seen here, from left to right, are as follows: (front row) Thomas Evans, Thomas Thiers, Neil Lomax, Robert Wohler, Charles Bramhall, Charles Trafford, and director Dorothy Stahl Underhill; (middle row) James Eirich, John Gaines, Sandor Haydu, John Upton, Robert Myers, William Gregory, and Harrison Pearce; (back row) Kenneth Holmes, Alan Carr, William Freeman, Jack Hansen, Richard Mort, William Chambers, and Robert Wortley.

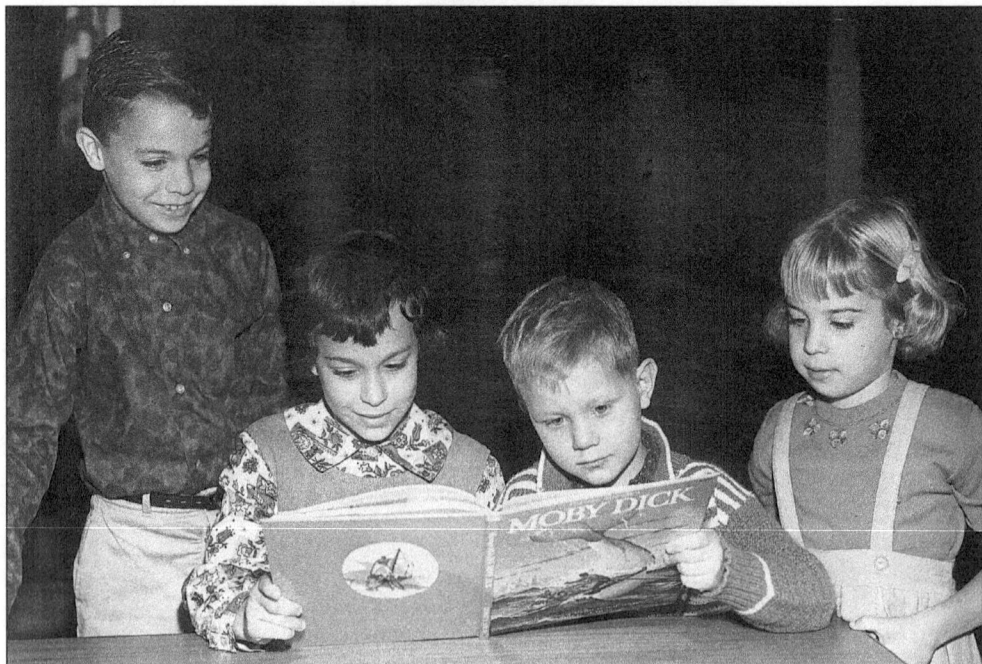

Students enrolled in Manasquan Elementary School read *Moby Dick* during the annual book fair in 1963 to raise money for the Marie Champion Scholarship Fund. Seen here, from left to right, are Donald Sherman, Susan Birckhead, Robert Wells, and Carole Hauck. The Marie Champion Scholarship Fund Committee makes an annual award to a Manasquan High School graduate who attended Manasquan Elementary School.

In this photograph taken during the 1937 Thanksgiving parade, high school seniors Angie Gardella (Mertens), left, and Jimmy Cassidy present their painted backs in this unusual float. The two are sitting on the float, surrounded by their costumes. (Photograph courtesy of the Mertens family.)

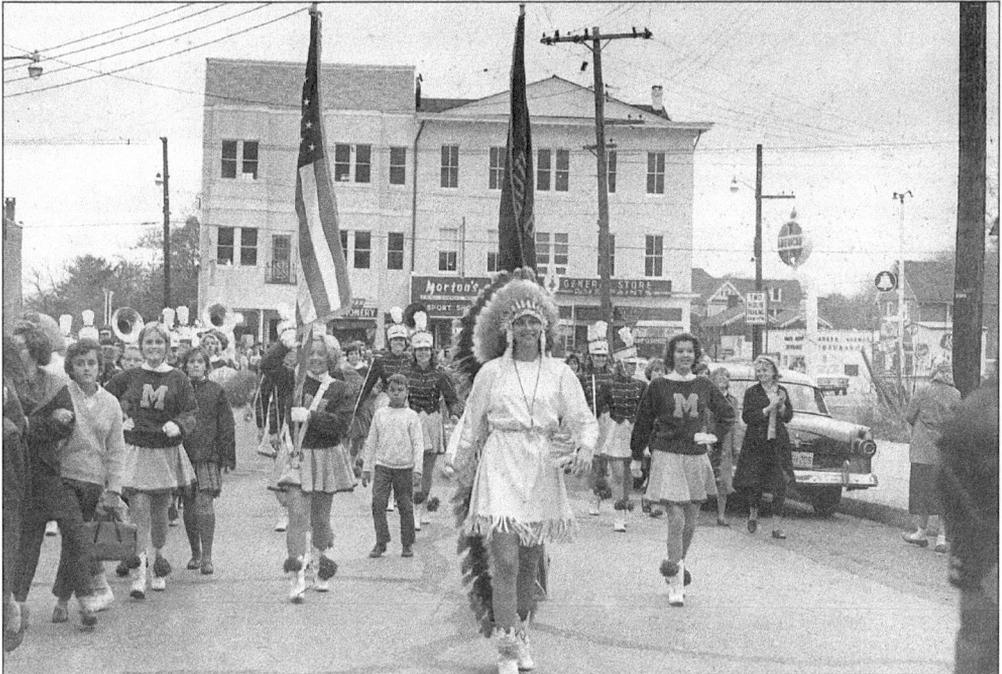

Dotti Green (Gerlach) of Manasquan—the drum majorette—leads the Manasquan High School Warrior Band and cheering fans along Broad Street during pregame festivities in this 1963 photograph. Decades later these festivities, including the parade, are every bit as popular. Morton's Sporting Goods is visible in the background.

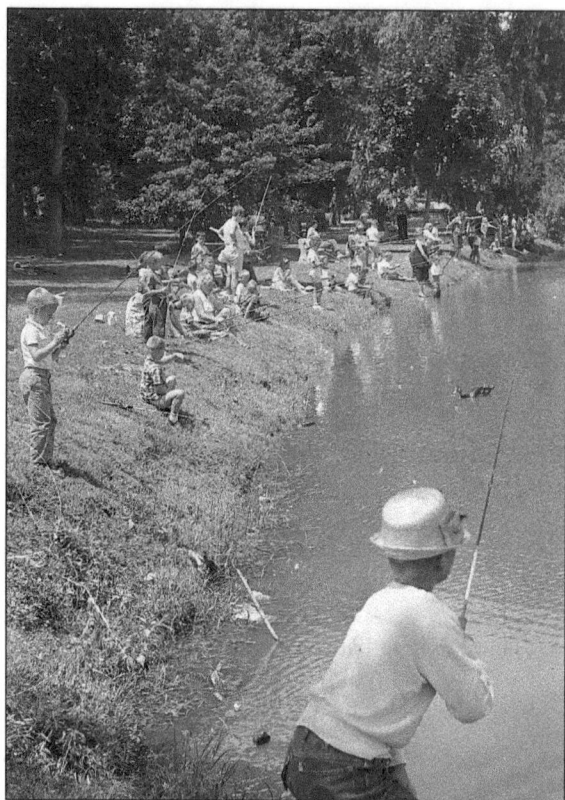

Children participate in the annual fishing contest at Mac's Pond on North Main Street. The pond and surrounding adjacent property was purchased from the McGreevey family for $30,000 in October 1962. Mac's Pond Park was dedicated by the town in June 1965.

The Manasquan Borough Hall and Police Department get a fresh look in this early 1960s photograph. The municipal offices are located on Taylor Avenue (Route 71). The building is the former site of the first high school in Manasquan.

Two

RESIDENCES . . .

DEVELOPING MANASQUAN

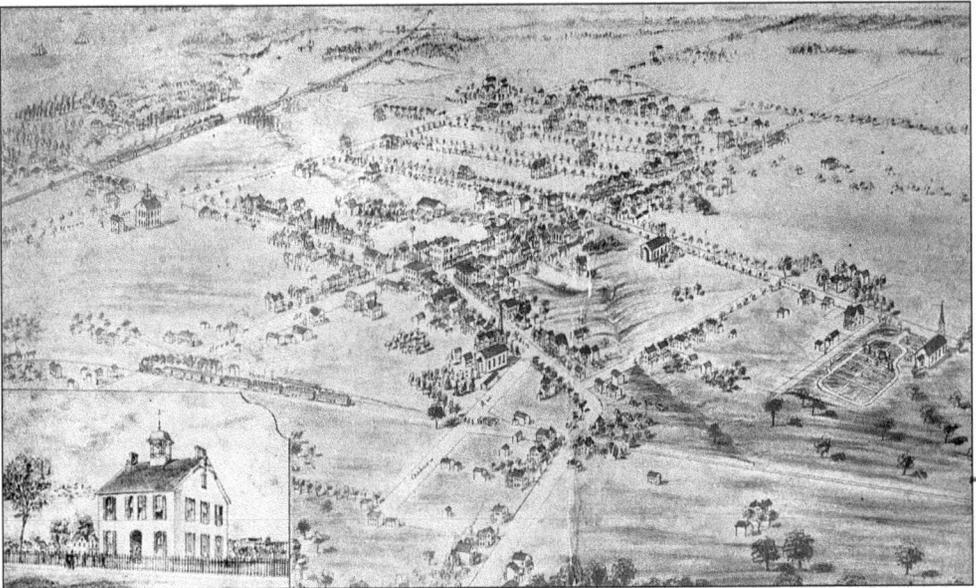

This c. 1884 sketch of Manasquan illustrates the borough's school, built in 1880, in the inset on the left and the Church on the Hill, far right, which was adjacent to Atlantic View Cemetery. Note the well-established business district on Main and Broad Streets, as well as the homes and farms that dot the landscape of the community.

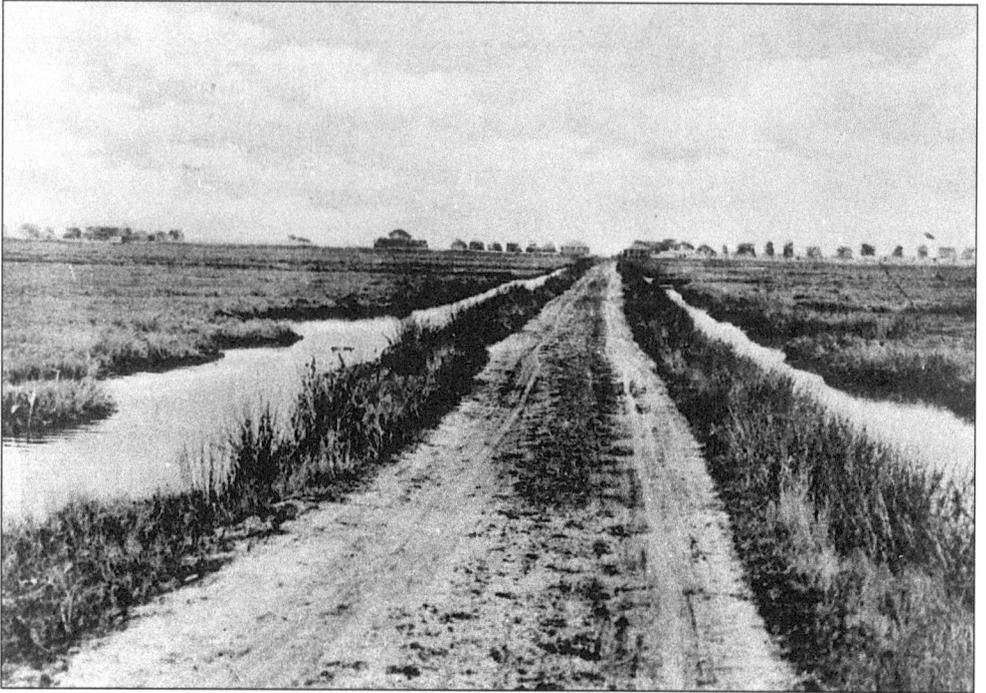

This dirt path from Manasquan to Brielle became what is now Brielle Road. Houses along the oceanfront in Manasquan can be seen in background in this early-20th-century photograph.

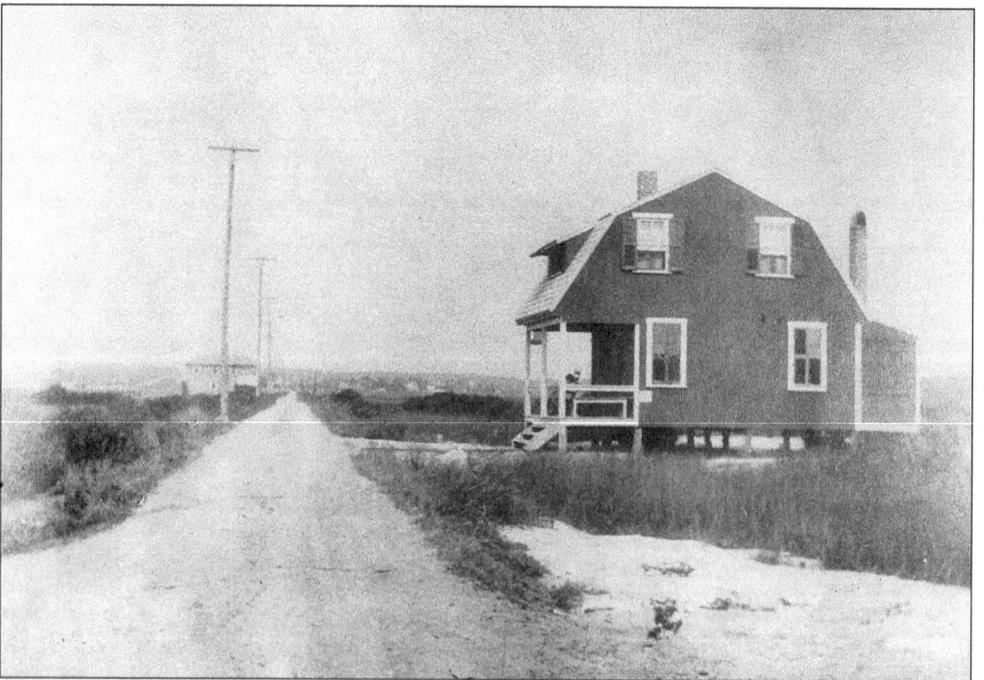

This house was one of the first ones constructed on Brielle Road when development began.

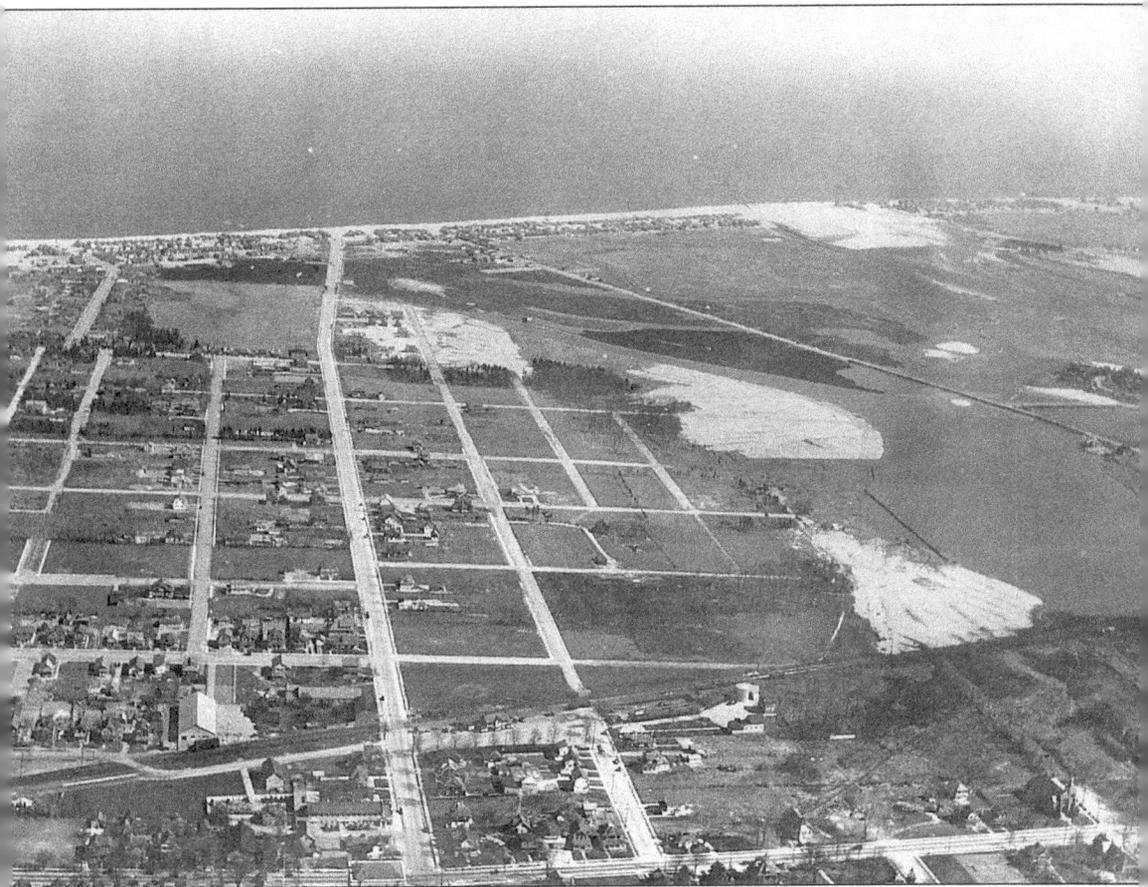

This aerial view of Manasquan was taken in the late 1920s. (Photograph courtesy of Howard and Linda McKeon.)

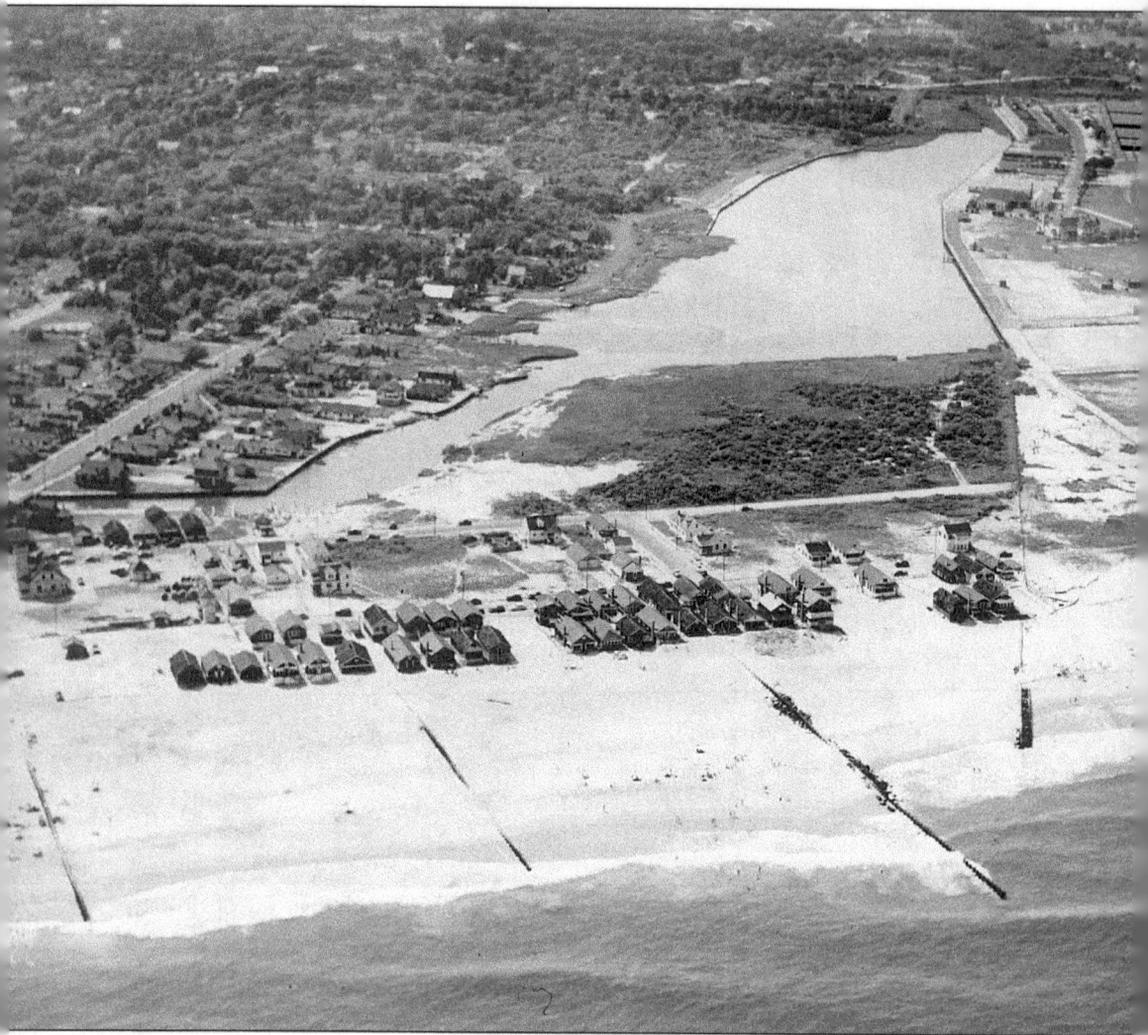

This aerial view of the northern end of the Manasquan beach area was photographed in the mid-1940s. Today, in addition to the residences, the area is home to the Little League field, tennis courts, and a hockey rink. Note the original location of the Kiddie Beach, in the center at the left. The U.S. Coast Guard Station is at the far left. (Photograph courtesy of Bob and Connie Watkins.)

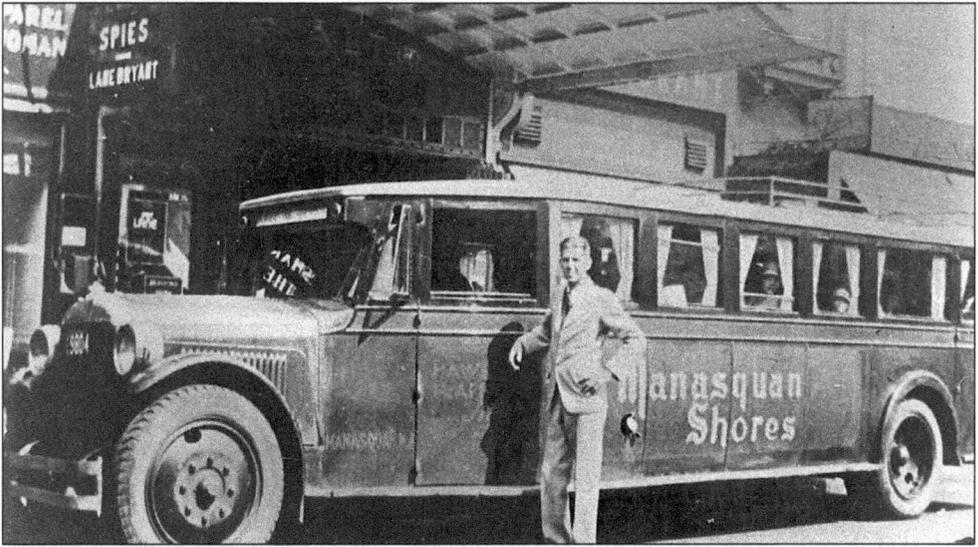

People interested in purchasing lots in Manasquan Shores, and later Manasquan Park, were offered free transportation from North Jersey on this bus provided by the real estate firm of Hawes and McAfee Inc. The firm was established in 1927 by Munroe C. Hawes and James B. McAfee, who were instrumental in developing Manasquan Shores and Manasquan Park (Wall Township), just west of Manasquan. Real estate agent Jack Cattanach, the brother of McAfee's wife, picked up prospective buyers from Newark for a daylong outing to the Manasquan area.

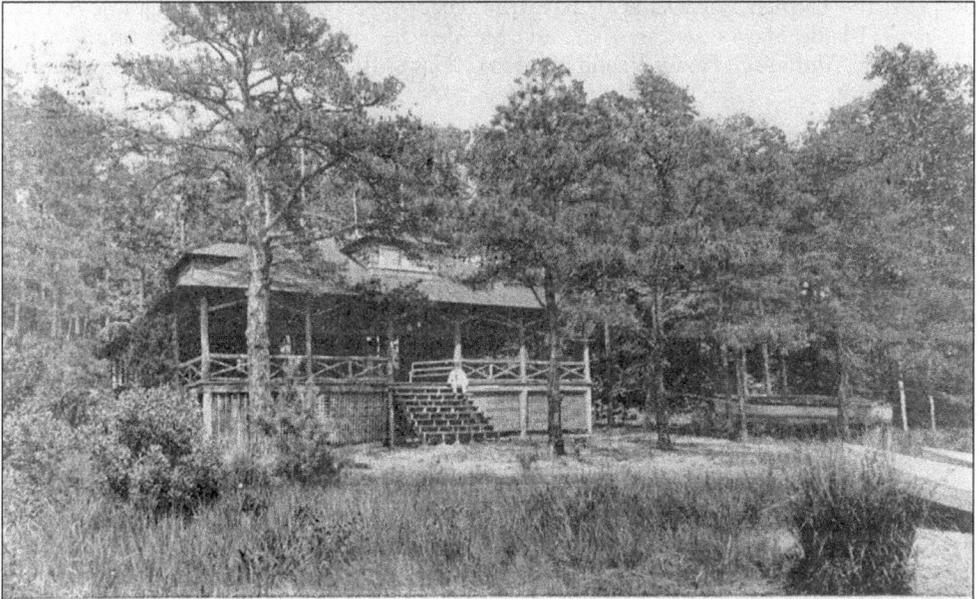

Club House, Manasquan Park, New Jersey Hand Colored

Seen here c. 1900, the Manasquan Shores Club House was located at the end of Myrtle Avenue and Riverside Terrace in Wall Township, on the shore of the Manasquan River. Originally the site of services under the direction of evangelist Dwight Moody, Hawes and McAfee acquired the property after the religious community failed. With the change in ownership, property owners in the area gained rights to use the private clubhouse. The real estate company entertained prospective buyers at the site.

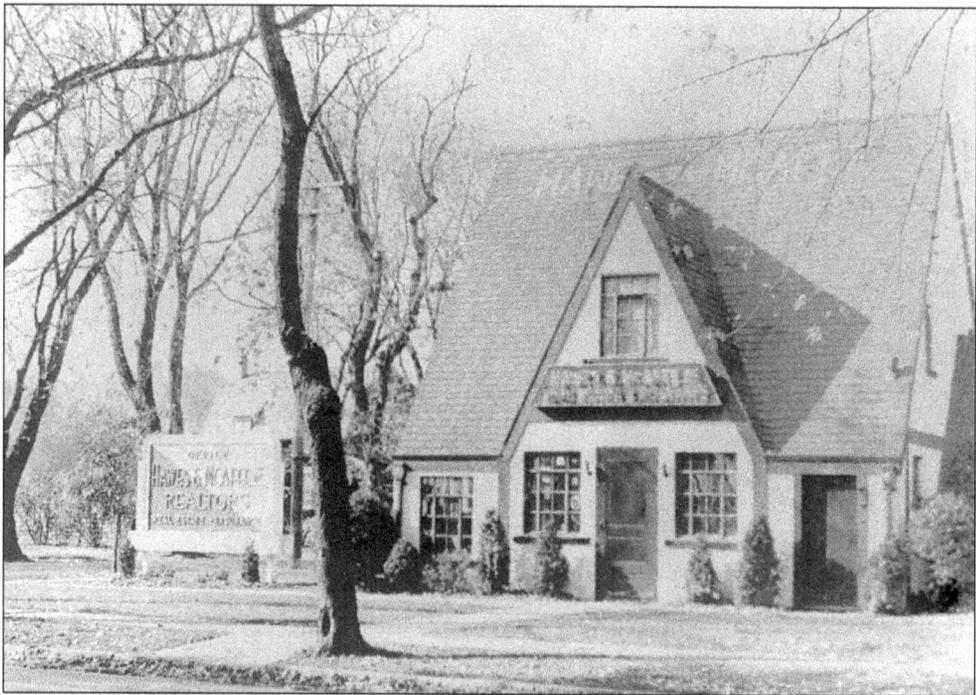

The original offices of Hawes and McAfee were located at Watson Place and Main Street. In 1929, the partners contracted to have the Tudor-style building at 111 Union Avenue (Route 71) built. Hawes died in 1987, and McAfee died in 1993. At the beginning of the 21st century, Munroe C. Hawes Jr. and Munroe C. Hawes III were operating the real estate and insurance firm.

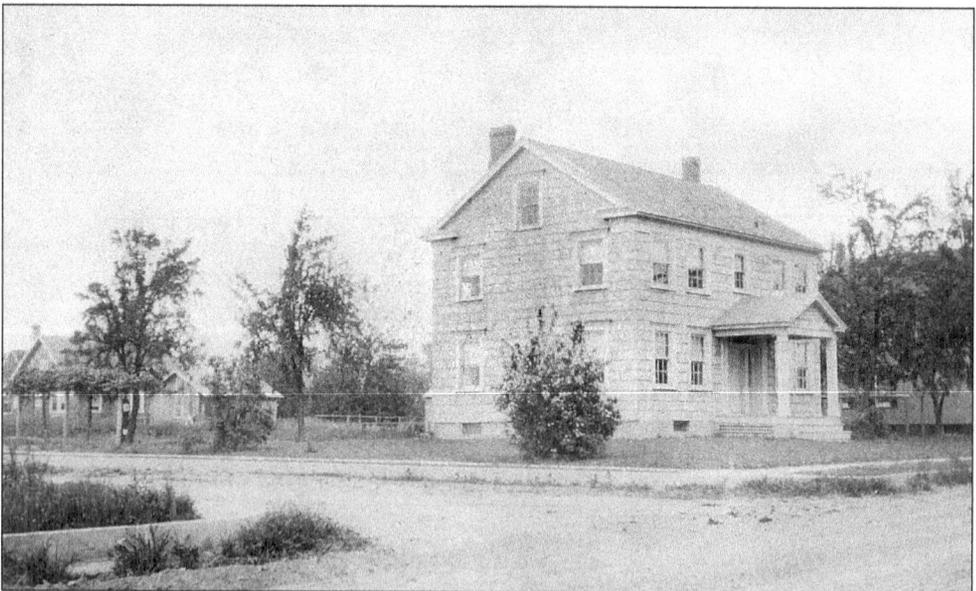

This two-story dwelling at the corner of Clark Street and Minnesink Road (47 Clark Street) shared the area with few other homes in the late 1920s. Notice the weeds in the unpaved street, as well as the presence of curbs and sidewalks.

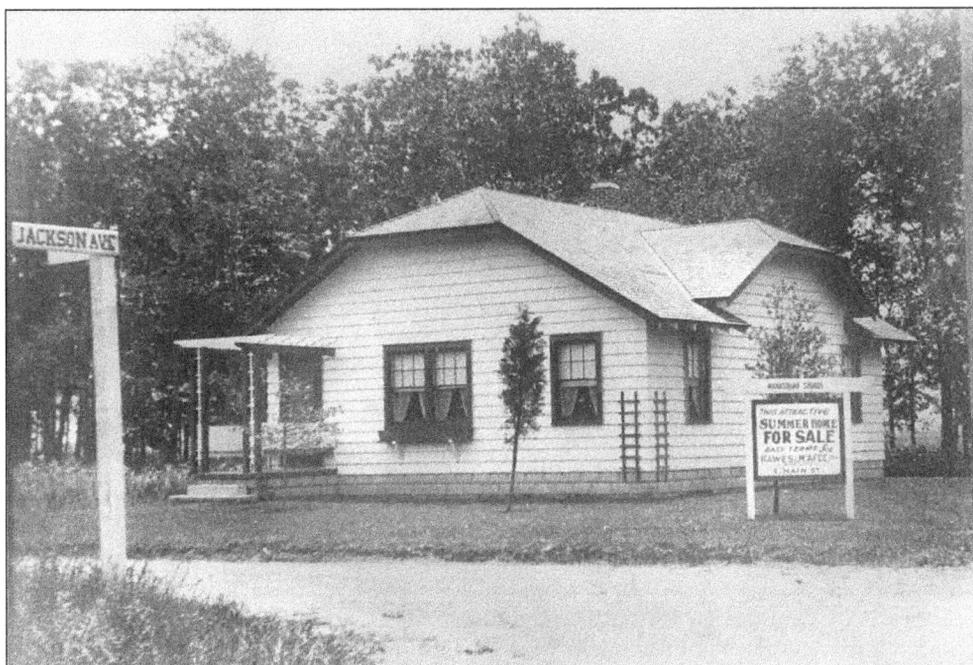

This home on Jackson Avenue was offered by Hawes and McAfee during the 1920s. Although this home was offered as a summer residence, the area east of the Manasquan Railroad was under development and year-round homes were also available.

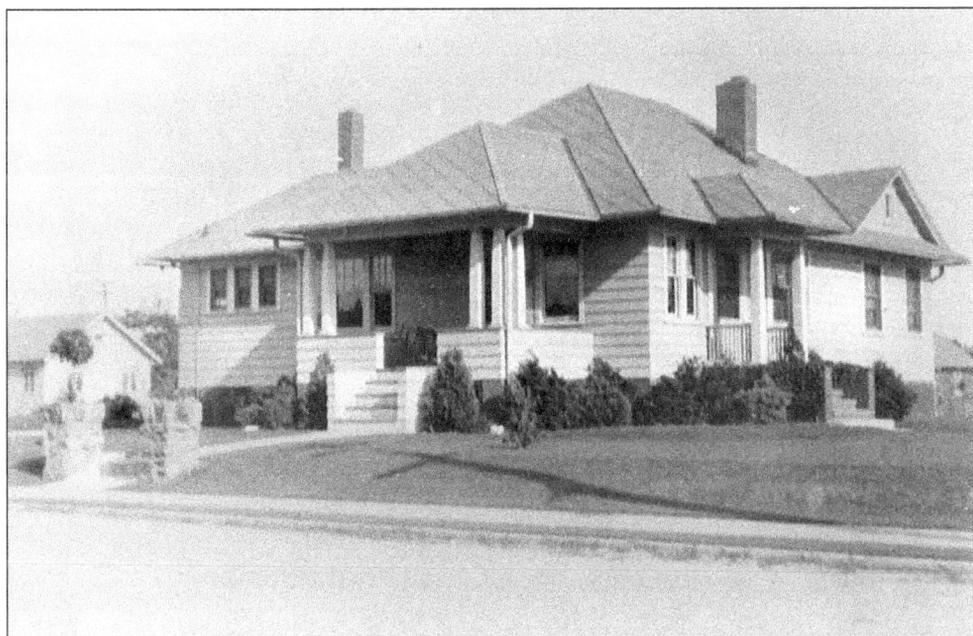

Built in the early 1920s, the house located at 22 South Farragut Avenue was the home of Joseph LaVance and his wife, Ellen. LaVance, a councilman in the borough, was a builder and also ran a seasonal newspaper store on First Avenue near Main Street. LaVance's nephew John Lavance and his wife, Janice Lavance, have resided in the home for 33 years.

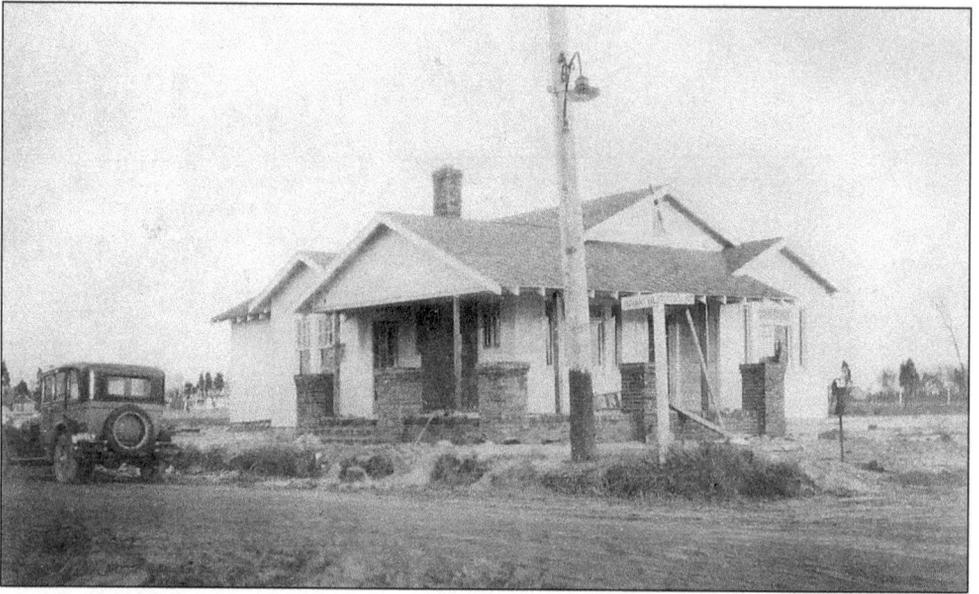

In the early 1920s, this home located on the corner of South Farragut and East Virginia Avenues (66 South Farragut Avenue) and owned by a Dr. Dranow was the first and only house on the block. The lack of water mains in the area mandated the use of the well pump seen in the front yard. This home was abandoned during the Great Depression.

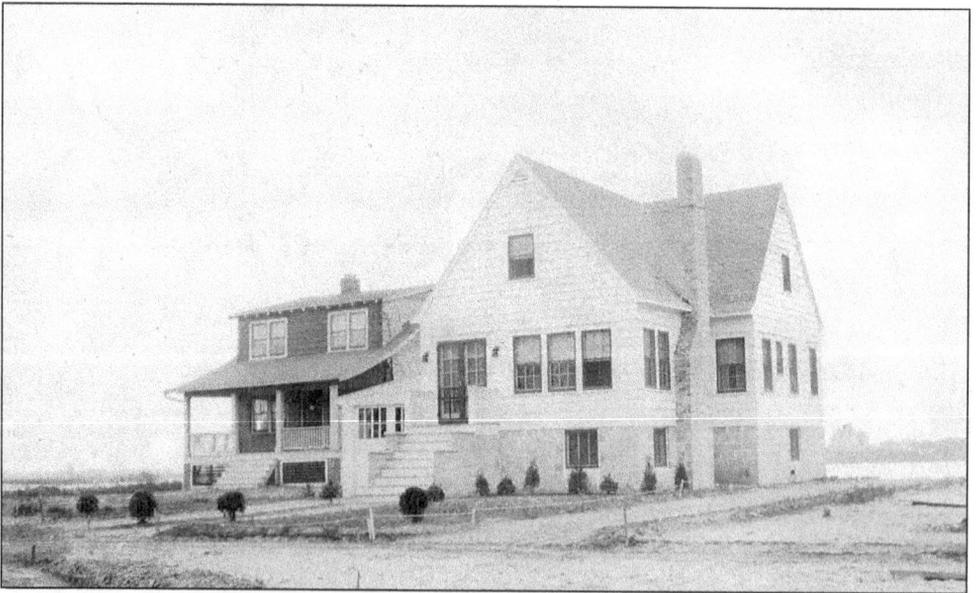

The house on the right, at 279 Perrine Boulevard, was the first residence on the Glimmer Glass. It was built in the early 1920s and offered fabulous views of the lake. Eyrwin Pulver, a dispatcher for the Manasquan Police Department, lived in the house at that time. During the 1930s, a tennis court was added.

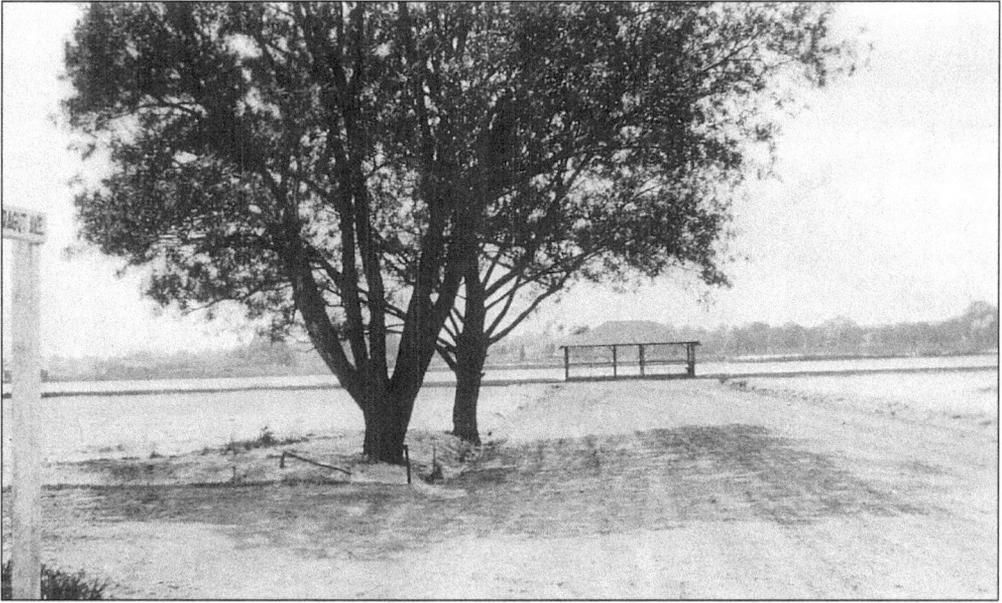

A summerhouse was located at the end of S. Farragut Avenue during the 1920s and 1930s. Some residents recall hours of fun fishing from the site as well as climbing these trees.

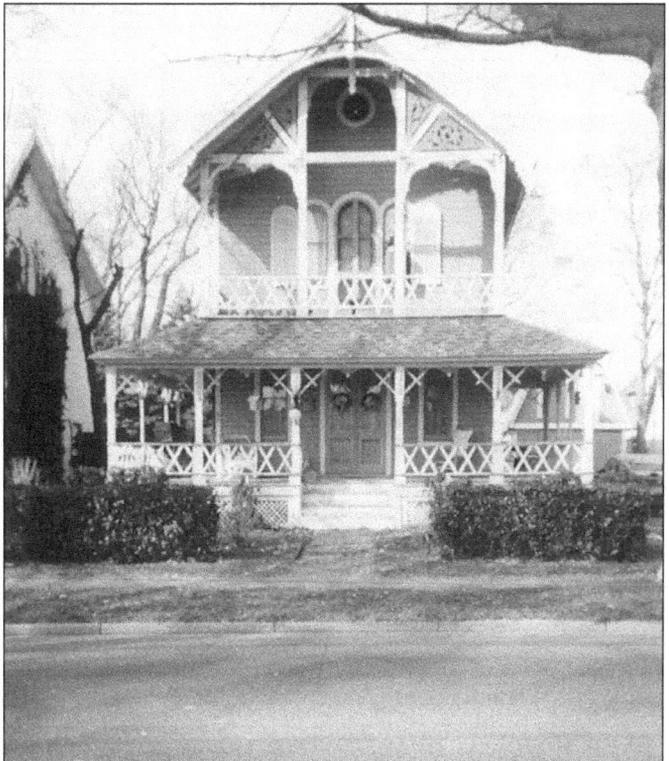

The "Victorian seaside cottage" at 123 Union Avenue (Route 71) was one of the first homes in Sea View Village. Tax records indicate that the house, which dates back to 1862, was built by George F. Estelle. Today, William and Toni (Marzulla) McChesney reside there. Toni McChesney, a graduate of Manasquan Elementary School and Manasquan High School, has served as borough historian since January 1, 1998.

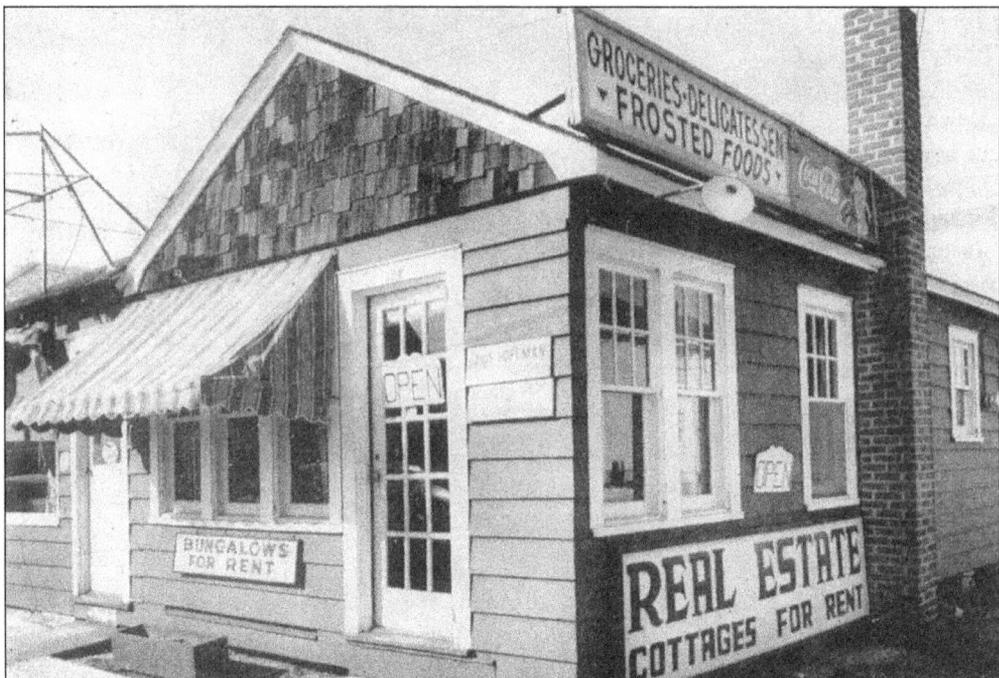

The real estate office of Gaius Hoffman was originally located on the corner of Brielle Road and Second Avenue. In 1953, Richard I. Wood Sr. bought the business and moved it to the corner of Main Street and Fourth Avenue in 1958. In 1975, the agency listed a year-round oceanfront cottage with a garage apartment for $75,000. Today, Robert S. Wood serves as the owner and the broker of the agency.

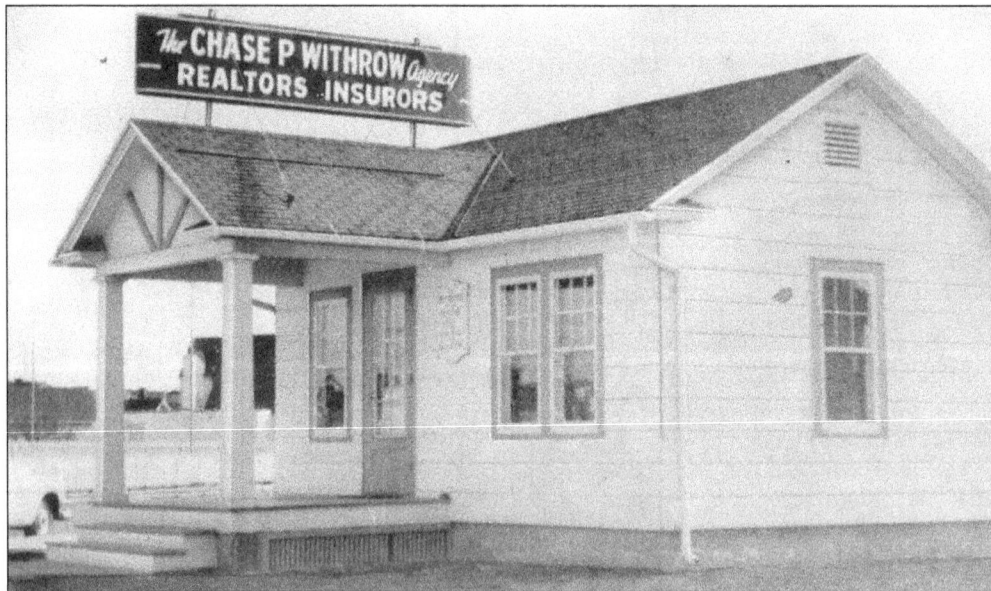

A branch office of the real estate and insurance firm of Chase P. Withrow opened during the spring of 1947 on the southwest corner of Main Street and Third Avenue. This view was taken in the 1980s. Withrow, a resident of the borough and a veteran of WW II, also maintained an office at 84 Virginia Avenue.

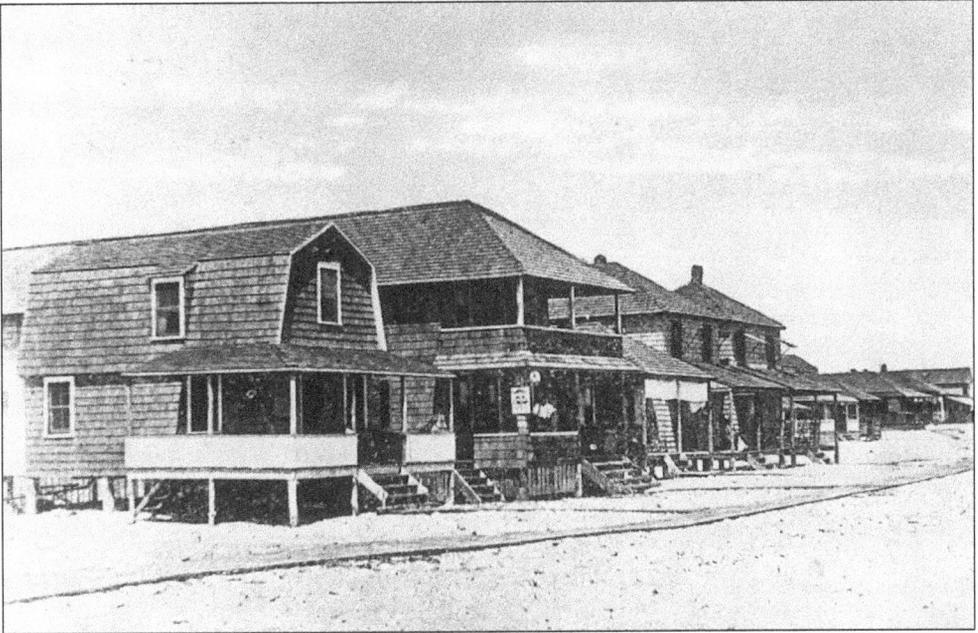

The 1880s bungalow colony in Manasquan featured homes with porch rockers, where residents could watch the day turn to evening for three months each year. Clapboard one- and two-story homes offered residents most of the conveniences of home away from home, even though bathroom facilities were not installed until the 1930s.

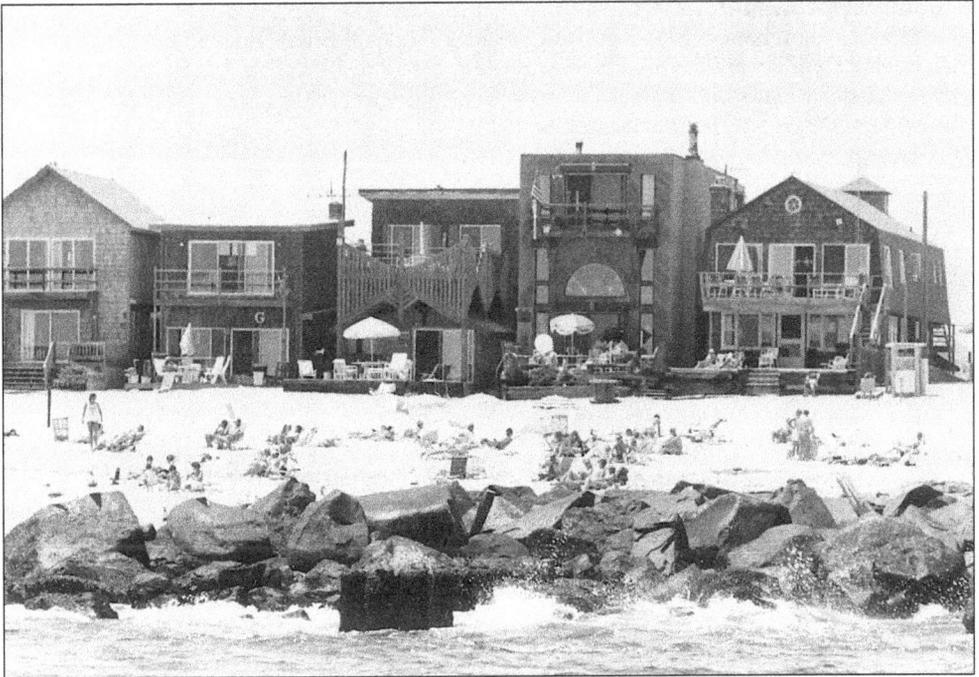

In sharp contrast, the homes in this 1986 photograph differ in size and style. These homes, many of which are year-round residences, are located at the north end of the beachfront.

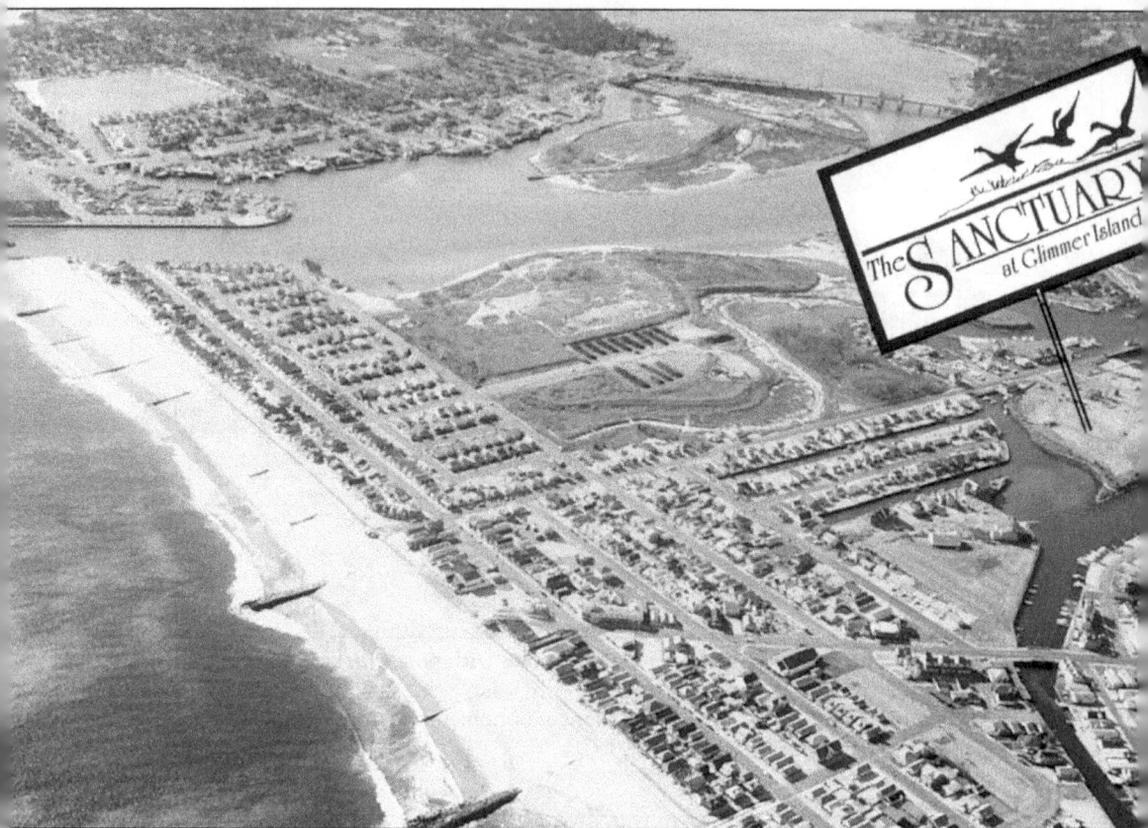

The Sanctuary at Glimmer Island was built on a peninsula off Brielle Road in the beach area of Manasquan. Developers advertised the site in the mid- to late-1980s as a "waterfront community with spectacular views of Glimmer Glass Harbor, walk to beach and marinas, with luxurious contemporary and conventional designs available."

Three

THE BUSINESS DISTRICT

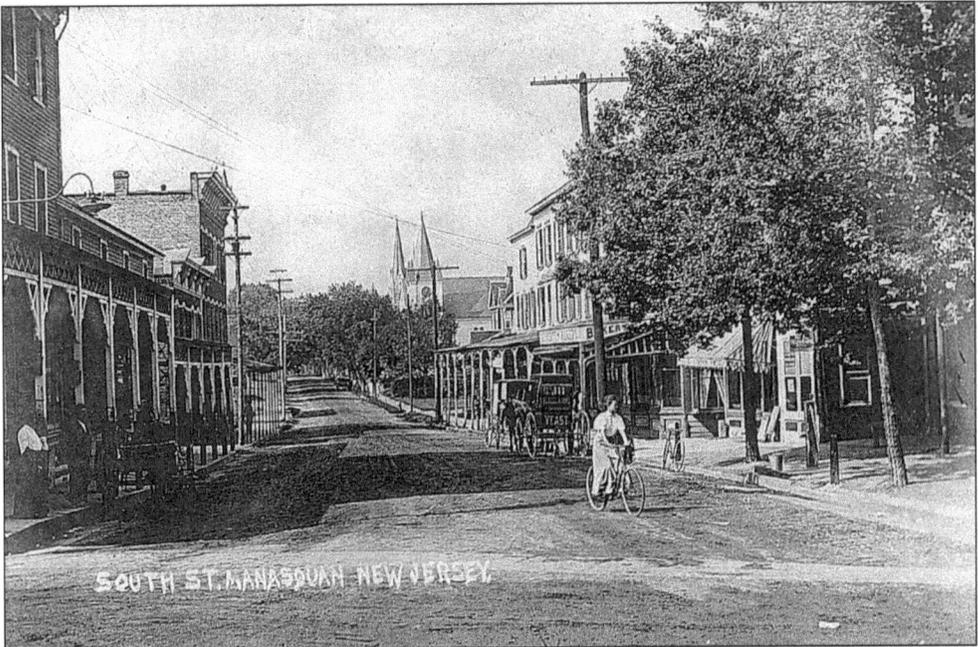

A woman pedals north on South Street in this *c.* 1900 photograph. The Manasquan First Baptist Church is visible in the distance on the west side of the street. (Photograph courtesy of Joseph and Barbara Jackson.)

The Coast Star

BUSINESS DIRECTORY

HOSKINS the PRINTER

For the year
1935

This 1935 business directory was published by Tracy M. Hoskins, the owner of the *Coast Star*, the weekly newspaper serving the borough. The 36-page "must have" directory featured advertisements for businesses, the borough's alarm signal code for fires, a tide table, and a railroad timetable.

This area guidebook was published by the Manasquan Businessmen's Association and included information on the town's retail merchants, doctors and dentists, town officials, and "sporting facilities for the outdoorsman." (Illustration courtesy of the Tassini family.)

This decal came from the Manasquan Businessmen's Association, the forerunner of the Manasquan Chamber of Commerce, which was established in 1960. The Businessmen's Association, like the current chamber of commerce, worked to promote retail stores and professional establishments in the community, as well as to contribute to the overall safety and quality of life of the community residents.

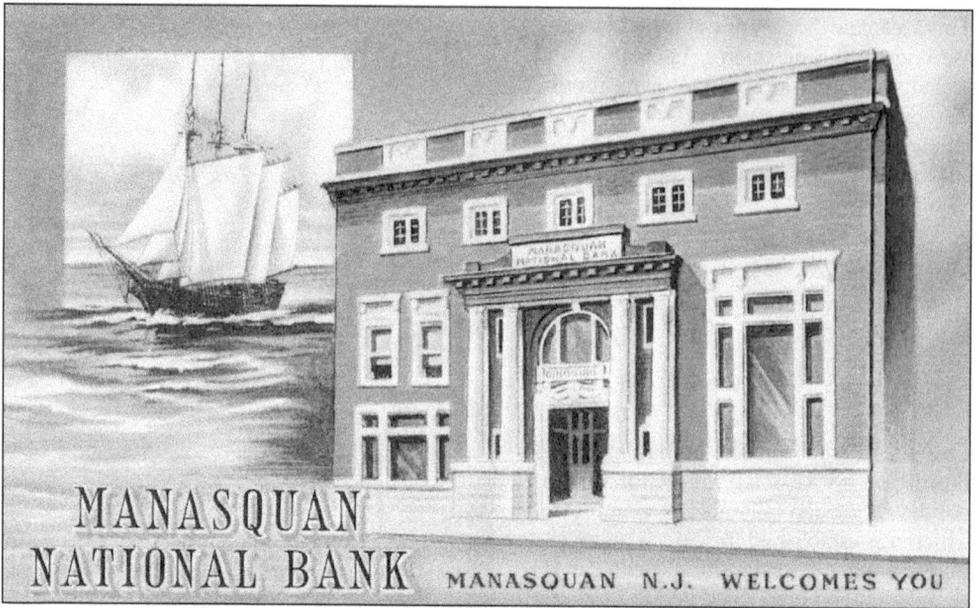

In August 1908, the Manasquan National Bank opened its door to the public at 107 Main Street. The building was constructed in 1883 and originally served as the First National Bank of Manasquan.

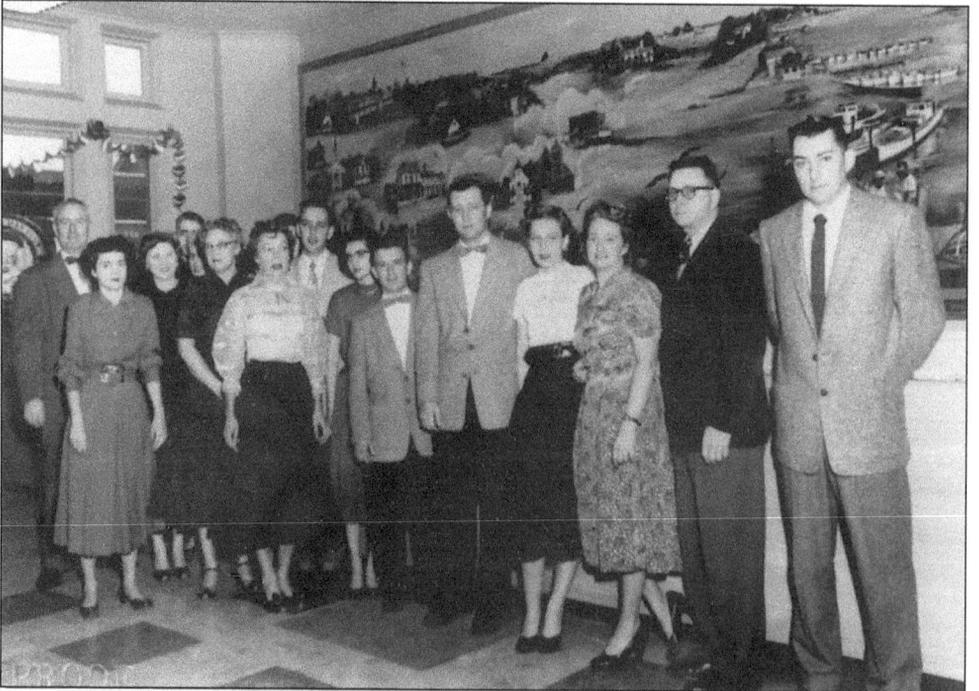

Employees of the Manasquan National Bank gather for a group photograph in 1954. Seen here, from left to right, are J. Wolcott Brown, Joan Smith, Molly Partridge, Roger Blair, Agnes Bailey, Daisy Briggs, Ted Rearick, Joan Herbert, Ray Pettit, James Brown, Gail Stires, Iva Tiernan, Robert M. White, and Richard Marks.

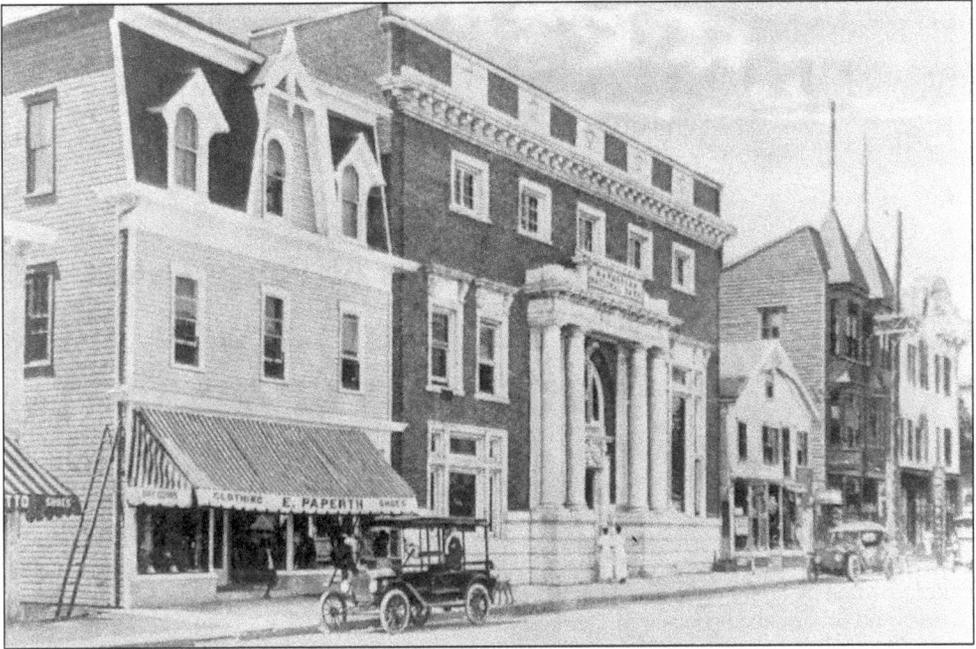

This *c.* 1900 view of the business district shows the E. Paperth Building at 111 Main Street. The opening celebration of the store (in the former M.S. Steinberg store) was held for ten days beginning on September 2, 1904. Owned by Ellis S. Paperth, the shop carried dry goods, clothing, linens, yard goods, and school supplies.

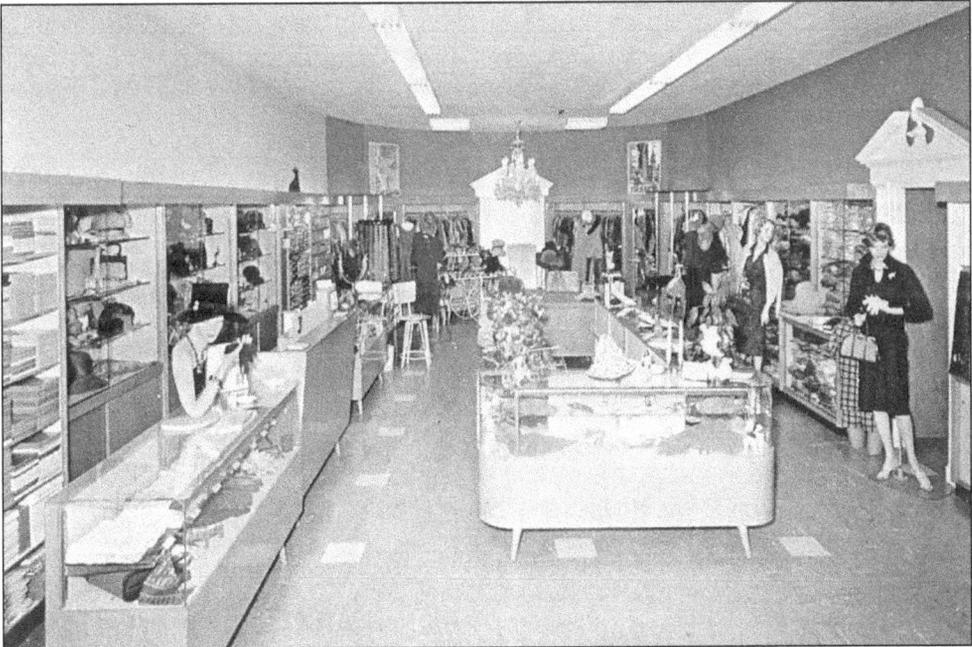

Sally's at 111 Main Street offered women the finest designer dresses and accessories. Sally Paperth Yatter owned and operated the shop, established as E. Paperth in 1904. When she died in December 1992, the shop closed. Today, after renovations, the building is the Center Food Market, owned and operated by Howard and Linda McKeon.

THOMAS' BAKERY

IS UNDER NEW MANAGEMENT

BEGINNING JUNE 1ST, 1921

WILL CARRY A FINE LINE OF

French Pastry and all kinds of Fancy Cakes.

BREAD BAKED TWICE DAILY.

F. BENNEWITZ

MAIN STREET - - - MANASQUAN, N. J.

TELEPHONE CONNECTION.

This advertisement announces the change in ownership from Thomas' Bakery to Bennewitz Bakery, owned by Fred Bennewitz. Located on Main Street, area residents said that Bennewitz's pastries and other baked goods were the best in the area.

OSBORN HOUSE,

SQUAN VILLAGE, N. J.

This new and convenient House is now open. It commands a view of the Ocean, Squan River, and an extensive scenery of country. It has advantages over many watering places, there being

FINE BATHING GROUNDS

both in the Sea and River.

BEAUTIFUL RIDES, SAILING, FISHING, &c.

Stages Connect with the R. & D. B. R. R. at Shark River.

Address FRANKLIN OSBORN, Proprietor.

Visitors to Manasquan in the late 19th century found the accommodations and fare at the Osborn House to be excellent. The hotel, located on the southwest corner of South and Main Streets, was well known throughout the state, as well as in New York and Pennsylvania. It was destroyed by fire on January 28, 1928. (Postcard courtesy of Richard Napolitan.)

Taken *c.* the 1950s, this summertime view of Main Street and Route 71 looks west. The Masonic Temple on the northwest corner of Main Street and Taylor Avenue (Route 71) was constructed in 1923. Members of the Free and Accepted Masons and Order of the Eastern Star met on the second floor of the brick building for many years. The third floor had a stage and an auditorium. The pharmacy on the first floor was established by William P. "Doc" Weir, who owned and operated the business for many years. Later, Herman Doctofsky and then Bernard Farber owned and operated the business. The pharmacy closed soon after this photograph was taken.

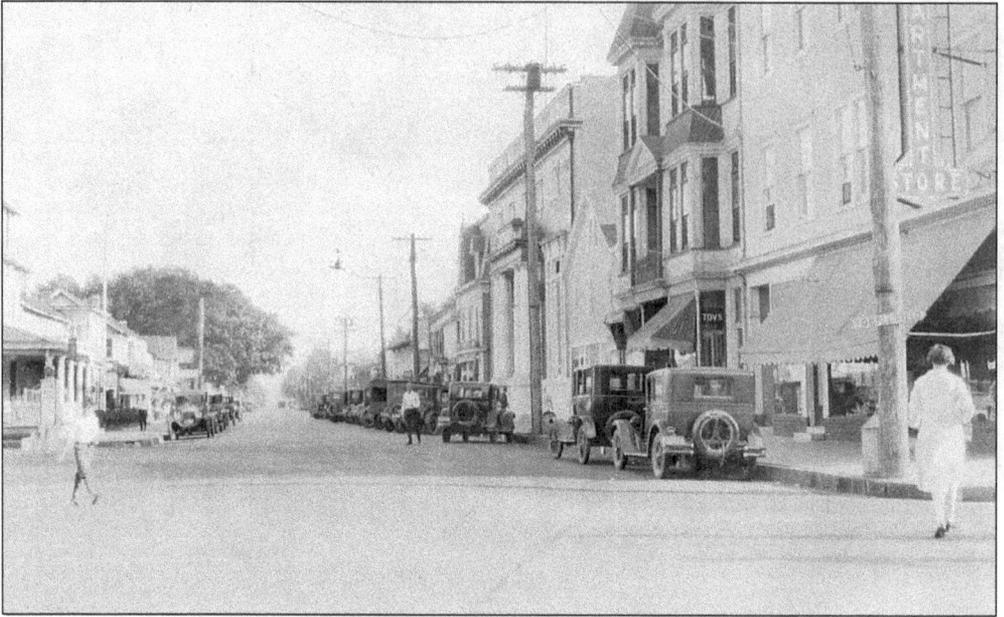

Looking east on Main Street in Manasquan during the early 1920s, a section of the Squan House is visible on the north side of the street. Note the blinker light used for heavy traffic. On the south side of Main Street are Sol Lewis's Department Store, which offered men's and women's clothing; Stanley Wood's Stationery Store; the Candy Kitchen, in the Borden Building; Benny Levine's Shoe Store; and the First National Bank.

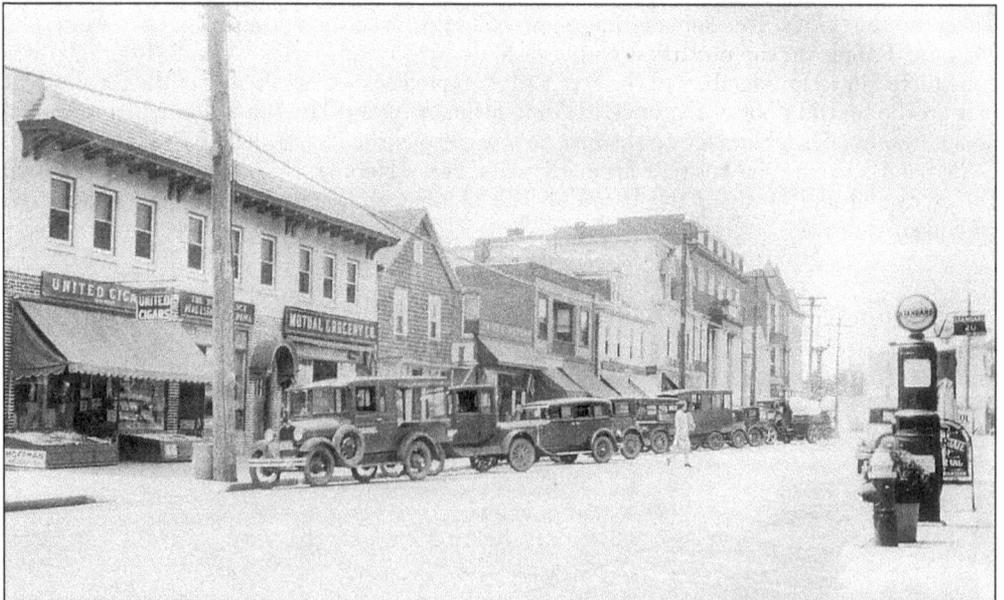

Main Street in the center of town featured the Mutual Grocery Store and the United Cigar Store (Tassini's) on the south side of the road. Frank and Peter Tassini owned and operated the cigar store for many years. The store also sold newspapers. Adjacent to the cigar store was the Bush Agency. The John R. Morris gas station and garage (today Manasquan Lighting) is on the north side of the street at the corner of Pearce Avenue .

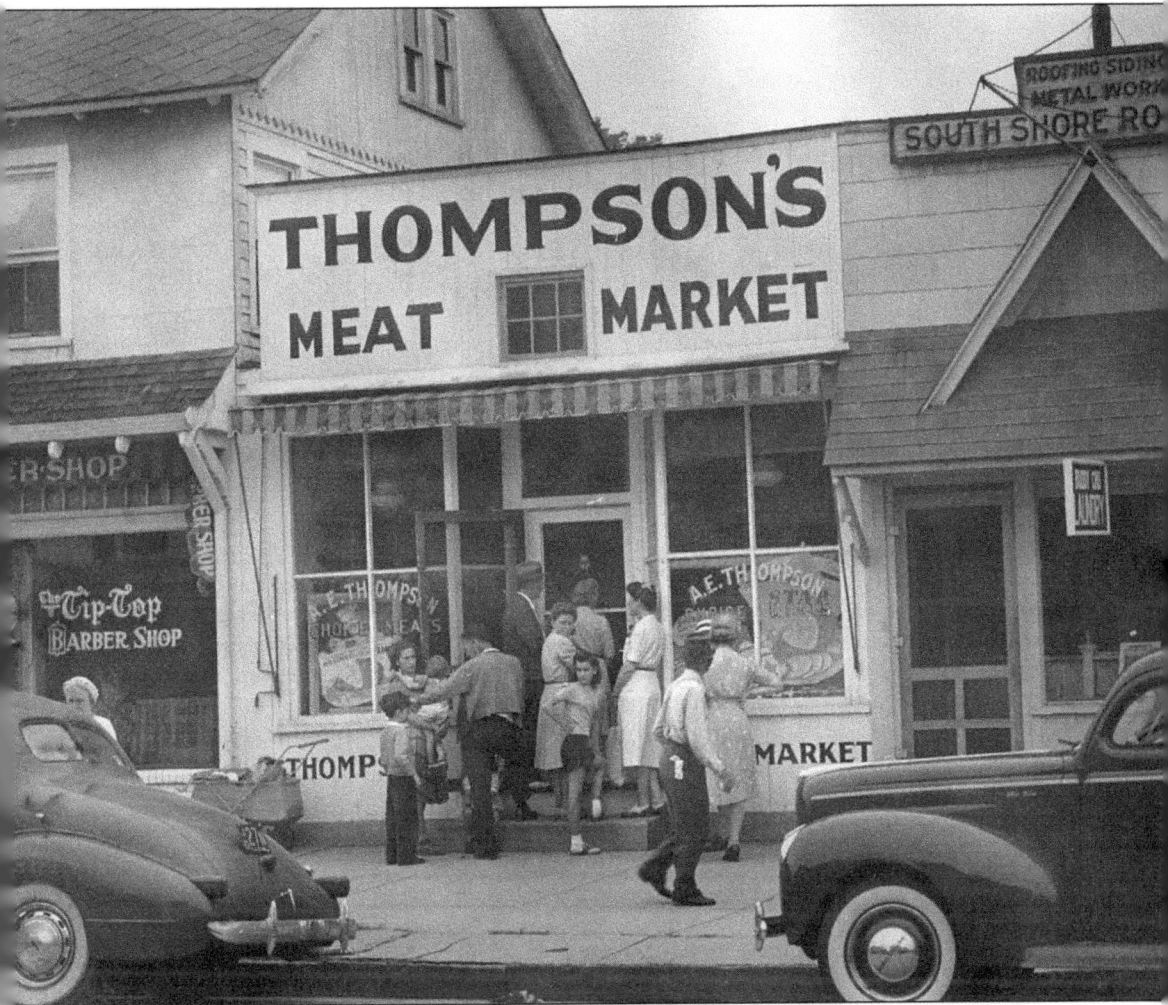

Customers wait outside Thompson's Meat Market in this *c.* 1944 photograph. The business was owned and operated by A. Eugene Thompson. The store sold fresh and salted meats, poultry of all kinds, and Heinz products and produce. These customers are using meat-rationing coupons issued during WW II. The Tip-Top Barber Shop was adjacent to the meat market; today, it is Cutter's Cove.

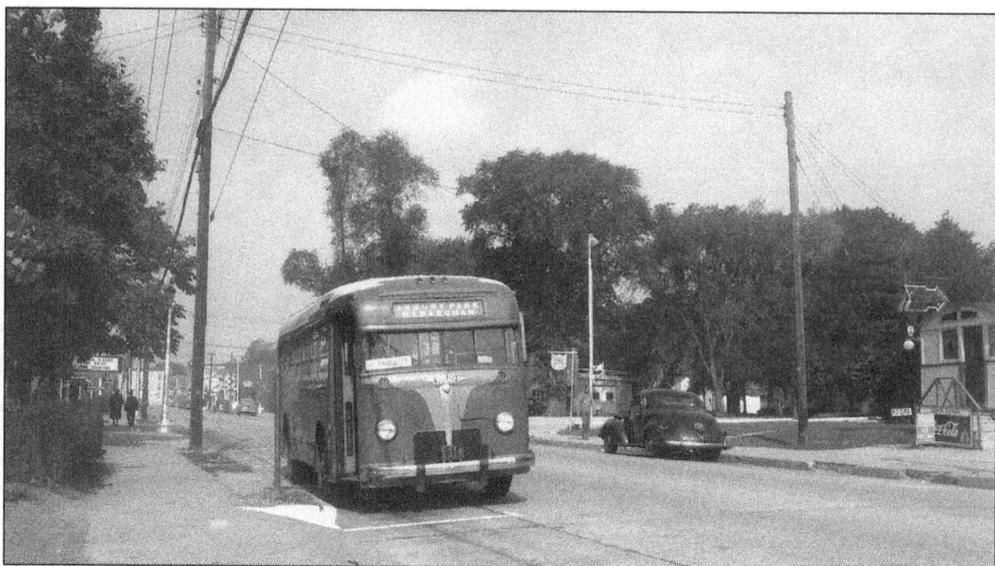

A bus from the Coast Cities Coaches makes its way along Main Street in the business district in this mid-1940s photograph. The bus route originated in Asbury Park and carried passengers south through Brielle and Manasquan and north to Long Branch. Advertisements for the bus service boasted "a super frequent schedule." Many area residents traveled to Asbury Park on Coast Cities Coaches for more extensive shopping.

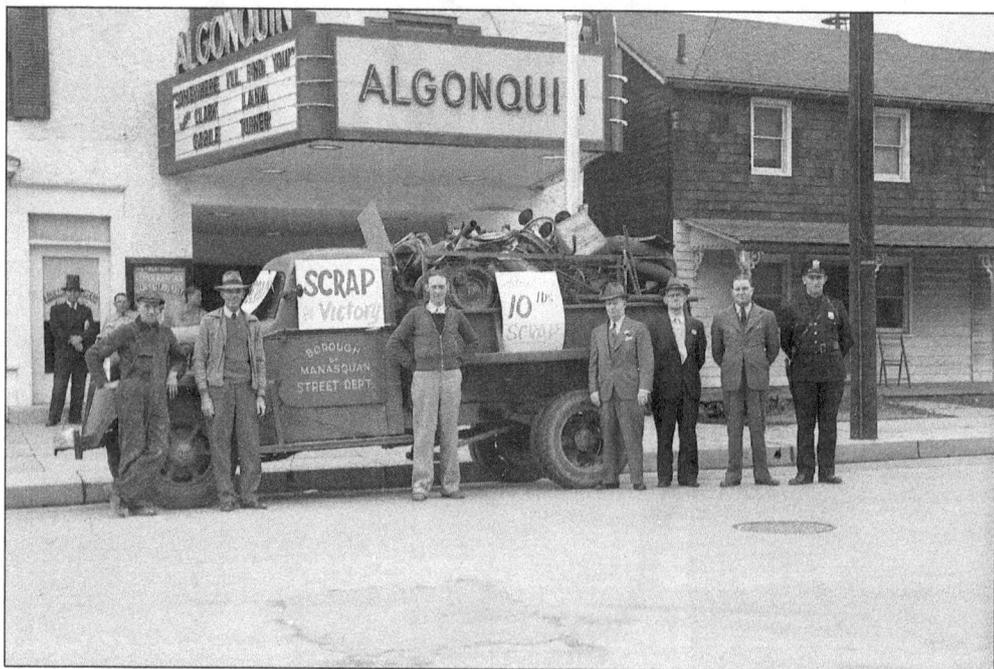

During WW II, area residents donated to scrap metal drives that collected metal for the war effort. These men are standing in front of the Algonquin Theatre.

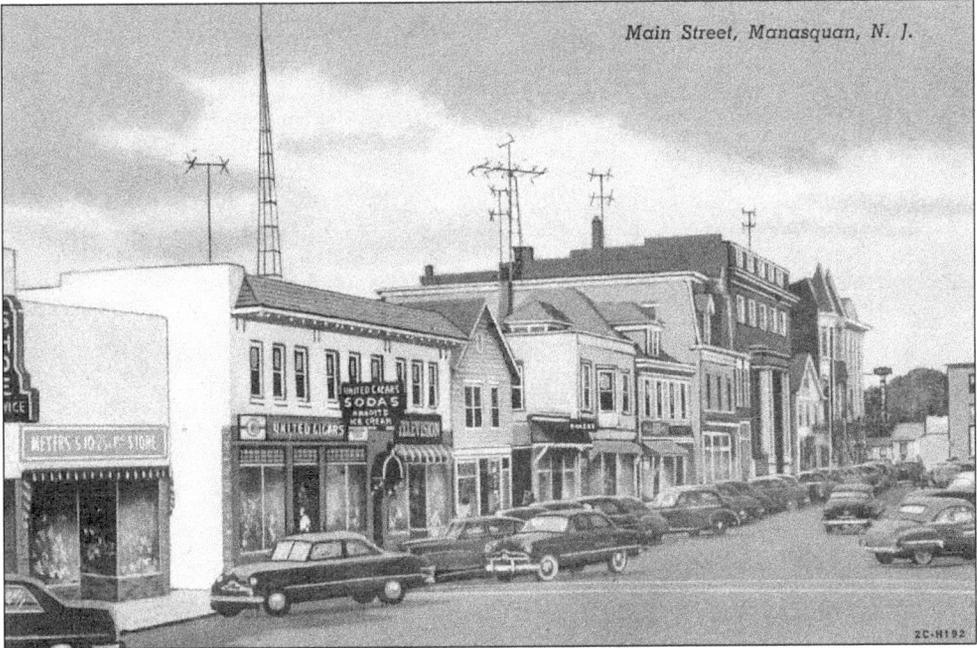

This view looking west along the south side of Main Street during the 1950s illustrates a thriving business community. Meyers' Variety Store was just one of the many stores along the street.

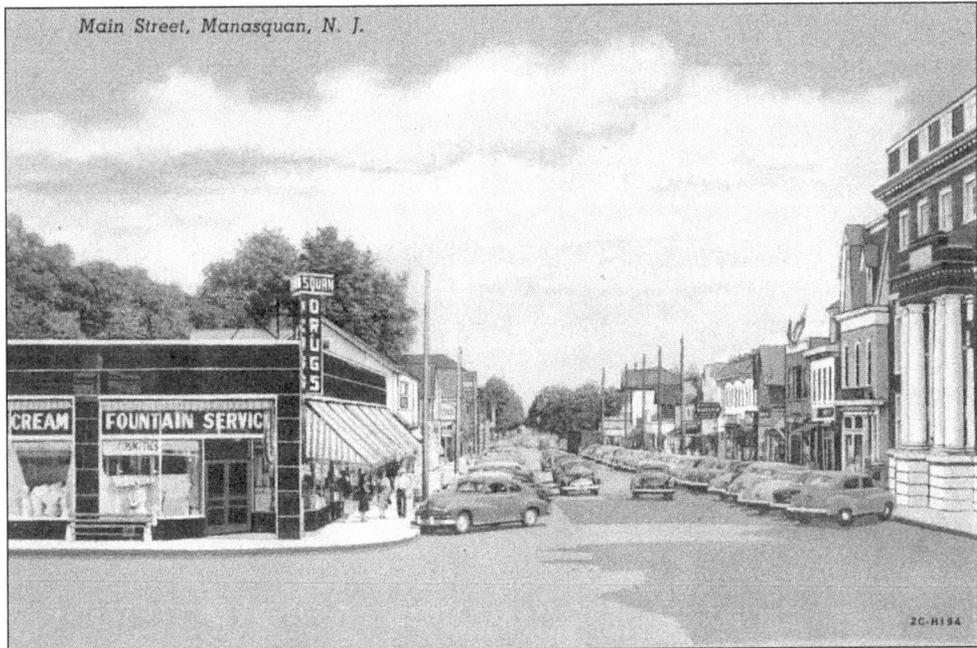

The north side of Main Street at the intersection of Broad Street offers a view of the west end of the business district. On the corner is Squan Drugs, which featured prescriptions, sundry items, and fountain service, where shoppers could sit and enjoy a cold root beer float and a sandwich at the counter. This site is currently Timm's Variety Store.

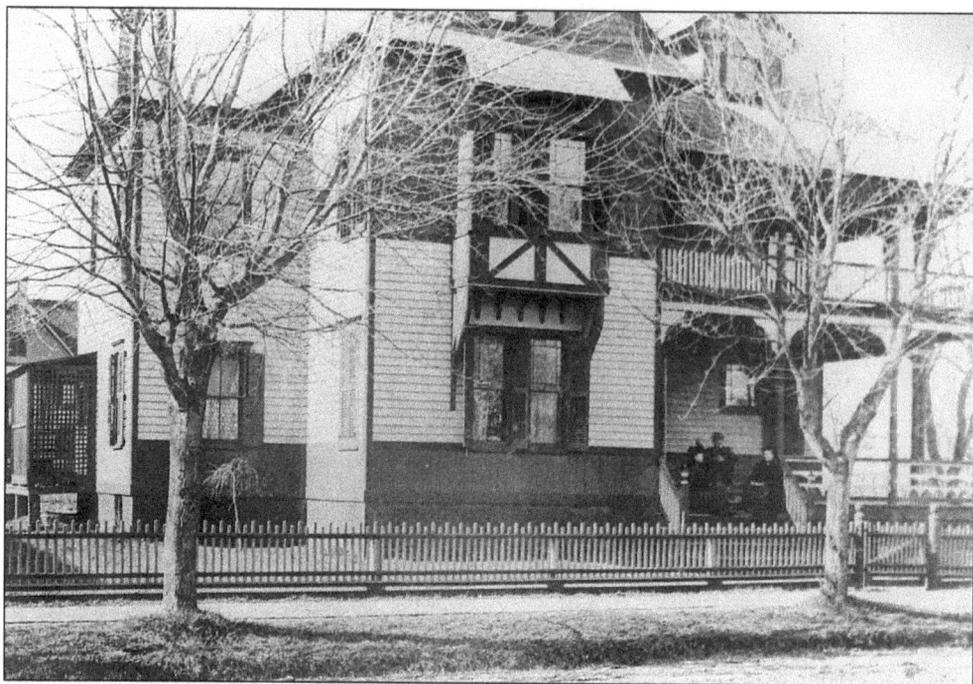

William Longstreet built this house at 117 Marcellus Avenue in 1882. This side view of the home was taken in 1890. In May 1999, Joseph and Barbara Jackson made history in Manasquan by opening the Nathaniel Morris Inn, a bed and breakfast, at the site. The establishment—fully restored to its Victorian charm—features a formal dining room, all rooms with private baths, and wraparound porches on two levels.

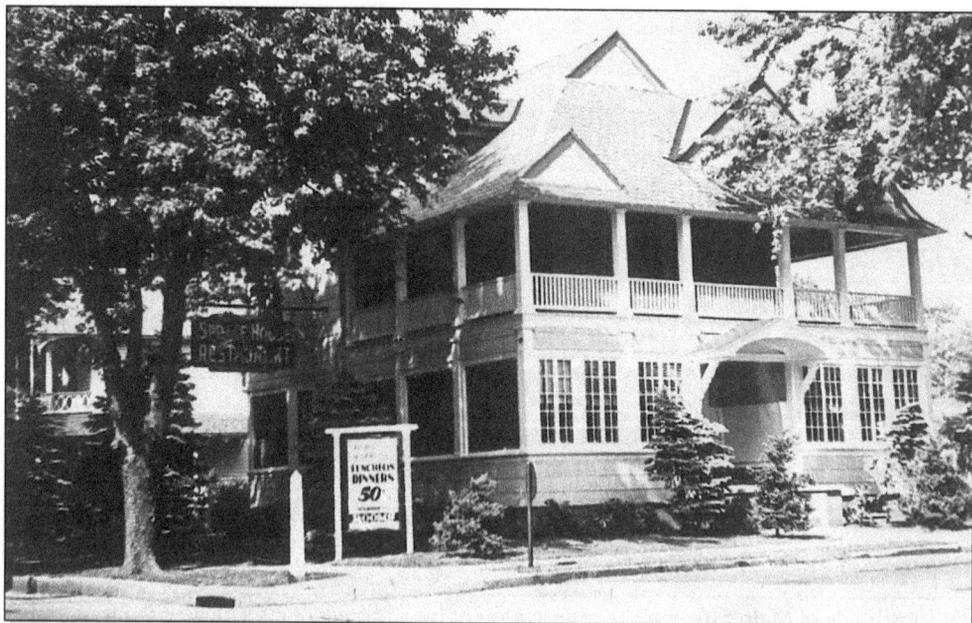

This more recent photograph of 117 Marcellus Avenue shows the building's many charms. Elizabeth Glaser owned the property from 1921 until 1940, operating it as the Spruce House Restaurant and the Spruce House Tea Room. She also completed an addition to the property.

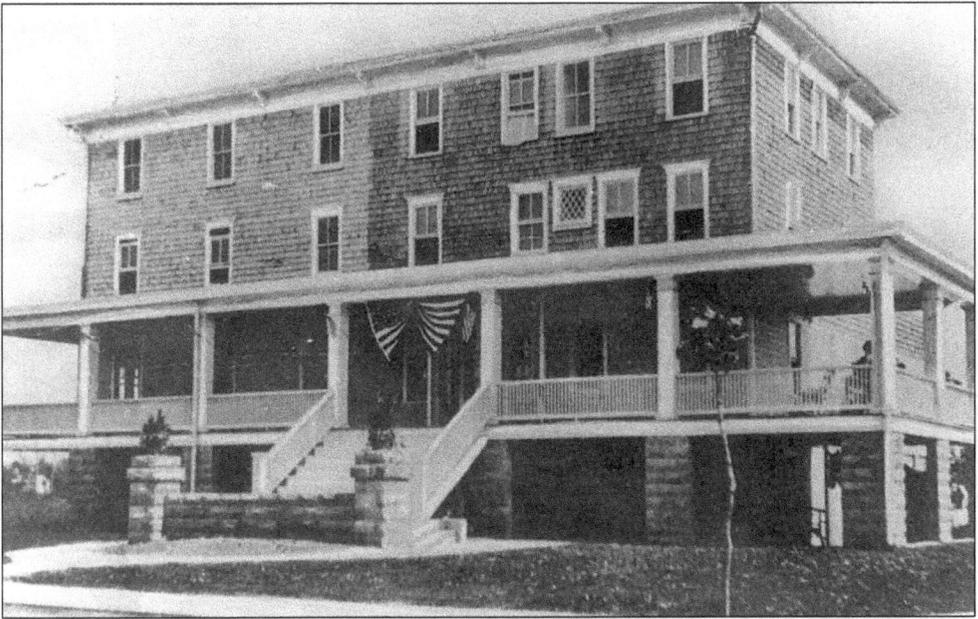

The Jackson House, now O'Neill's, was moved by its proprietors Mr. and Mrs. Ernest W. Froehlich from Fletcher Avenue to its present location at 390 Main Street. On a cold and snowy night in February 1949, Lillian Urick, the sister of Mrs. Froehlich, was murdered here. The crime has remained unsolved for more than 50 years.

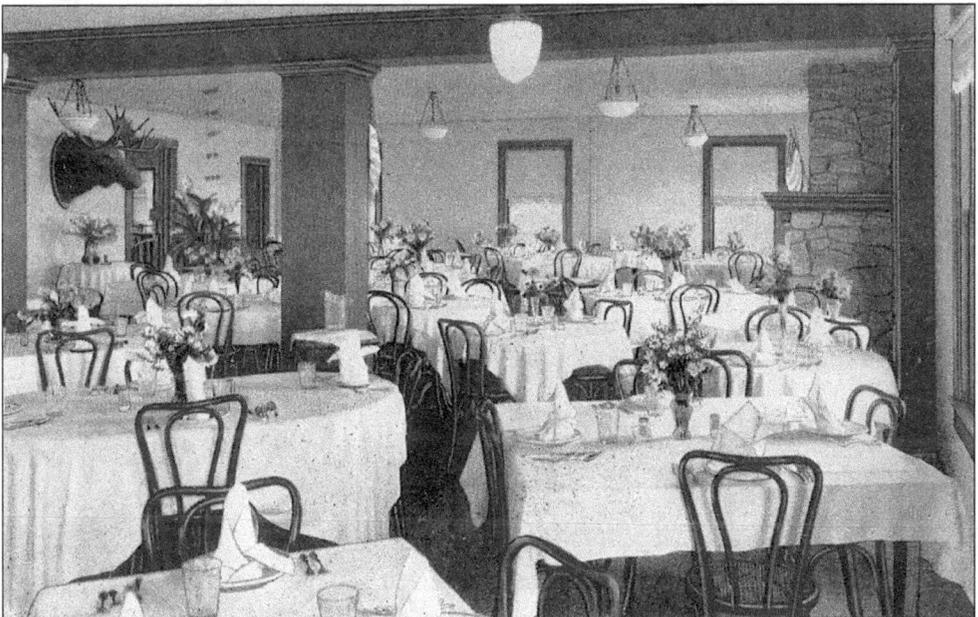

The Jackson House Hotel and Restaurant was once advertised as the "nearest boarding house to the beach." This mid-1940s postcard shows an elegant dining room decorated in American country-house style, complete with a nonindigenous moose head.

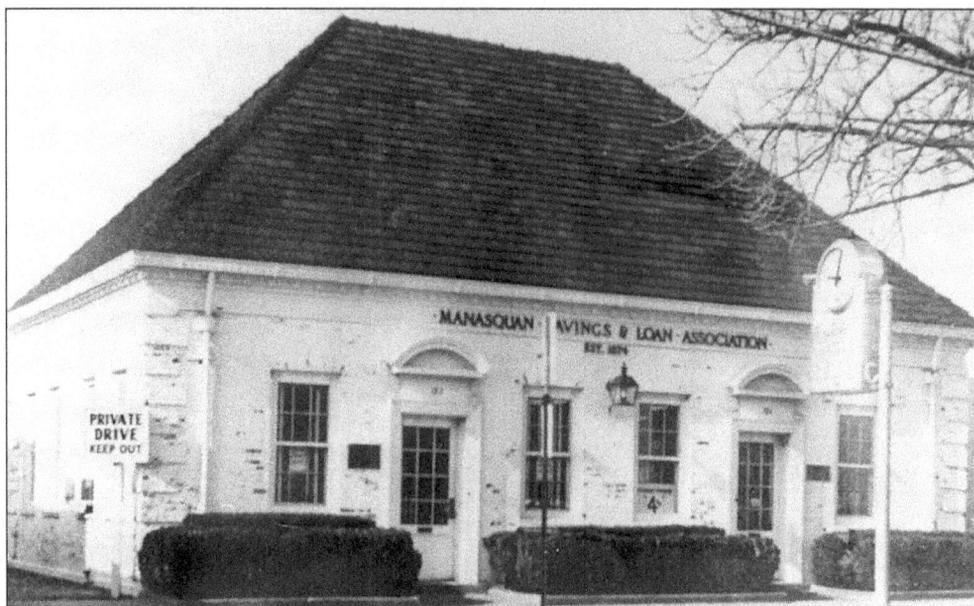

This photograph of the Manasquan Savings and Loan Association was taken in 1964, prior to exterior remodeling. The oldest continually-run banking institution in the borough, it was established in March 1874 as the Squan Village Building and Loan Institution. In 1910, it became the Manasquan Building and Loan Association. Today, it is known as the Manasquan Savings Bank. Originally, there were 11 members of the institution.

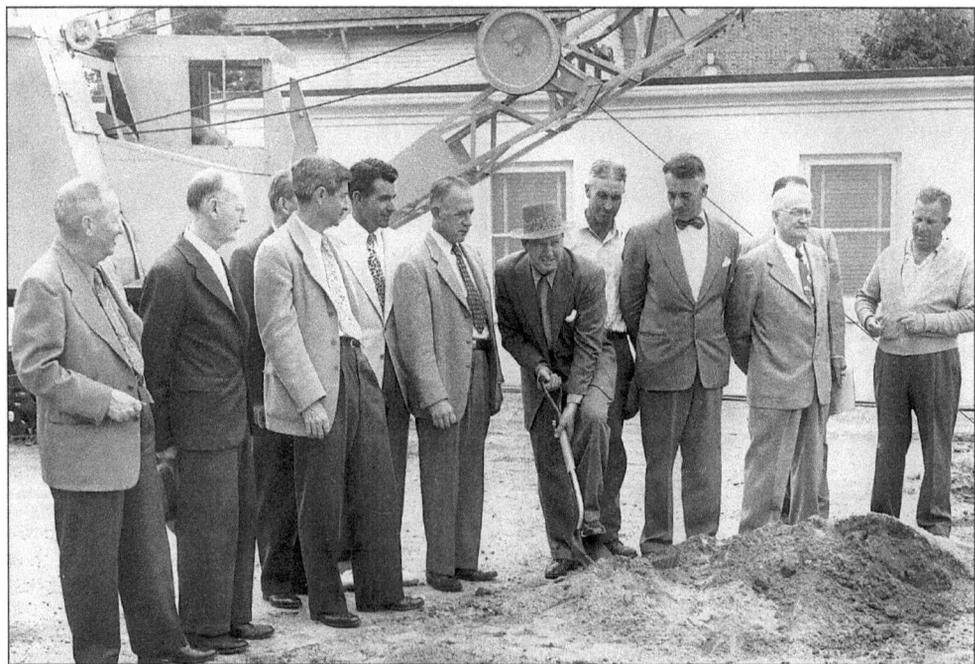

Ground-breaking ceremonies for the post office on Main Street were held on June 5, 1951. Participating in the event, from left to right, are Joseph LaVance, Tracy M. Hoskins, Hubbard F. Edick, George Mueller, Raymond Baker, owner of the property Irving B. Kirsch, Ralph Brown, Raymond McGreevey, W. Lafayette Danley, and William Logan.

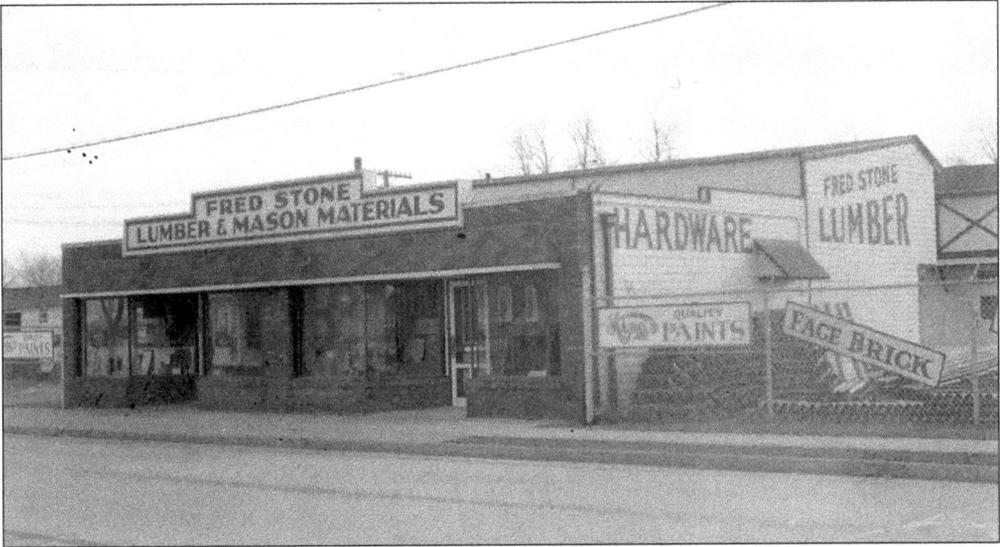

Photographed c. 1935, Fred Stone Lumber and Mason Materials was located on Atlantic Avenue between the former railroad tracks on Broad Street and Osborn Avenue. It was the second lumberyard in the borough and sold sashes, frames, doors, molding, household goods, fishing tackle, and garden tools. In later years, the lumberyard was destroyed by fire. The company's hardware store was located at 140 Main Street.

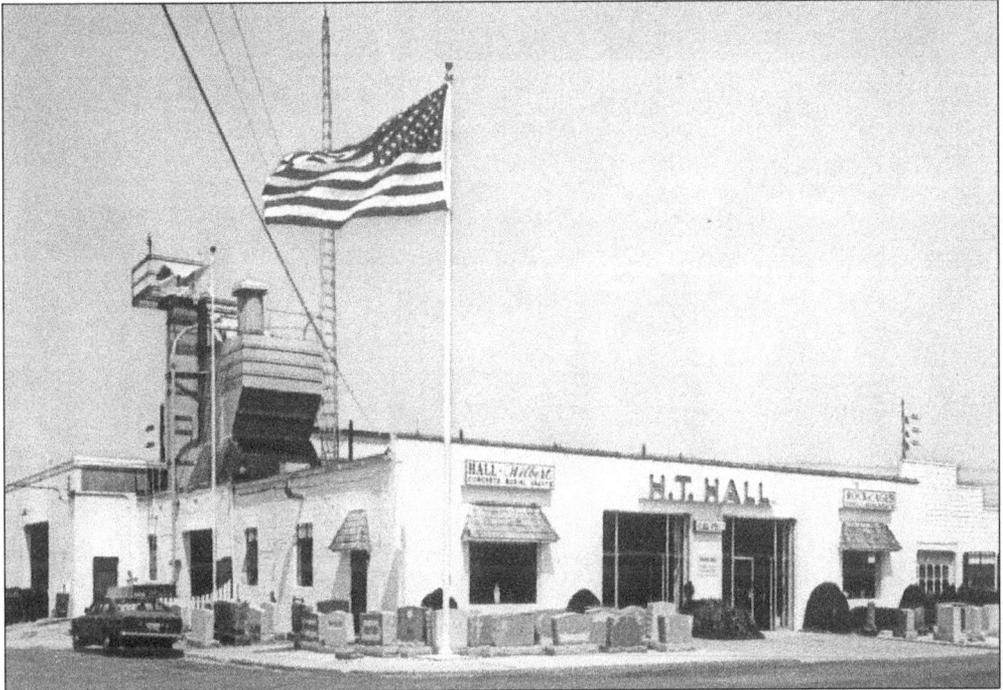

H.T. Hall Inc., a monument and burial vault business, was established in 1930 by Harold T. Hall Sr. and his wife, Edna Hall. The business was started on Pearce Avenue near Main Street and was later moved to its present location on Parker Avenue. In 1946, H.T. Hall expanded to include Rock of Ages memorials. The business continues under family ownership and is now run by a son and grandson.

Wilfred F. Sherman, the son of John and Jane Sherman and a lifelong resident of Manasquan, changed the name of Taylor's Mill to W.F. Sherman Millwork after acquiring the business. He had two children, W. Lee Sherman and Doris Sherman (Swader). Lee Sherman followed his father in the business in 1935, and his son Donald L. Sherman joined the firm in 1951. (Photograph courtesy of Donald and Nancy Sherman.)

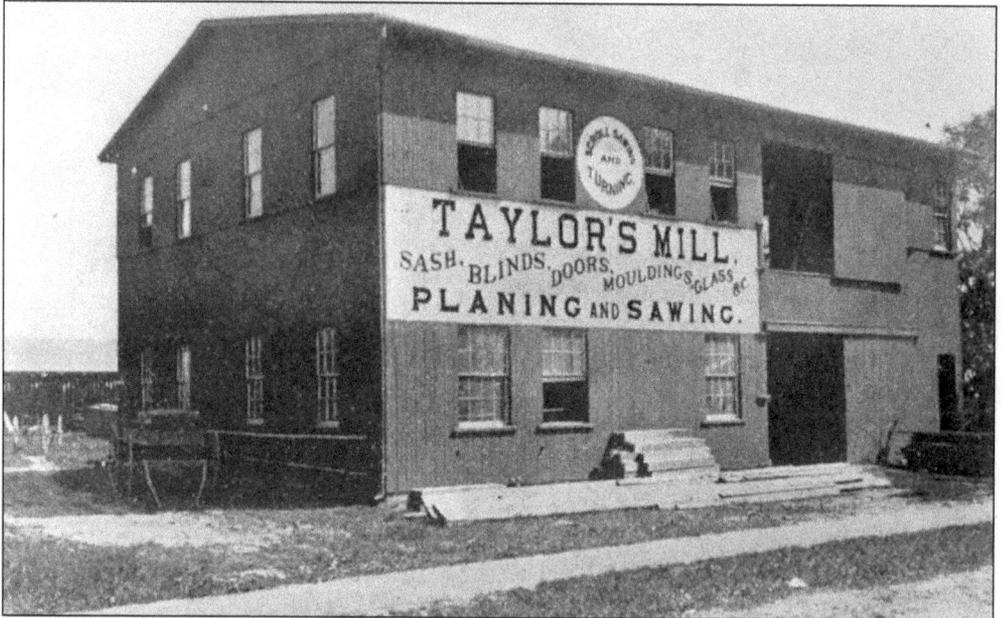

The business located at 84 Broad Street has been serving the area with custom millwork since 1878. W.F. Sherman and Son Inc. was established as William P. Taylor Steam Saw and Planing. After Taylor died in 1929, his nephew Wilfred F. Sherman, who had worked at the mill since age 12, purchased the business and refurbished it from 1930 until 1934. (Photograph courtesy of Donald and Nancy Sherman.)

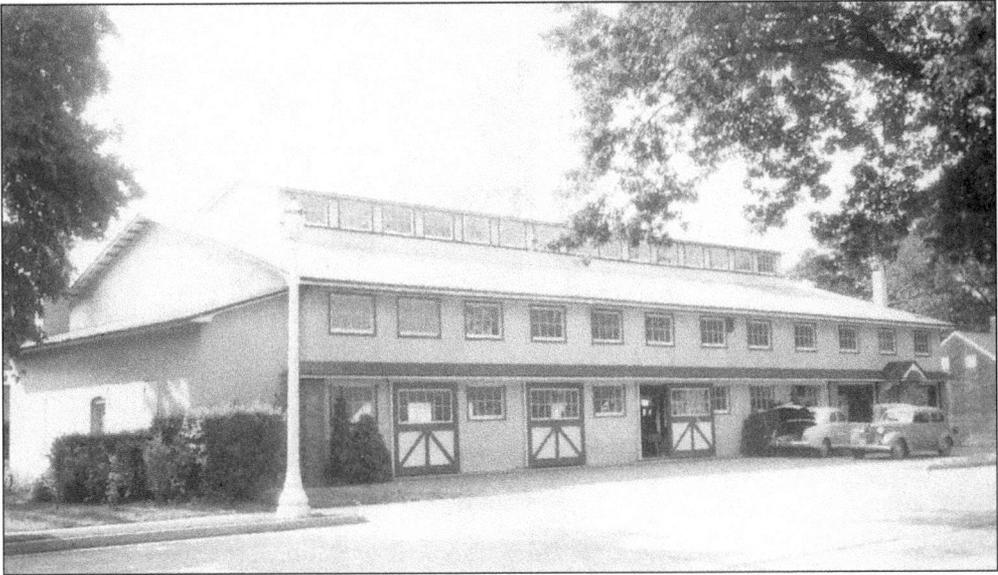

The W.F. Sherman Millwork building in this 1939 photograph is quite different from the original structure. The old building was destroyed by fire in 1911. Then in 1929, the business was damaged by fire. That year, Wilfred Sherman acquired the the mill and rebuilt it. Today, the fifth generation of the family runs the operation. The Jackson family home is visible at the far right. (Photograph courtesy of Donald and Nancy Sherman.)

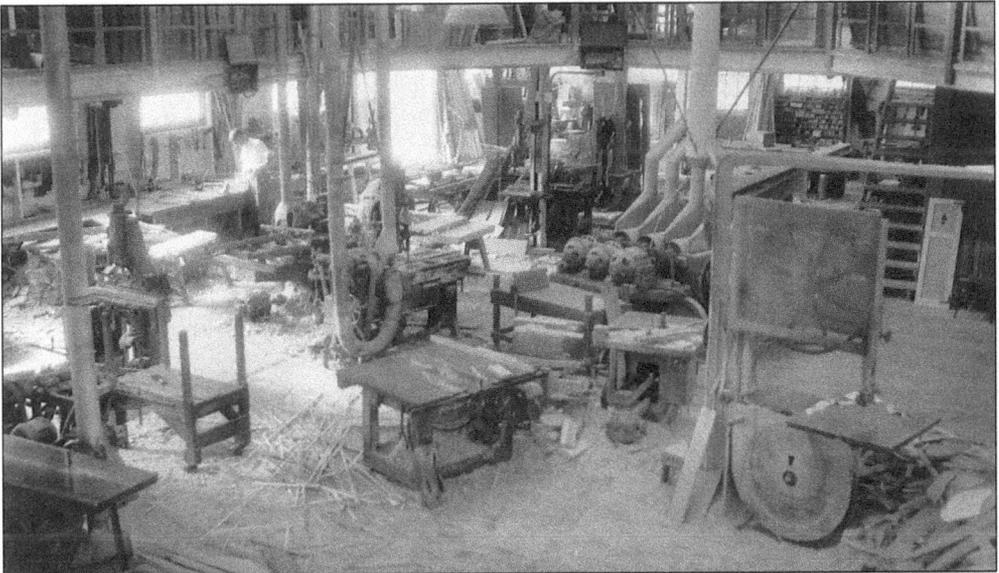

This interior view captures the daily operation of the millwork company in 1939. Donald Sherman Jr. and Alan Sherman run the mill today. Their sister Diane Sherman Siliato has worked in the business as well. The business focuses on high-end residential architectural millwork as well as custom work for restoring the area's many Victorian (and older) homes. (Photograph courtesy of Donald and Nancy Sherman.)

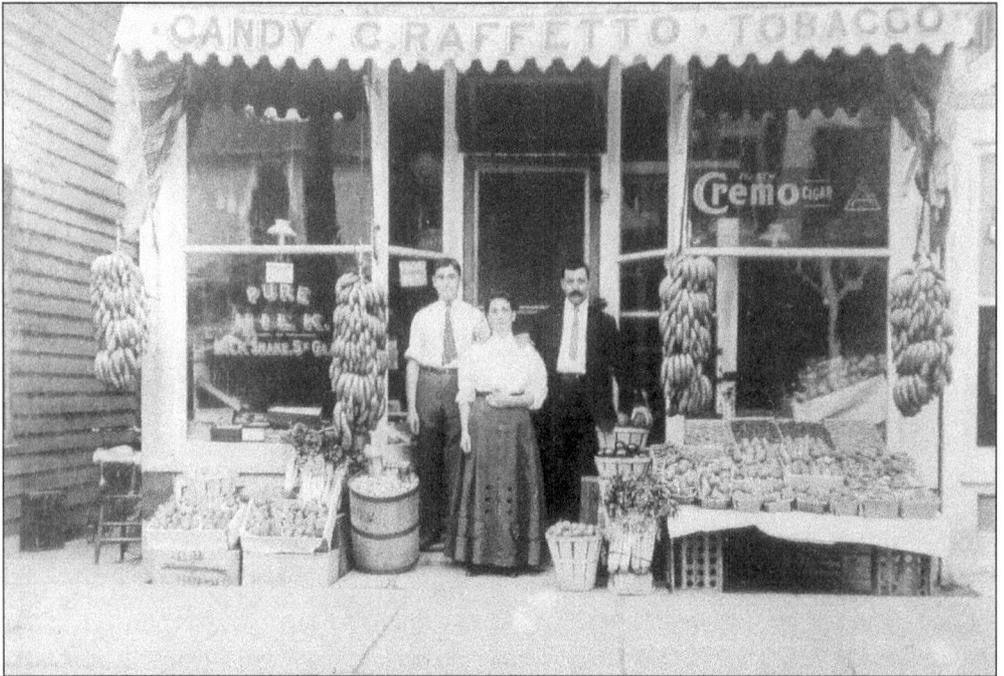

Mr. and Mrs. Charles S. Raffetto and their son Joseph stand in front of Raffetto's Store. The store was established in 1909 by Charles S. Raffetto, a cobbler from Italy. The first store was located on South Street and was later moved to 115 Main Street.

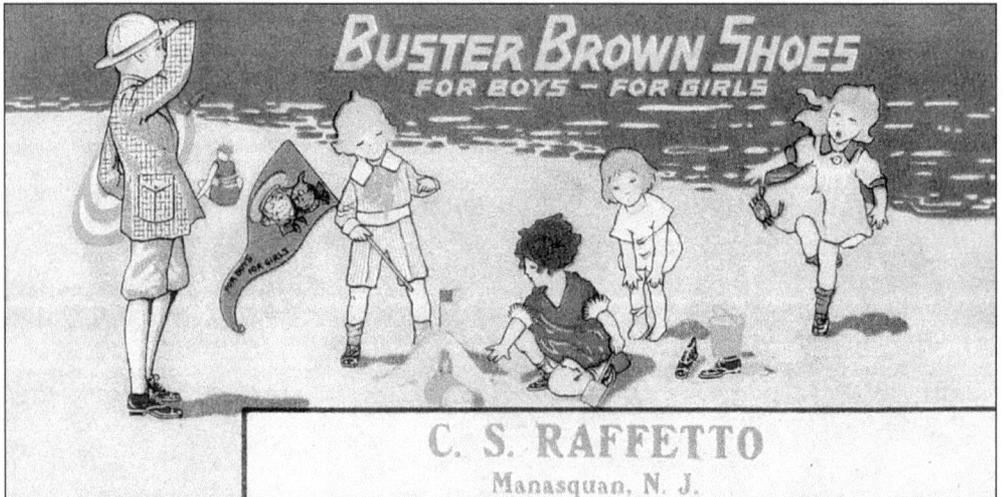

This advertisement was for Raffetto's Family Shoe Store at 115 Main Street. Charles S. Raffetto sold the original store to his daughter Vera, a native of Manasquan, and her husband, Ted, after operating it for decades. Today, Raffetto's Shoes is owned and operated by Raffetto's granddaughter Carol Raffetto Hill and her husband Joe, who are Manasquan residents. The store carries children's footwear exclusively. (Postcard courtesy of Richard Napolitan.)

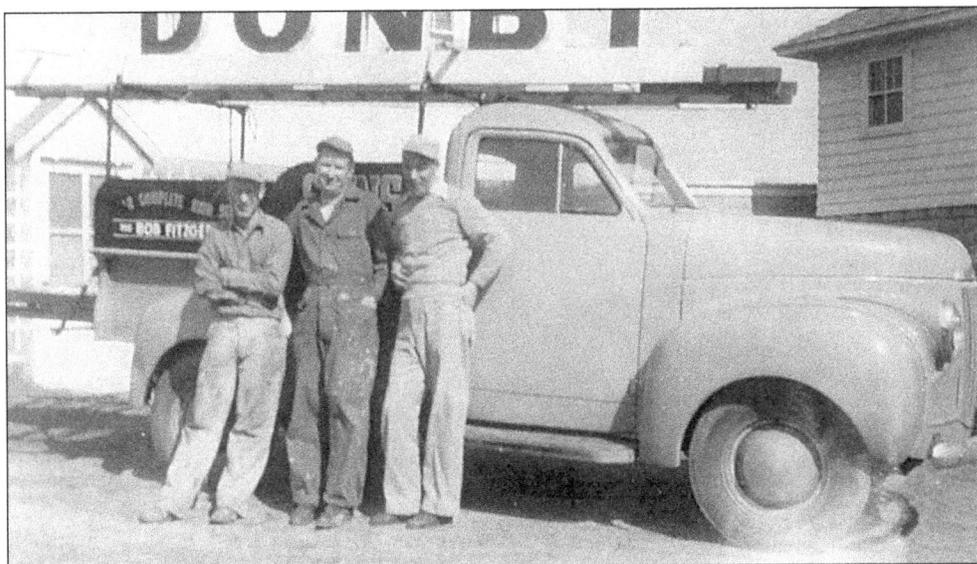

Bob Fitzgerald, center, owner of Bob Fitzgerald Signs, and his employees Jackson Anderson and Lester Ivins take time out from creating signs for a business in Lavallette in this 1947 photograph. Fitzgerald established his lettering business in 1939, when he was only 16, and is still at the helm today. (Photograph courtesy of Bob and Helen Fitzgerald.)

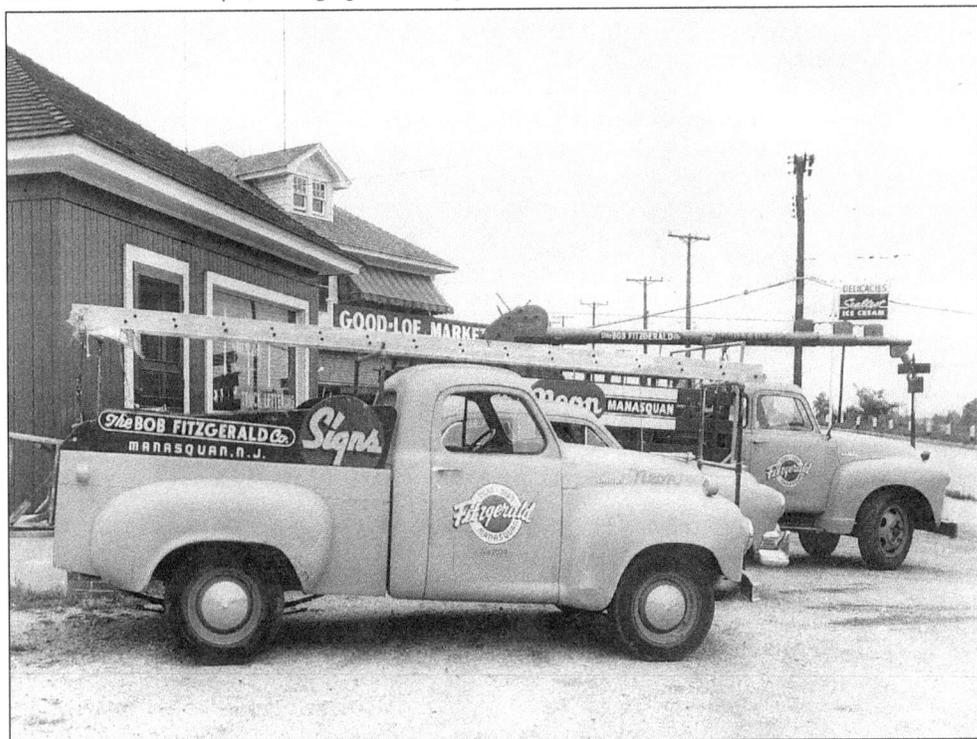

With ladders atop the Fitzgerald fleet of trucks in the 1950s, Bob Fitzgerald is ready to go and letter signs, trucks, and automobiles. In 1957, he published *Practical Signshop Operation*, which is now in its seventh edition. His wife, Helen Fitzgerald, assists him in the business, which is located at 117 Taylor Avenue (Route 71). (Photograph courtesy of Bob and Helen Fitzgerald.)

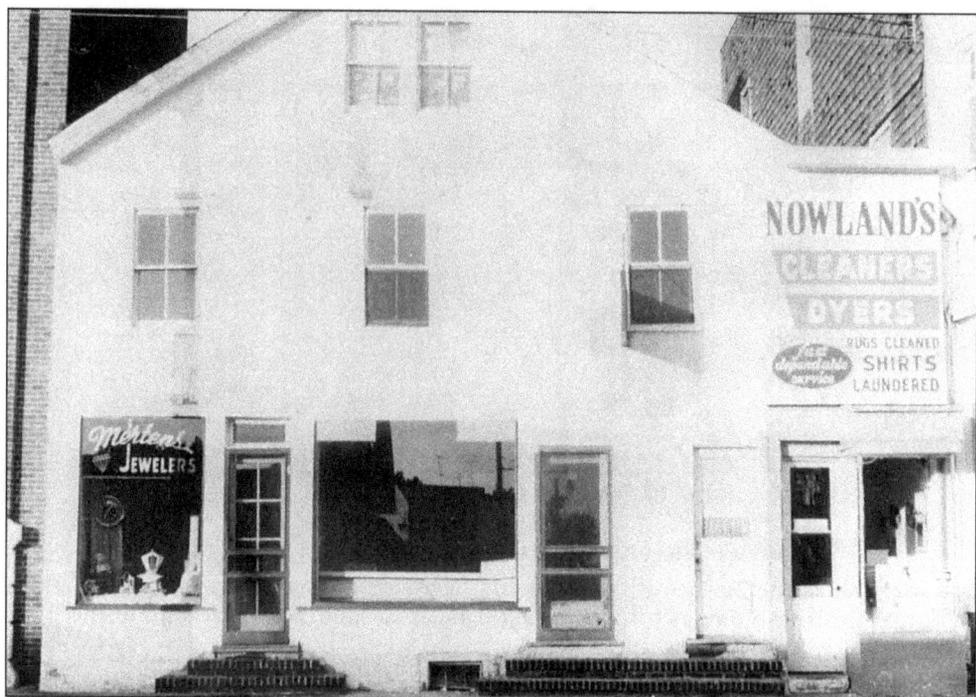

This 1946 photograph captures Mertens Jewelers when it was established and originally located between the bank and the Borden Building. The business was owned by Angie (Gardella) and Erwin Mertens. The building was demolished in the late 1950s, and the business was relocated in the borough. (Photograph courtesy of the Mertens family.)

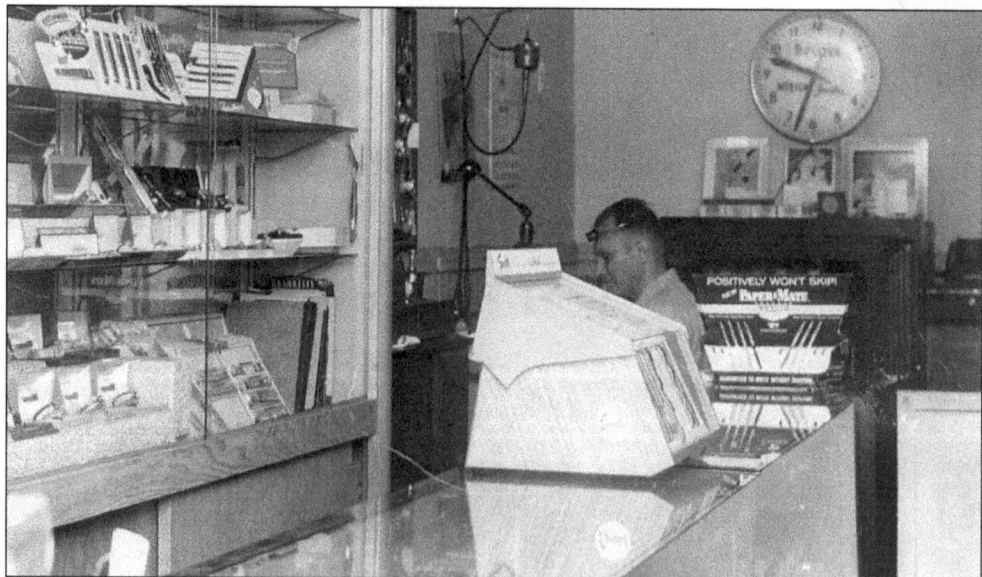

Erwin Mertens repairs jewelry in his shop, Mertens Jewelers, in this 1950 picture. Paper Mate pens sold for $2.50 and the advertisement for them stated: "Positively won't skip." Rent for the shop space was $16 a month when it was located in the building between the bank and the Borden Building. Since 1973, son Carl Mertens has worked in the family business, which is located at 114 Main Street. (Photograph courtesy of the Mertens family.)

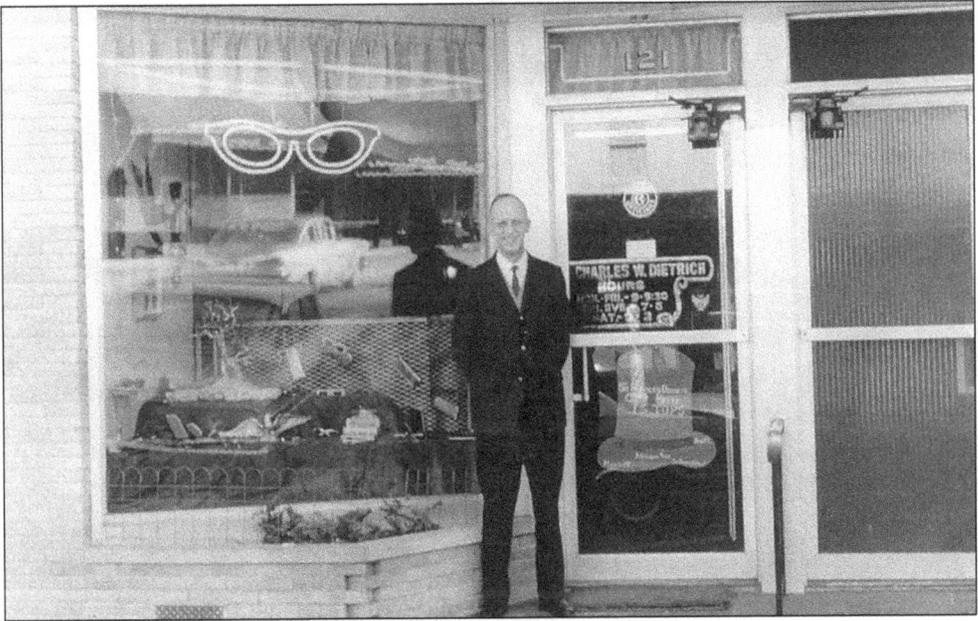

Charles W. Dietrich, owner of Dietrich Opticians at 121 Main Street, fitted many of the area's residents with eyeglasses. Dietrich established the business in 1959. His daughter Gail (Dietrich) Goetz and her husband, Eric Goetz, joined the business in 1966. The business was later moved to its present location at 134 Main Street. Today, grandson Peter Goetz also works at Dietrich Opticians. (Photograph courtesy of Eric and Gail Goetz.)

Wm. S. Wilkins Men's Store was a busy shop, which rented tuxedos and sold casual clothing, shoes, sports jackets, outer jackets, and other men's clothing. This photograph was taken in August 1951, during opening festivities in the first location of the business, at 93 Main Street. (Photograph courtesy of the William S. Wilkins family.)

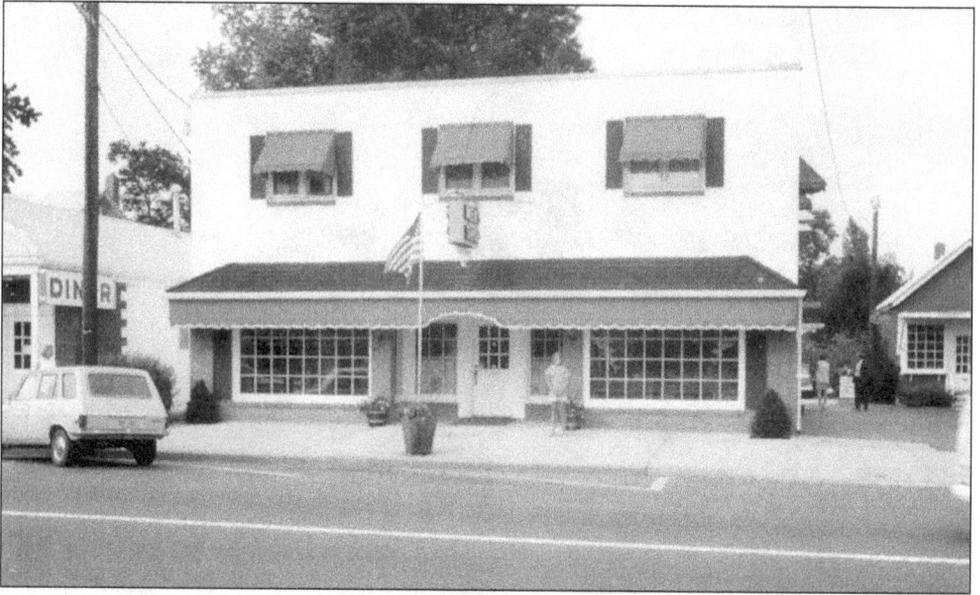

Judy Wilkins, the daughter of William S. and Carolyn Wilkins, stands in front of the Wm. S. Wilkins Men's Store at 132 Main Street, after construction was complete in 1967. The business was established in 1952 and had been located in two other buildings on Main Street. William S. Wilkins was a graduate of Manasquan High School. (Photograph courtesy of the William S. Wilkins family.)

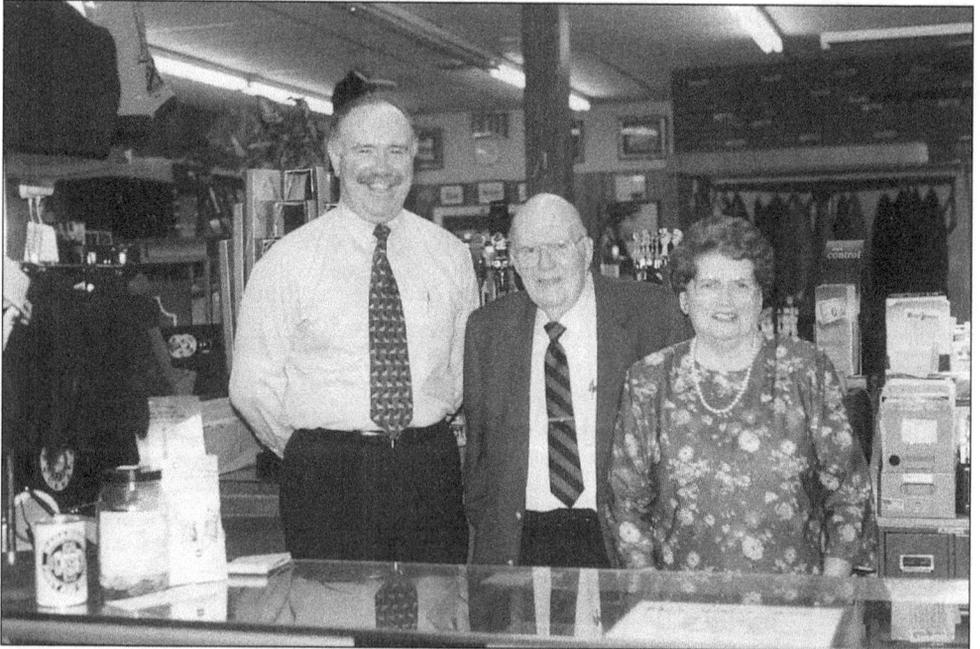

William S. Wilkins, center, and his wife, Carolyn Wilkins, owners of Wm. S. Wilkins Men's Shop, are joined by Ric Henderson, who was employed at the store for 31 years. In March 1999, when this picture was taken, Wilkins announced that the business would be closing the following month. The couple's children Larry, Carol, and Judy Wilkins worked in the store at various times over the years. (Photograph courtesy of the William S. Wilkins family.)

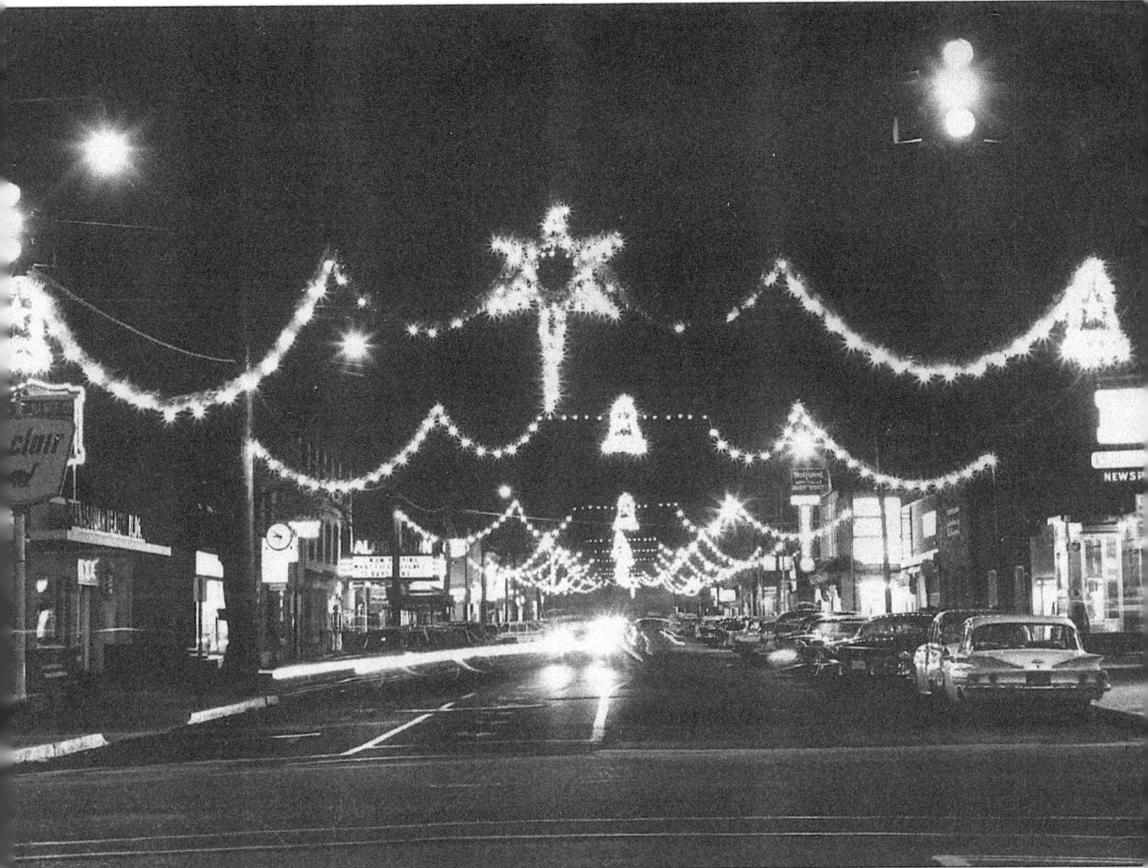

More than 15 strings of Christmas lights with 1,000 bulbs spanned Main Street in this 1962 image, looking west. The festive decorations were lighted for the annual Thanksgiving eve parade, prior to the Manasquan High School Thanksgiving football game. The lights were—and still are—provided by the Manasquan Chamber of Commerce and the Borough of Manasquan.

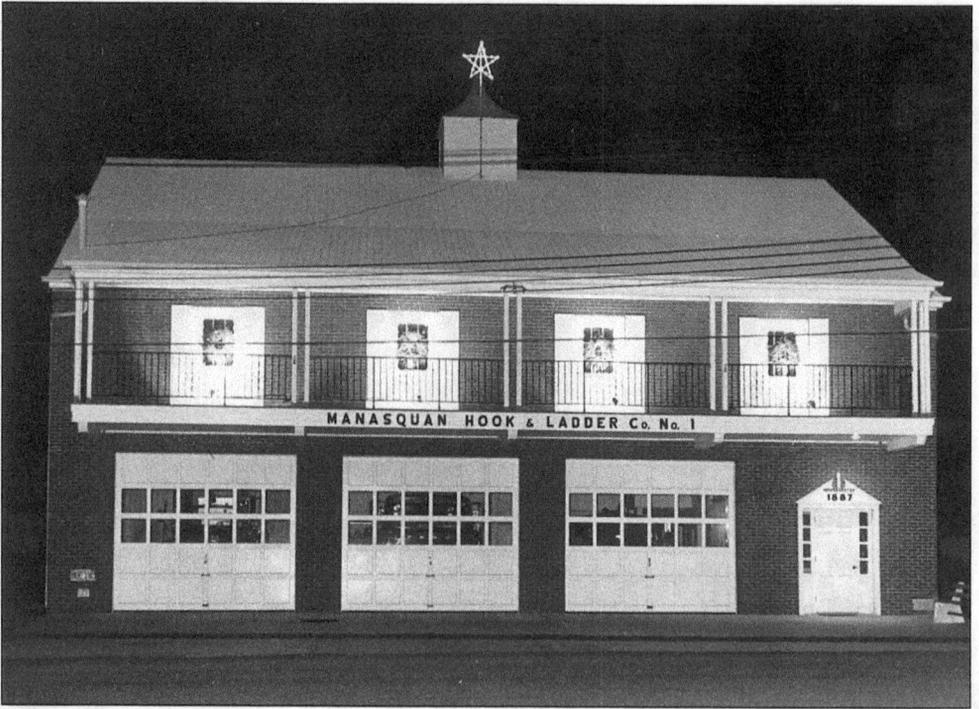

Manasquan Hook and Ladder Company No. 1 in Old Squan Plaza is aglow for the season with festive holiday lights in this 1962 image.

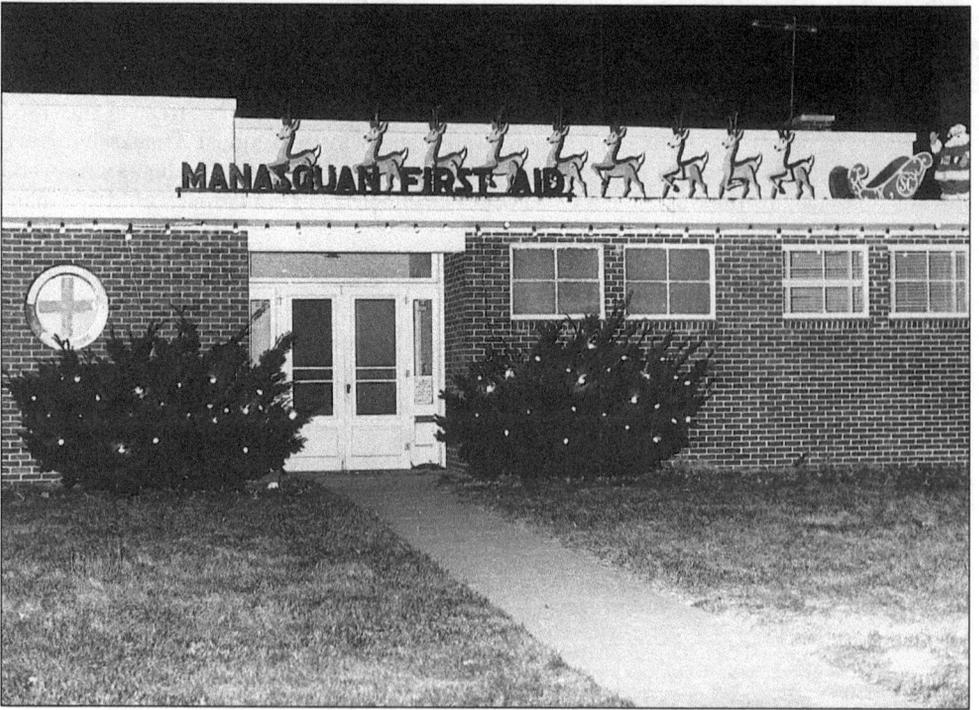

On Broad Street, the Manasquan First Aid Building was also decorated for the holiday season in 1962.

Four

SEA CAPTAINS
AND SHIPS

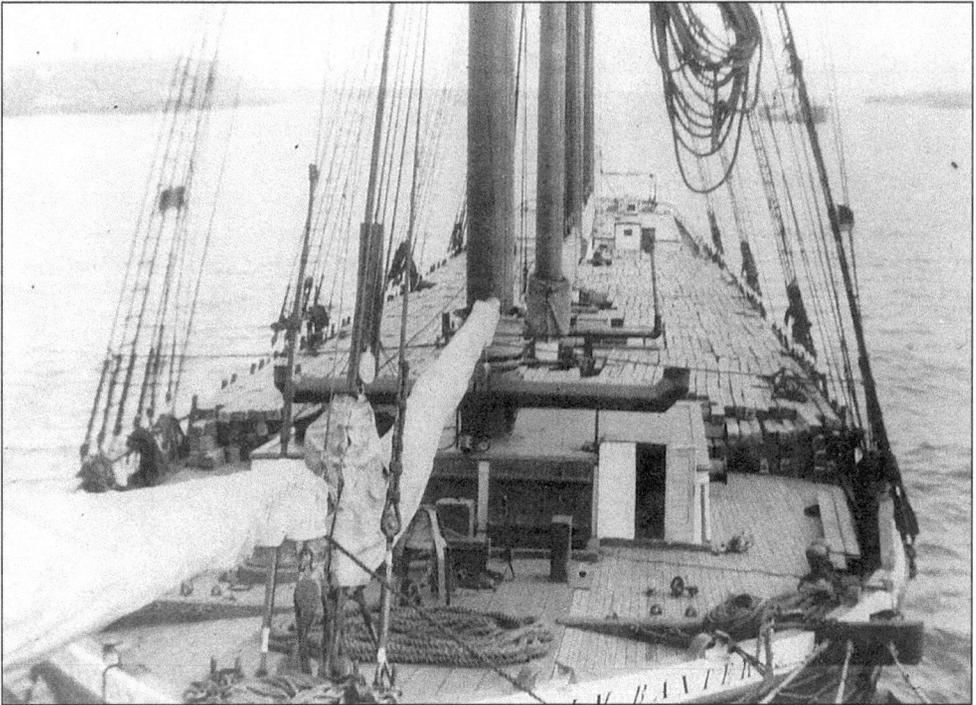

The *Malcolm Baxter Jr.* was an impressive sailing ship. The ship was 240 feet long and 45 wide and boasted three decks and three holds. Its mainmasts were 103 feet and its topmasts 53 feet. The ship was built for Capt. George G. Bailey of Manasquan. The *Baxter* sailed from Maine to South Carolina, as well as to Spain. (Photograph courtesy of Wayne and Betty Bailey.)

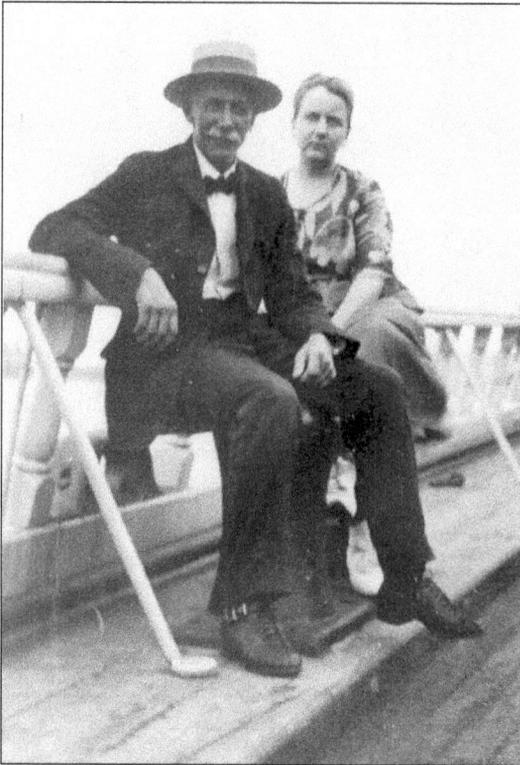

Capt. Alvin Pearce and his wife, Annie Pearce, are photographed on the decks of one of his ships. Pearce was captain of the *Frances Taussig*, the *Esther K*, and the *Augusta*. A lifelong Manasquan resident, he was born in 1873 and died in 1934.

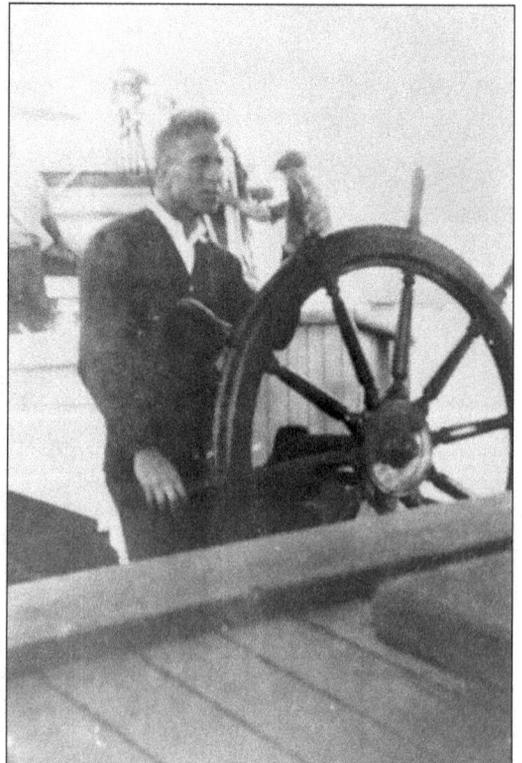

Ernest J. Pearce was one of many ship captains who lived in Manasquan. It was once reported in the *Manasquan Seaside* that it would have been difficult to walk Main Street without seeing a sea captain. Many borough streets are named for captains, and descendants of these seafarers can be found throughout southern Monmouth and northern Ocean Counties.

Lewis H. Pearce sailed the *F. Mervin*, the *Mattie V. Rulon*, and the *Lookout*. He, like many other members of his family, took to the open seas before the beginning of the 20th century. Pearce Avenue in the borough is named for this early family of sea captains and businessmen.

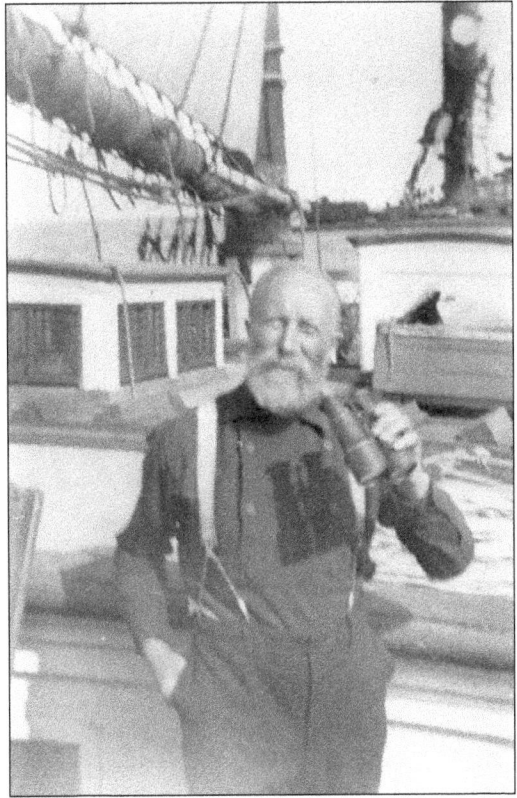

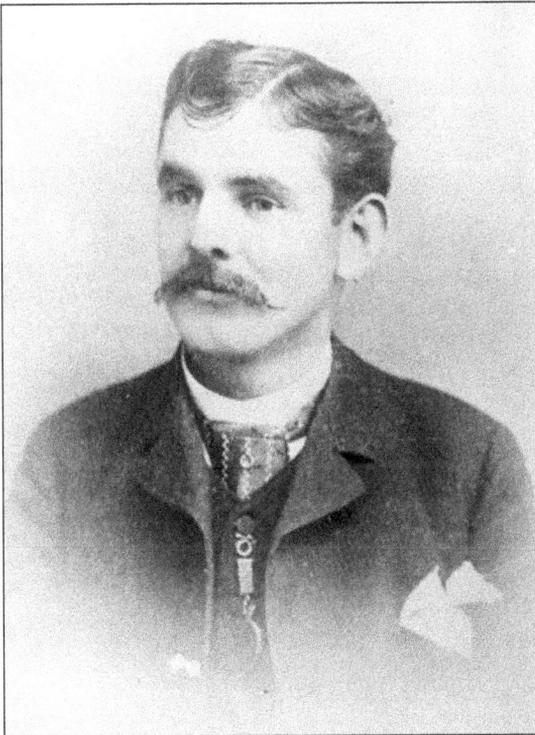

Another family with strong ties to the sea were the Longstreets. Enos Longstreet, one of three brothers, was born in 1850 and died in 1918. The names of the ships he sailed are undocumented.

Spencer Longstreet, the brother of Enos and Randolph Longstreet, lived from 1857 to October 1894, when he was lost at sea at the age of 37.

Randolph Longstreet was the third brother. Specific information about him is not documented. The father of the three brothers was early Manasquan resident James Longstreet, who lived from 1818 to 1902.

Capts. George Rankin and James Green sported their Sunday clothes for this 1888 photograph. Both local sea captains, their ships included the *Manasquan*, the *William Clarke*, and the *Enterprize*. (Photograph courtesy of Wayne and Betty Bailey.)

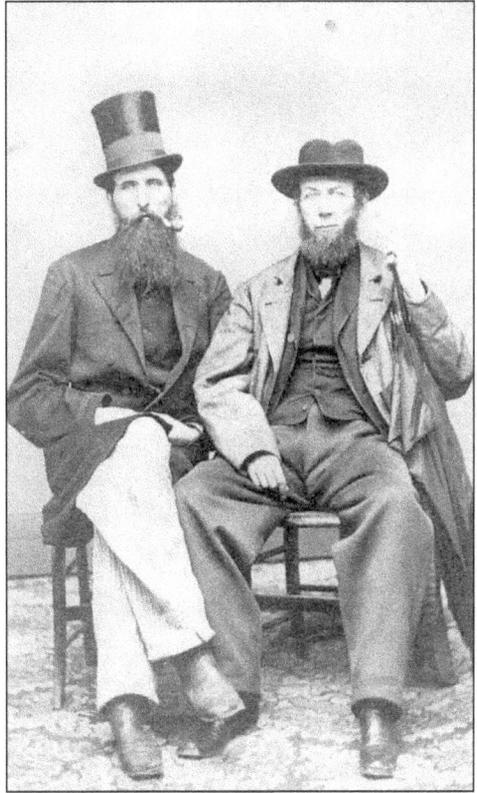

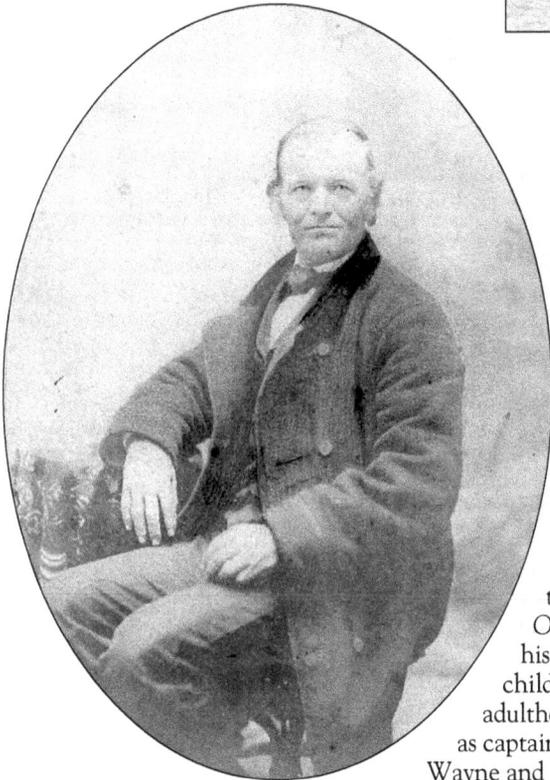

Capt. William H. Bailey of Manasquan was born in 1812. He sailed the *Wave*, the *Mary Jane*, the *Lavinia*, and the *Abram Osborn* before marrying at age 44. He and his wife, Mary Green Bailey, had seven children. Four children, all males, lived to adulthood and followed him to the sea, serving as captains of many ships. (Photograph courtesy of Wayne and Betty Bailey.)

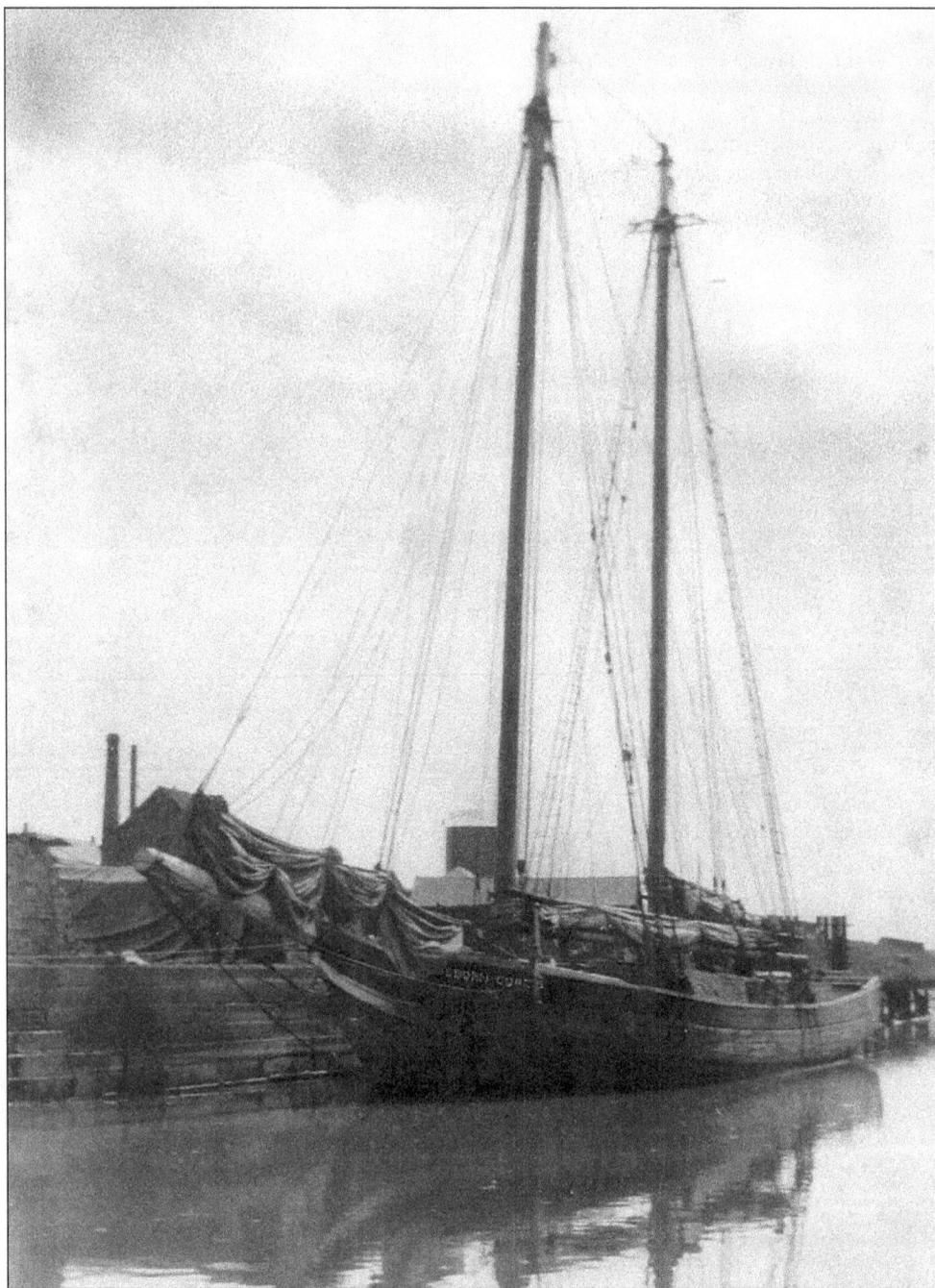

The *Osborn Curtis*, built on the shores of the Manasquan River in the 1860s, was a typical Manasquan ship. The two-masted ship was abandoned in 1918. (Photograph courtesy of Wayne and Betty Bailey.)

Capt. George G. Bailey, born in 1839, resided at 96 South Street. He graduated from Manasquan Grammar School and like his father, William H. Bailey, soon thereafter took to the sea. He sailed the *William H. Bailey*, the *Calvin B. Orcutt*, the *Charles G. Endicott*, and the *Malcolm Baxter Jr.*, as well as others. (Photograph courtesy of Wayne and Betty Bailey.)

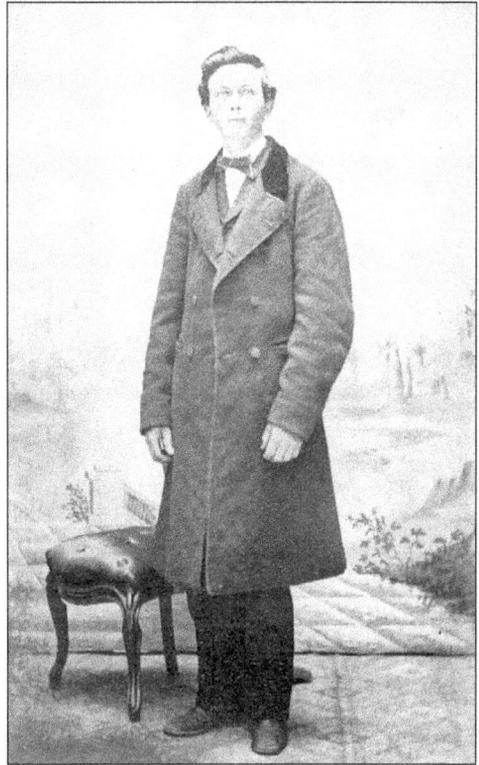

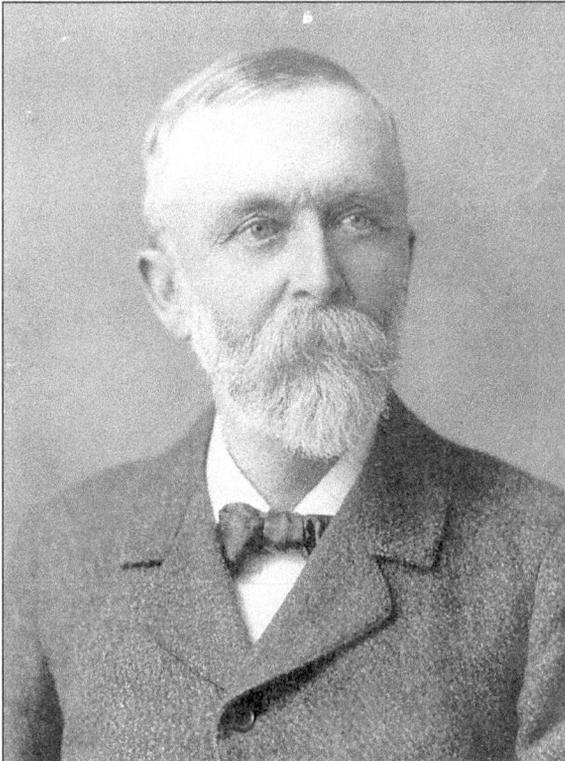

After retiring from the sea, Capt. George G. Bailey remained active by serving in public office. He was mayor of Manasquan from 1884 to 1893 and also was a Monmouth County freeholder. He died in 1916. (Photograph courtesy of Wayne and Betty Bailey.)

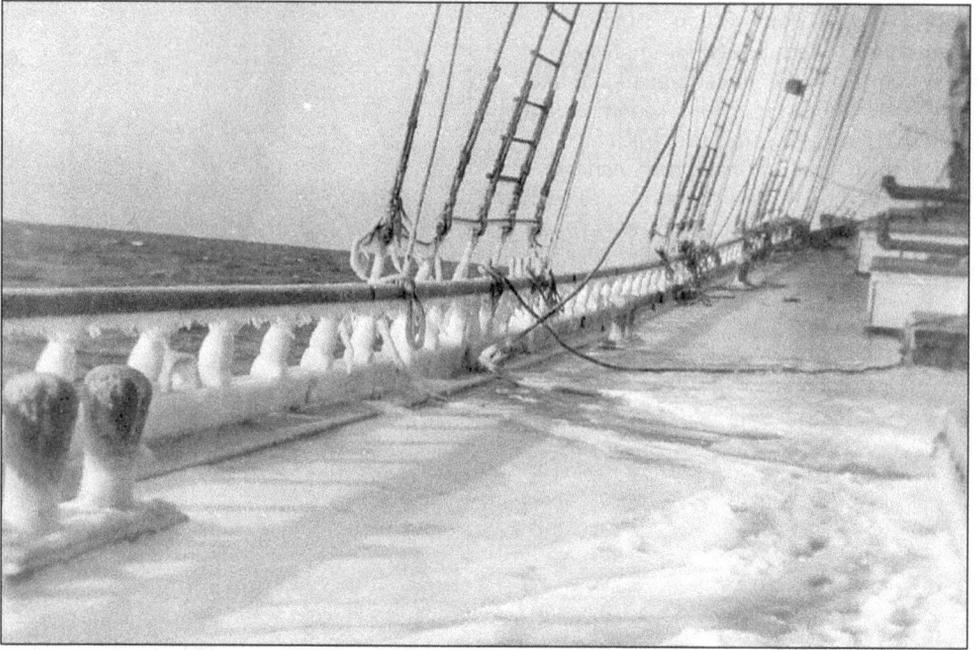

Frigid temperatures did not slow the *Malcolm Baxter*. This image taken in the early 1900s shows the ice-covered decks of the *Baxter*, sailing off the coast of Cape Cod, Massachusetts. Built in 1900 for Capt. George Bailey of Manasquan, the four-master carried cargo such as grains, ore, lumber, and ice. The ship was later sold and eventually sank in Carlisle Bay, Barbados. (Photograph courtesy of Wayne and Betty Bailey.)

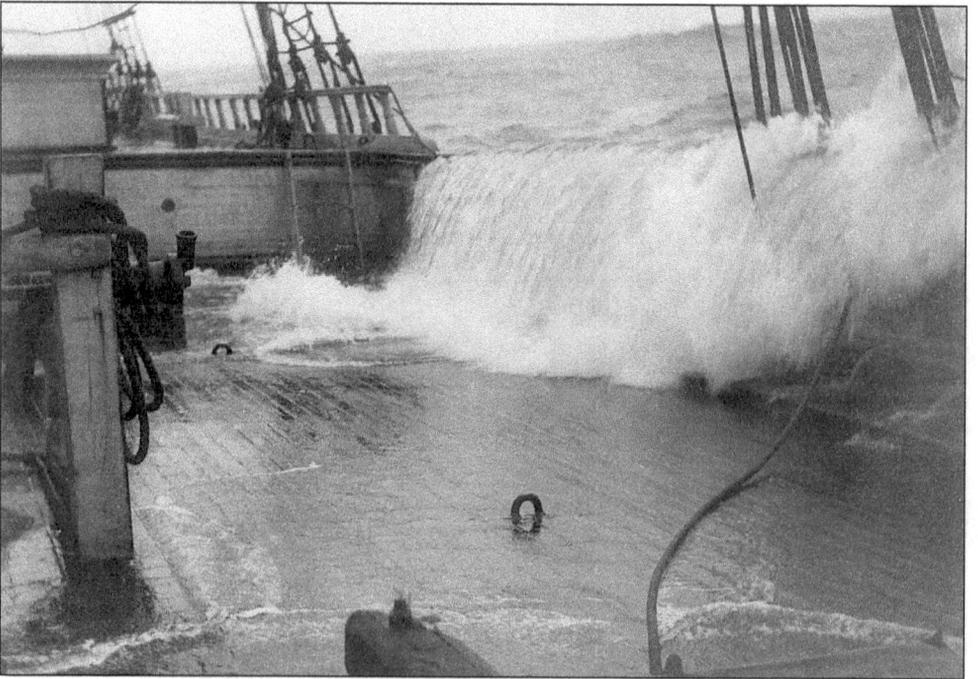

Passing over the Nantucket Shoals off Massachusetts, the *Henry S. Little* is the recipient of a saltwater bath as waves crash over its side. (Photograph courtesy of Wayne and Betty Bailey.)

72

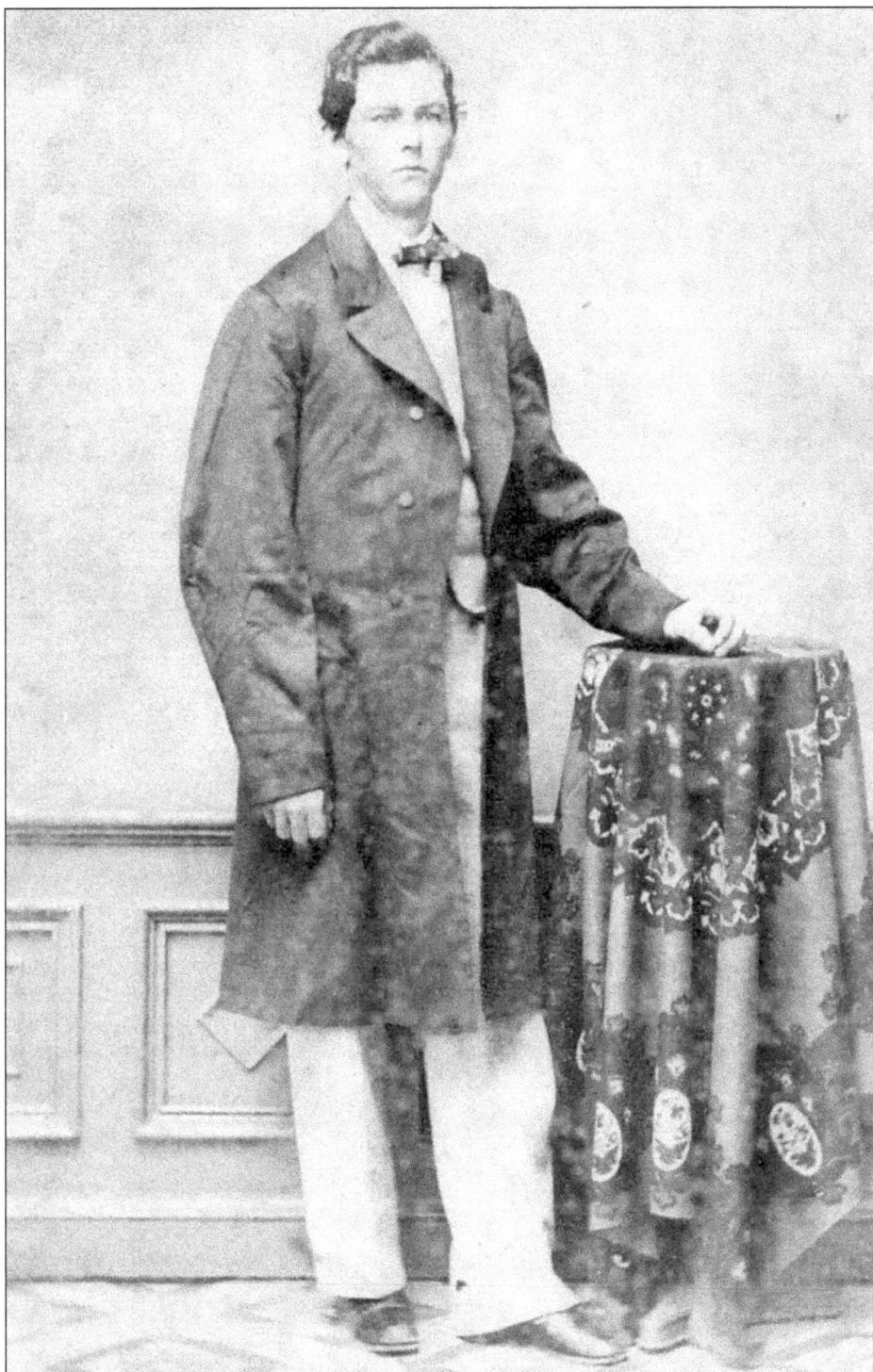

Capt. Forman O. Bailey, the son of William H. Bailey, sailed the *Samuel S. Thorpe* and the *Henry S. Little* and shared his father's passion for the sea. He was born in 1843 and died in 1930. (Photograph courtesy of Wayne and Betty Bailey.)

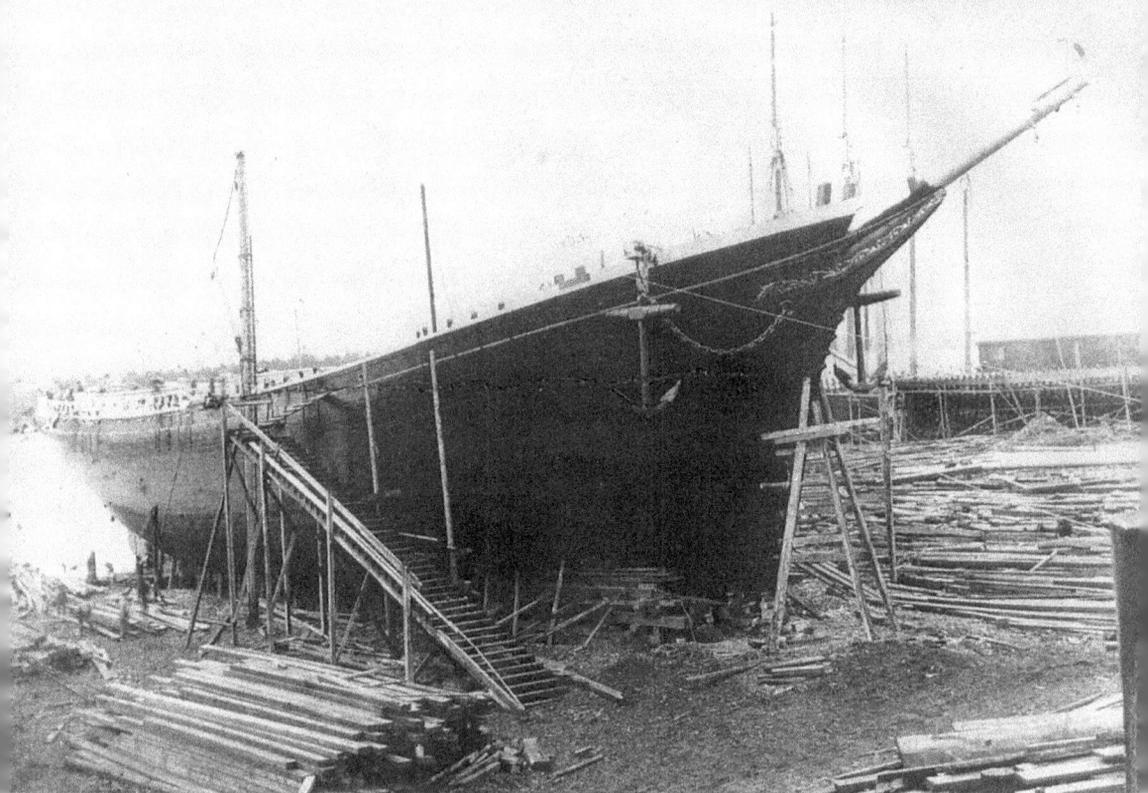

Schooner HENRY S. LITTLE, 1,096 Tons. Capt. F. O. BAILEY.

Built by NEW ENGLAND SHIPBUILDING CO., Bath, Maine. Launched June 4, 1889.

Photographed by J. C. Higgins & Son, Bath, Maine.

Lumber for shipbuilding was plentiful in New England, especially from the pine and hardwood forests in Maine. Capt. Forman O. Bailey of Manasquan contracted to have the *Henry S. Little*, a schooner with a capacity of 1,096 tons, built in Bath, Maine, by the New England Shipbuilding Company. The vessel was launched on June 4, 1889. (Photograph courtesy of Wayne and Betty Bailey.)

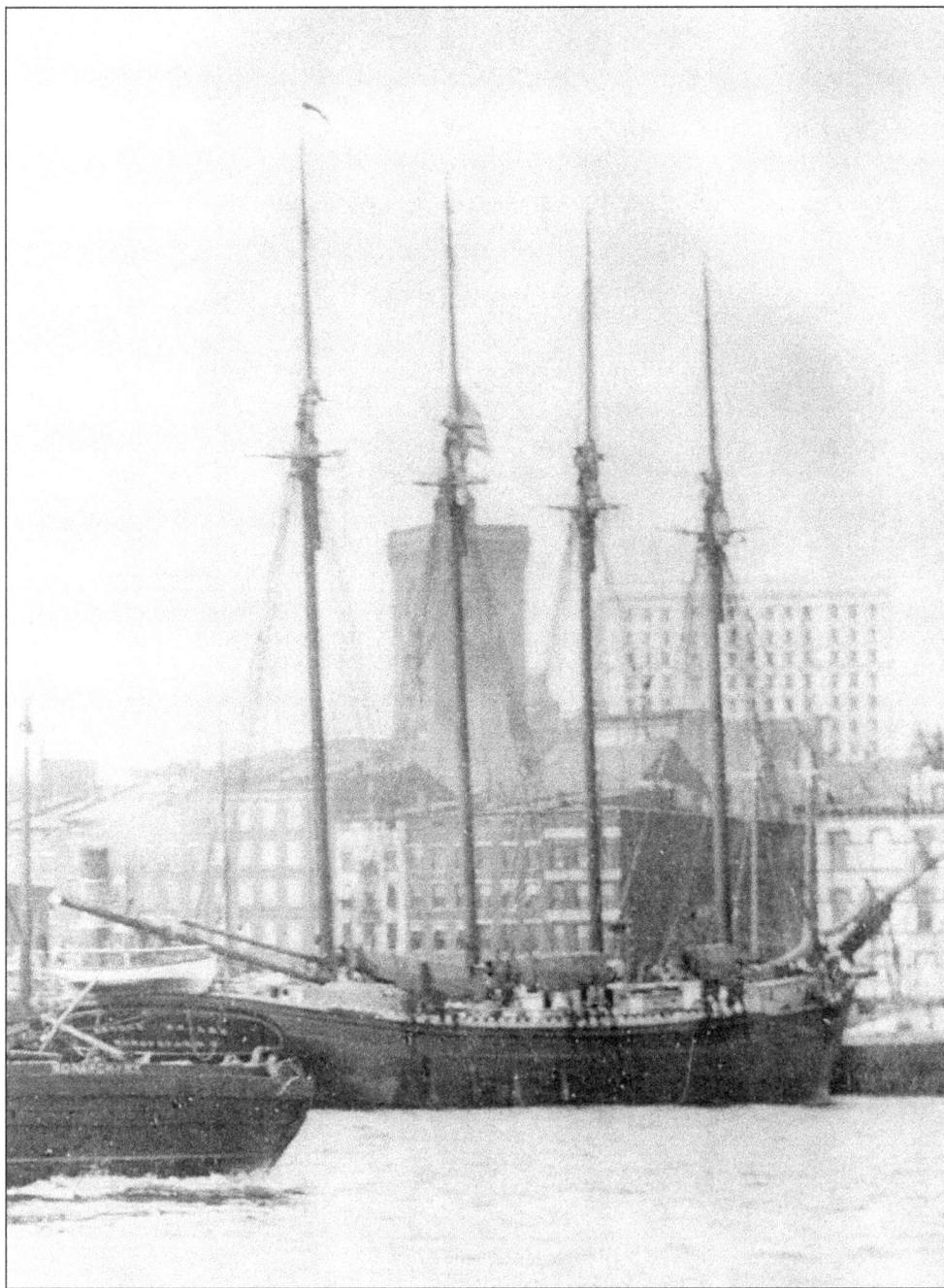

The four-master *George Bailey* was built in Bath, Maine, in 1890 for Capt. Asher Curtis of Manasquan and his partners. The ship was lost at sea in February 1901. (Photograph courtesy of Wayne and Betty Bailey.)

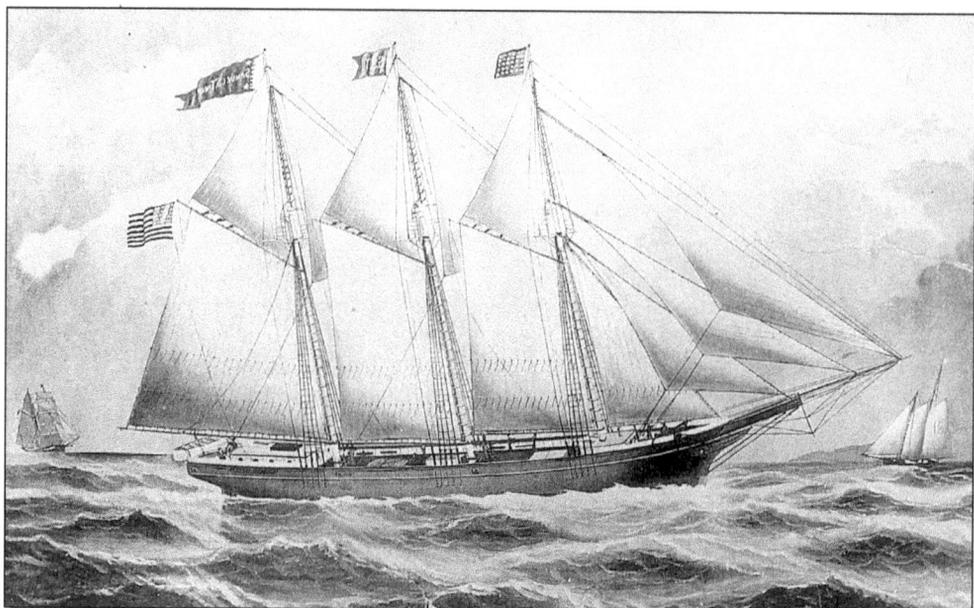

Capt. Forman O. Bailey often raced the sleek three-master *Samuel O. Thorpe* against the *William H. Bailey*, the three-master sailed by his brother George G. Bailey. Nephew Forman T. Bailey of Manasquan recalls the brothers' fierce competitiveness and the risks they took to outrace each other, even in high seas and horrific weather—all in good fun. (Photograph courtesy of Wayne and Betty Bailey.)

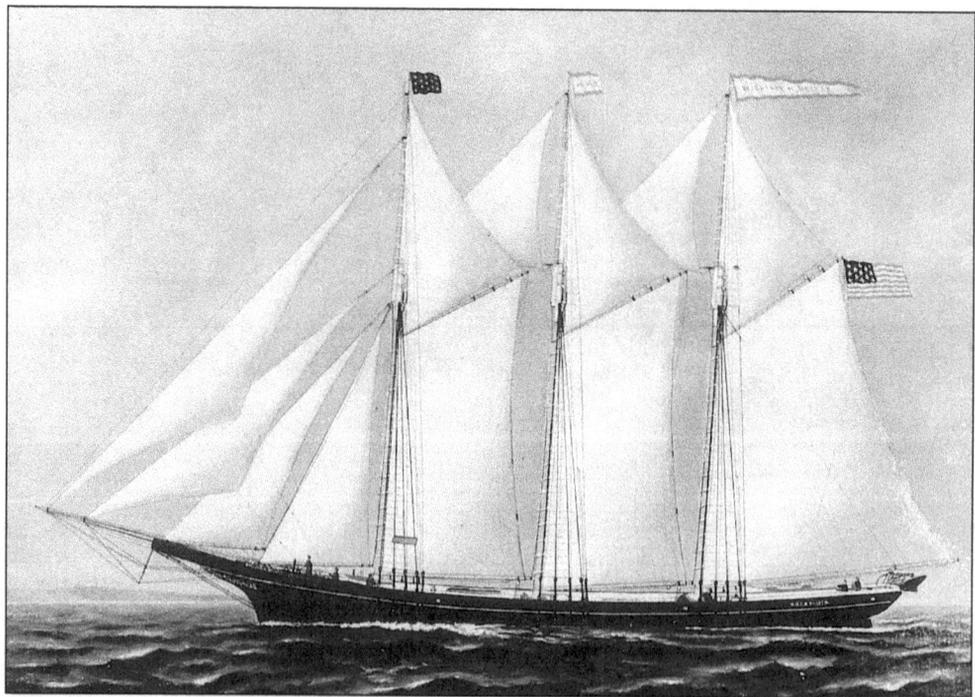

Capt. George G. Bailey sailed the *William H. Bailey*, named for his father, a Manasquan sea captain and businessman. The ship completed numerous commercial runs along the East Coast. (Photograph courtesy of Wayne and Betty Bailey.)

Five

HURRICANES, NORTHEASTERS, AND SNOWSTORMS

At about 40 feet in height, the near tidal wave that rolled through Manasquan Inlet during the hurricane of September 1938 was one of the worst to make landfall this far north. Two waves, similar in size and power, followed the first through the inlet. Randy's at the Inlet (now Carlson's Corner) was braced and shuttered during the storm but still suffered so much damage that it had to be rebuilt before opening the following summer. (Photograph courtesy of Warren Randolph.)

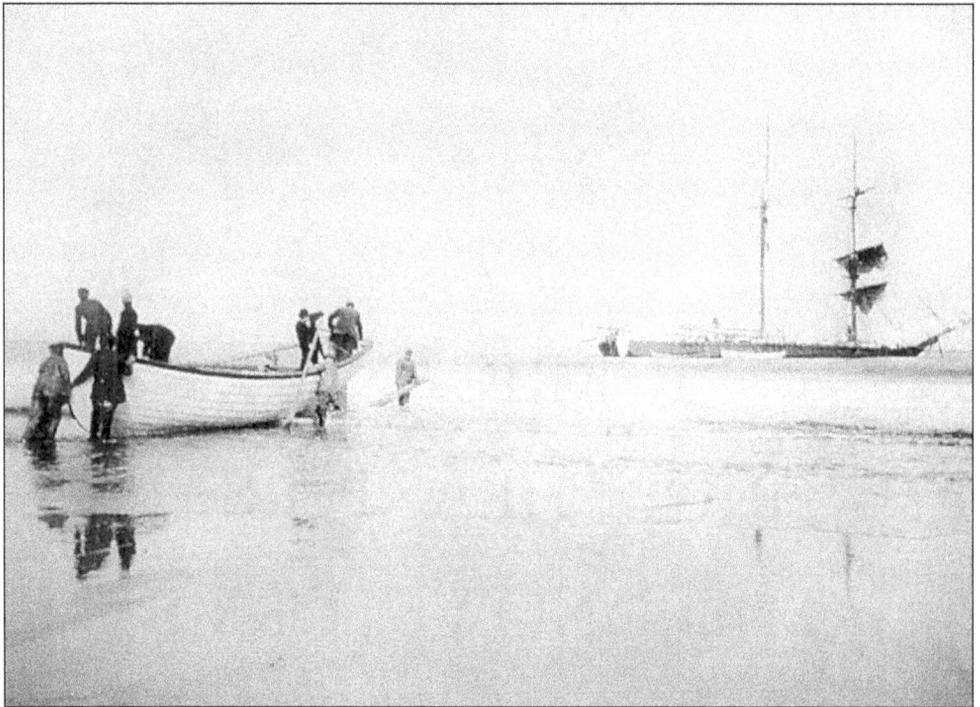

The *Antioch* was carrying lumber from Savannah, Georgia, to New York City when it was driven ashore in the heavy fog on an early morning in March 1913. News of the shipwreck spread quickly, and hundreds of men were on the beach at Ocean Avenue to assist in running the breeches buoy (lifesaving equipment) ashore, which saved all of the crew.

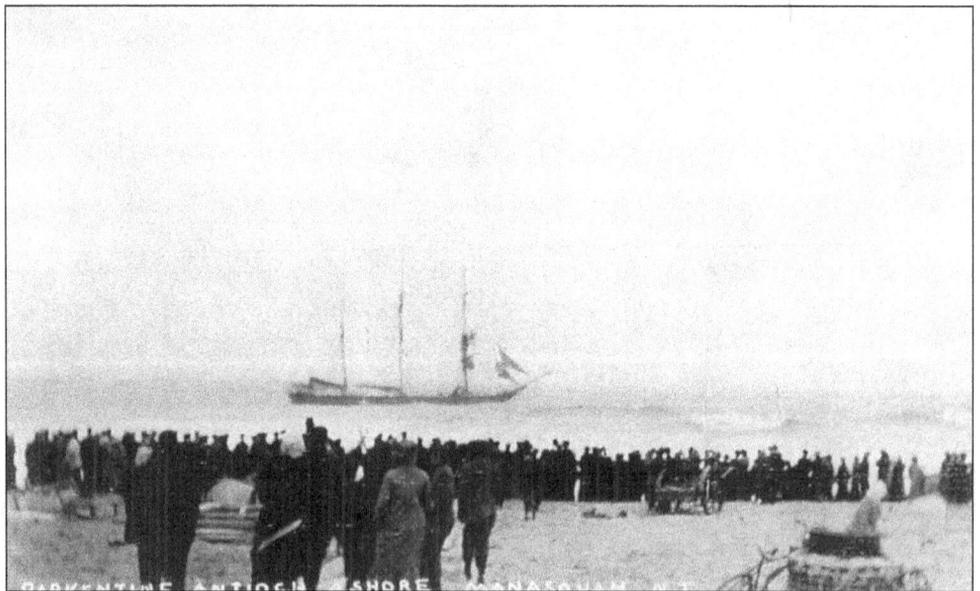

The *Antioch* was the last barkentine wrecked off the coast of Manasquan. The three-master was built in Kennebunk, Maine, in 1876, and its home port was Boston. The ship had a gross tonnage of 986 and a net tonnage of 844. It was 183.3 feet long, had a beam of 35.2 feet, and drew 21 feet of water.

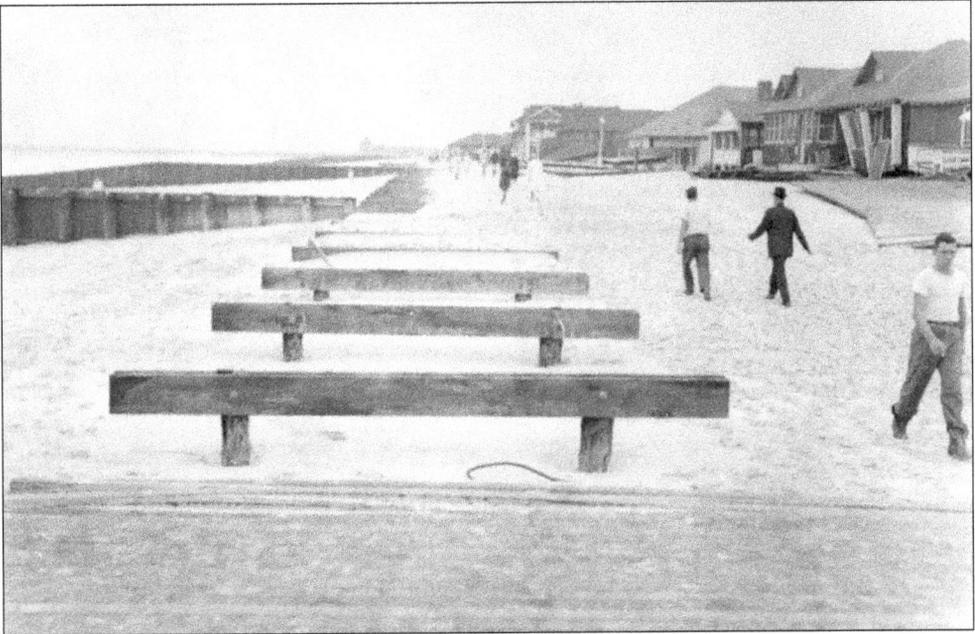

Manasquan Beach had a boardwalk until the hurricane on Labor Day of 1938 demolished it. The storm was known as the "Labor Day Hurricane"; it was not until the 1950s that storms were officially named.

The summer season ended abruptly in 1938 when the hurricane blew through. In this photograph, residents assess the damage to bungalows at the south end of the beachfront after the tides had receded. During the hurricane, powerful waves crashed onto the beach, undermined the boardwalk, and sent pieces of the wooden structure into nearby homes.

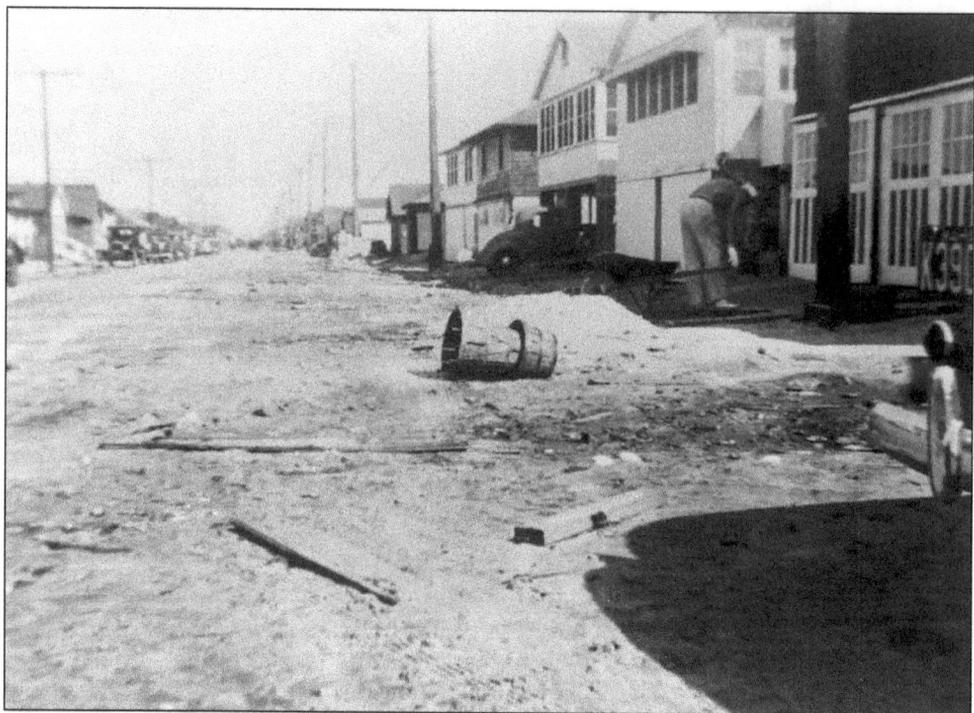

Tons of sand, shells, pieces of the oceanfront boardwalk, and debris covered the roadway following the 1938 hurricane. Twelve people were injured during the storm, including Tracy M. Hoskins, who was struck by a wave as she stood in front of Weir's Pavilion, and Dr. J.B.W. Lansing, who was injured when a section of the boardwalk struck his car and forced it into a cottage on First Avenue and Brielle Road.

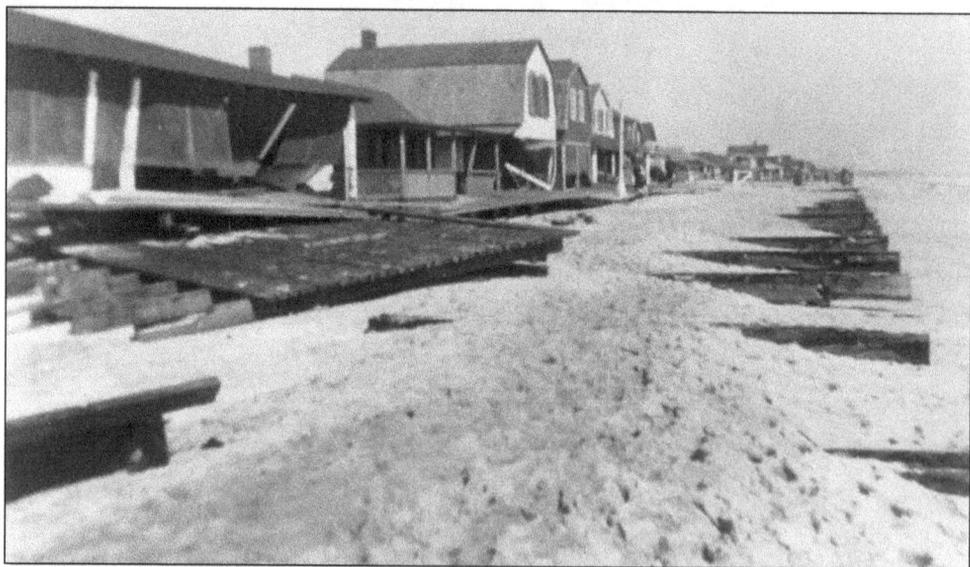

This scene following the hurricane of 1938 was taken at the southernmost end of the Manasquan beachfront. The boardwalk, completed in August 1928, has been ripped from its foundation. Bungalows from Brielle Road to the Manasquan Inlet suffered the most damage because sections of the boardwalk were tossed against the homes.

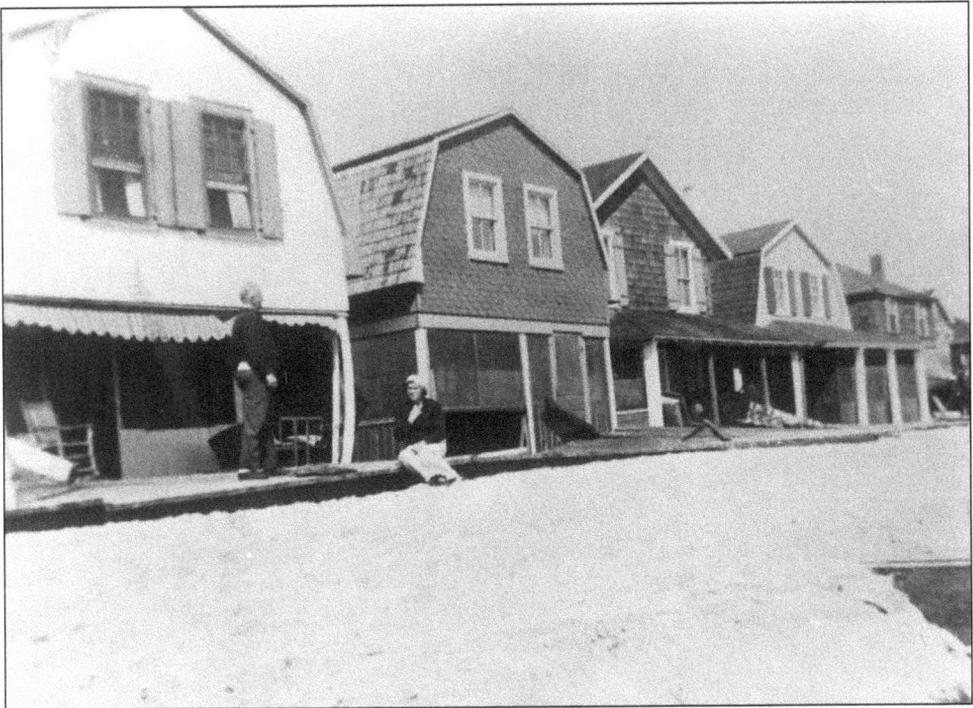

This photograph illustrates the power of the ocean during the 1938 hurricane. Several sections of the rest on the porches of these oceanfront homes. Also, the force of the water against the homes caused foundations to be washed away and deposited tons of sand along First Avenue.

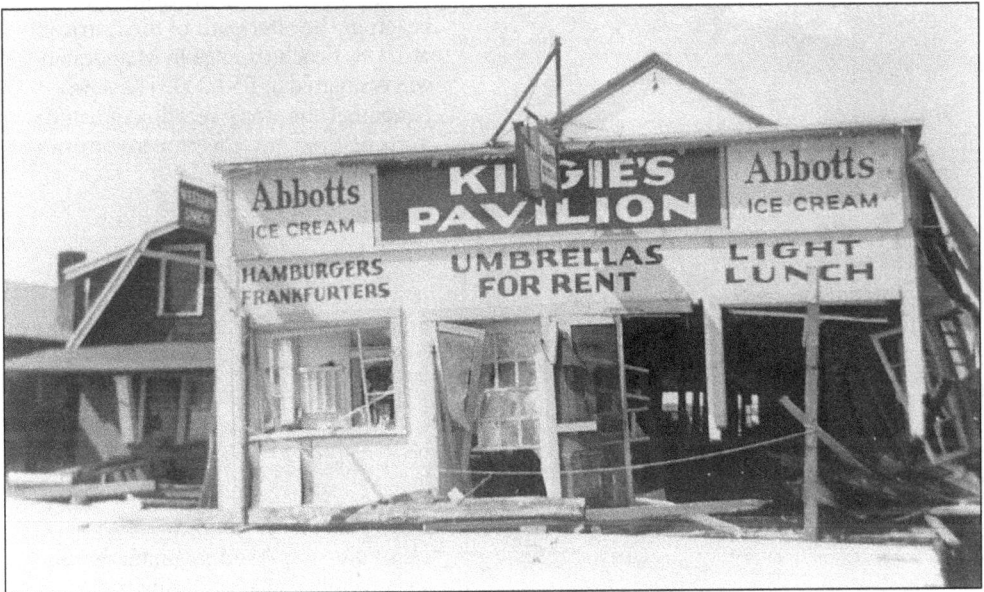

Owned by Kingman Potter and located on the Main Street beach, Kingie's Pavilion was destroyed during the hurricane of 1938. Also, the front of Seyfried's Penny Arcade was badly damaged. Winds were clocked locally at 61 miles per hour as the storm passed by, 100 miles offshore.

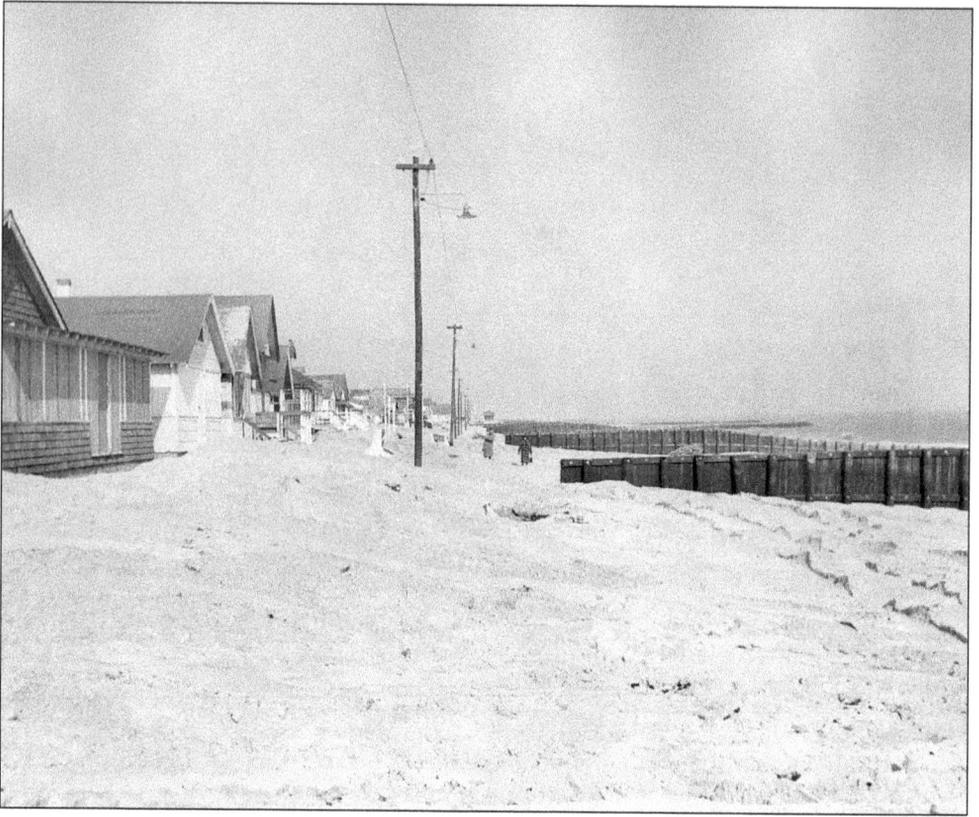

Local residents view the damage to the beach in the aftermath of the hurricane of 1938. Beach damage in Manasquan was estimated at $50,000. Those who remember the storm recall no advance warning from any government entities or the media.

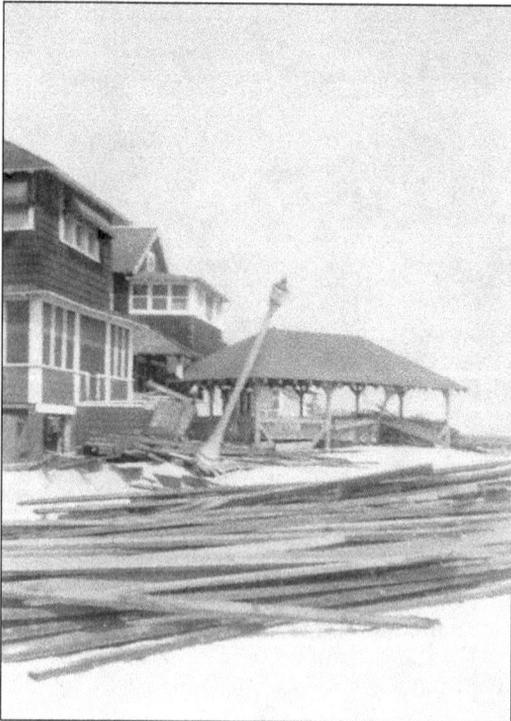

This Pompano Avenue summerhouse was severely damaged during the 1938 hurricane. Storm damage along the Jersey Shore was estimated at $2 million. (Photograph courtesy of Warren Randolph.)

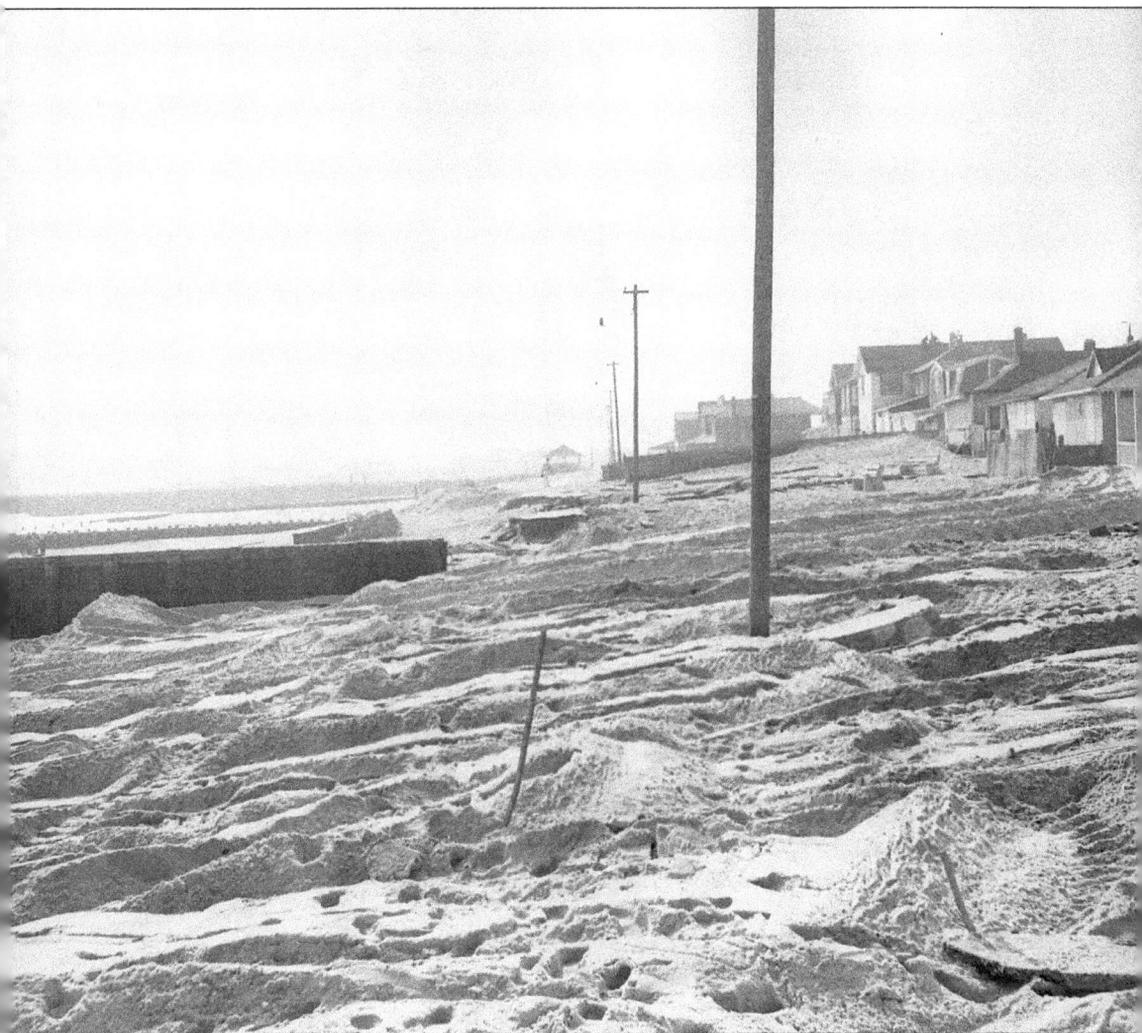

No structure along the oceanfront in Manasquan escaped damage during the hurricane of 1938, which was one of the worst storms of the century for the entire Eastern Seaboard. Strong winds and powerful waves wreaked havoc along the beachfront and roads in the immediate area.

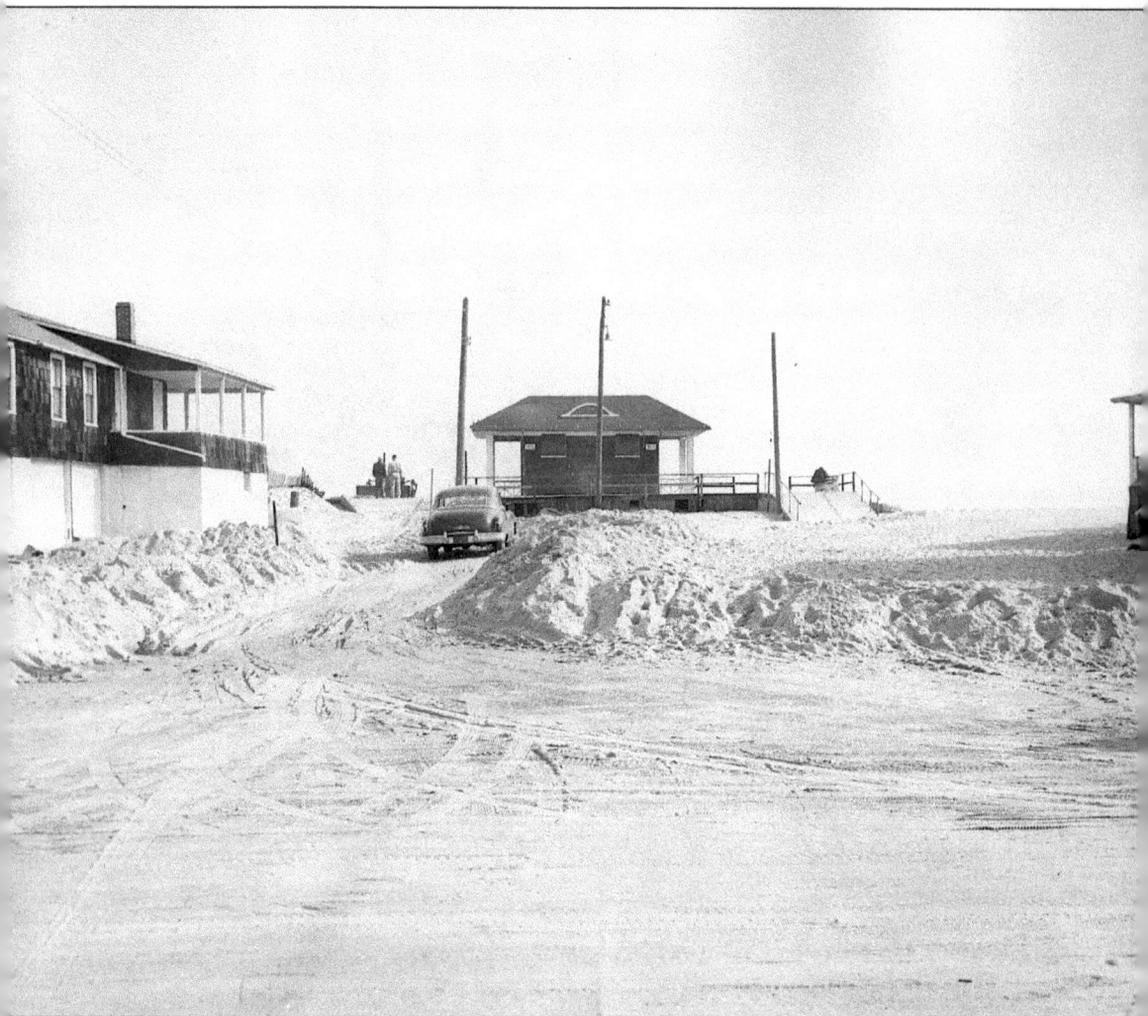

Tons of sand were pushed by the strong ocean waves and wind to this location at the top of Brielle Road. Tractors and earth movers were brought in to put the sand back on the beach.

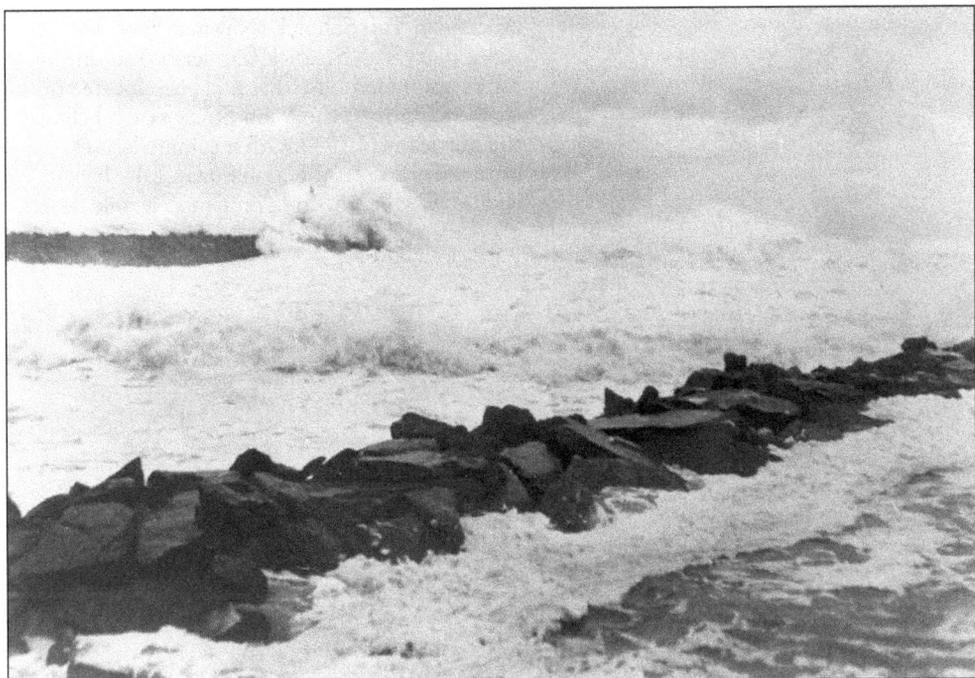

The second and third swells rolled through the Manasquan Inlet and across the sands of the south end beaches during the 1938 hurricane. The massive force with which the waves hit the beach caused extensive damage to boardwalk businesses and beachfront homes. (Photograph courtesy of Warren Randolph.)

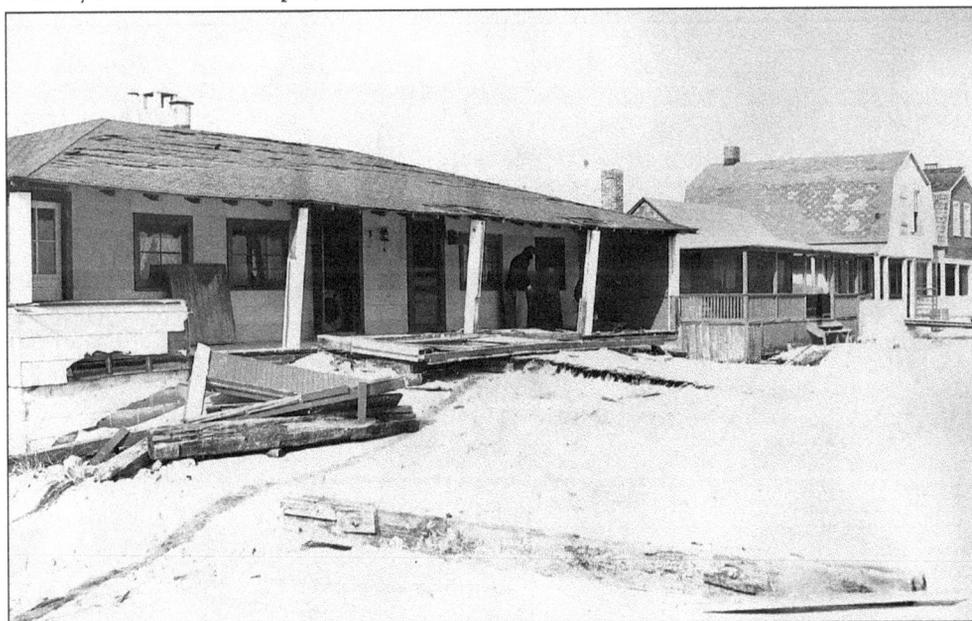

Winds up to 75 miles an hour ripped through oceanfront homes during a hurricane on September 14, 1944. In this photograph, owners of beach bungalows view the damage. Many of them spent days shoveling sand from inside their homes and drying rugs and furniture that had been soaked when water raced in through the front door and out the rear door.

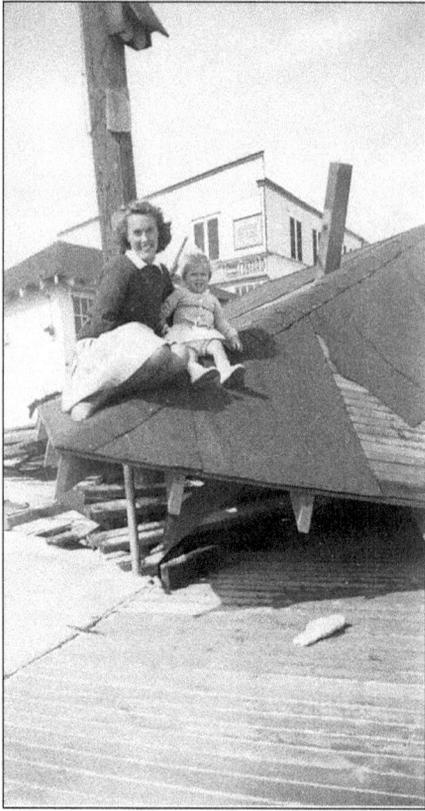

Alice Jean Van Schoick (Newman) and her niece Betty Van Schoick (Anderson) sit on the top of a summerhouse that had been located on the beachfront at the Main Street beach before the hurricane of 1944. Other summerhouses, especially those at the Manasquan Inlet beach, Riddle Way beach, and Pompano Avenue beach, also suffered damage.

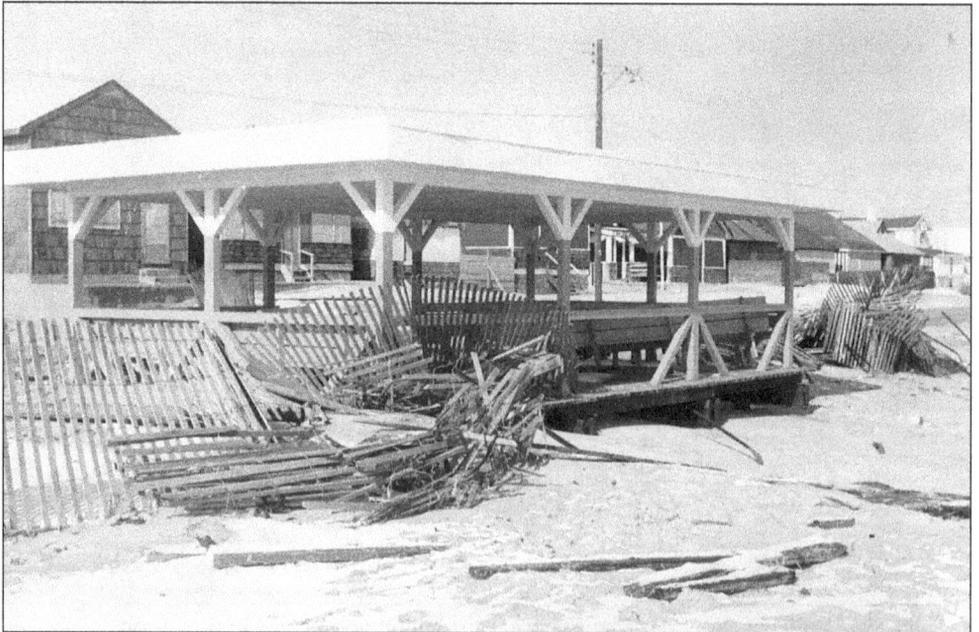

The great March northeaster of 1962 packed the winds and tidal surges of a hurricane for three full days. Wooden snow fences used to hold sand on the beach were destroyed, and the foundation of the summerhouse at Riddle Way beach was undermined.

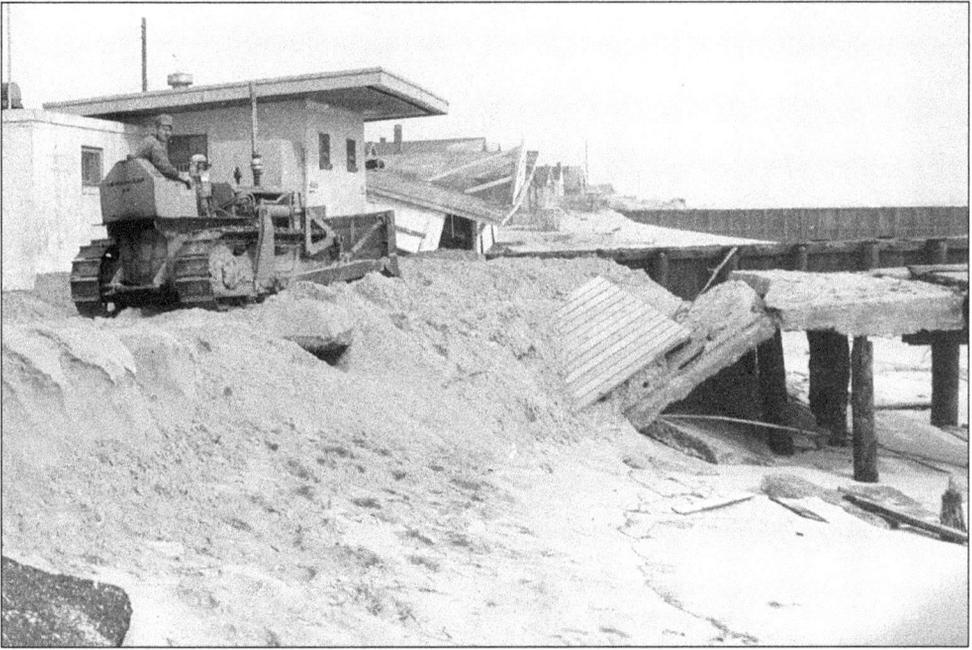

William Tilton, borough superintendent of the Manasquan Public Works Department, clears the debris and sand from the Ocean Avenue beach entrance following the 1962 storm. The public rest rooms were spared any damage, but the Sea Watch and asphalt boardwalk were not as lucky.

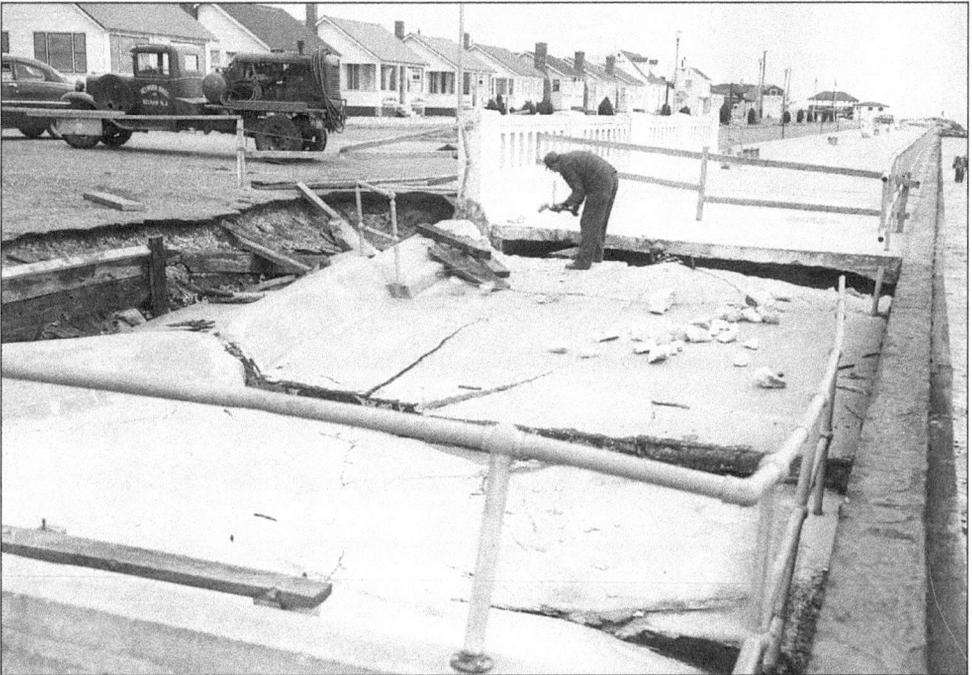

The esplanade at Manasquan Inlet was damaged in the March 1962 storm, also called the "Ash Wednesday Storm." The damage to the esplanade and the beach walkways and the loss of some 500,000 cubic yards of sand, which was swept out to sea, was estimated at $500,000.

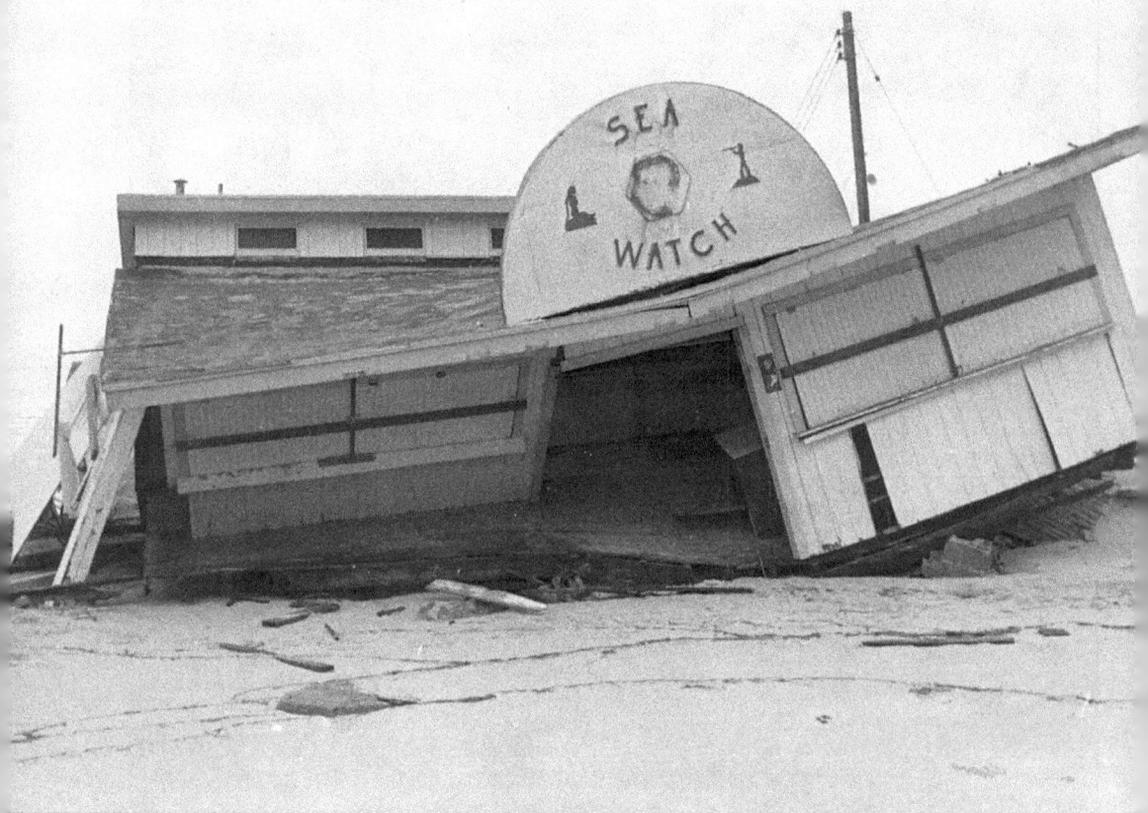

The Sea Watch, a fast-food restaurant just north of Ocean Avenue on the beach, was demolished during the storm. Joe and Helen Esposito built the eatery in 1952, after they had purchased the property from the Star Fishery Company. In 1964, the Espositos sold the Sea Watch and beach to the Richard Mueller family, who still own the property and have run the beachfront since 1980.

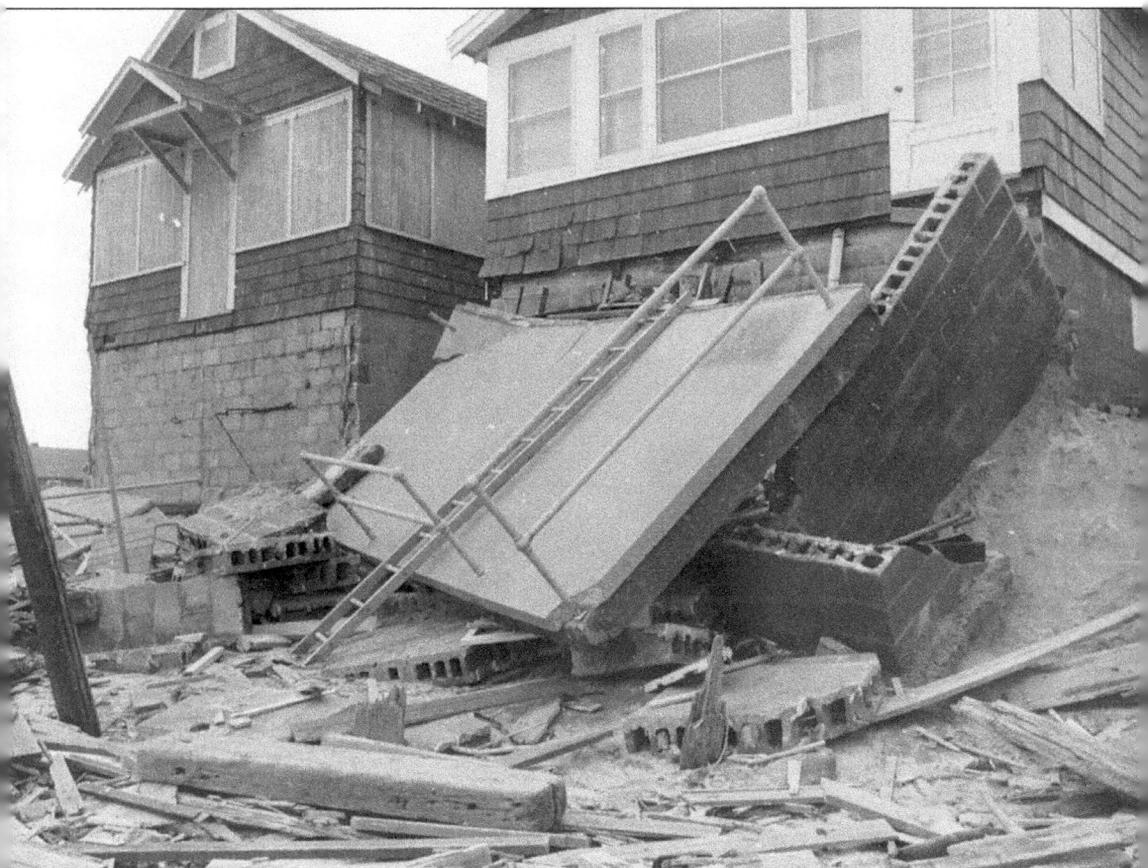

Houses at the north end of the beachfront were destroyed during the 1962 storm. Residents who lived in Manasquan during the March northeaster claim that it was one of the worst storms they can remember.

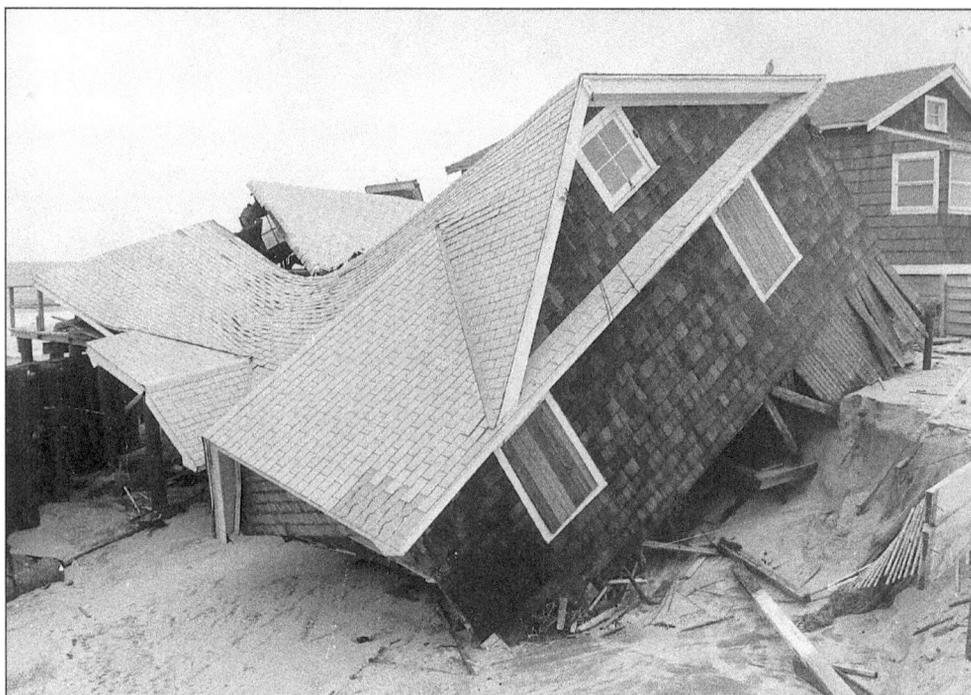

This last home at the north end of the oceanfront was completely ripped from its foundation and destroyed by the powerful waves and gale winds of the March 1962 storm. Today, this site is an empty lot.

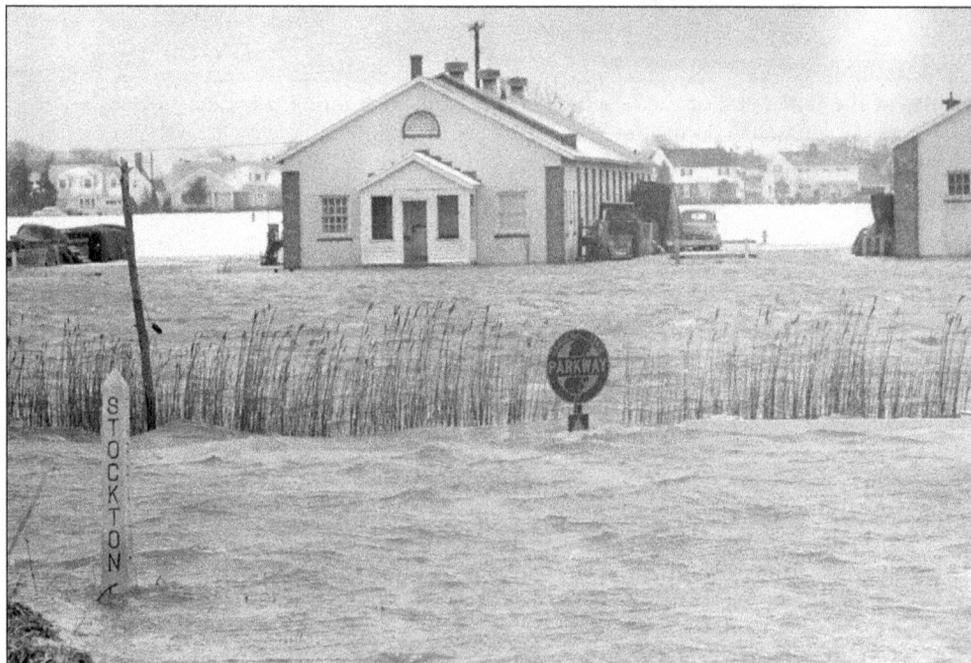

This high tide followed the 1962 northeaster. This photograph, taken with a telescopic lens, shows the water of Stockton Lake pouring over Stockton Lake Boulevard and North Farragut Avenue. The tide was 5 feet above normal when this image was taken.

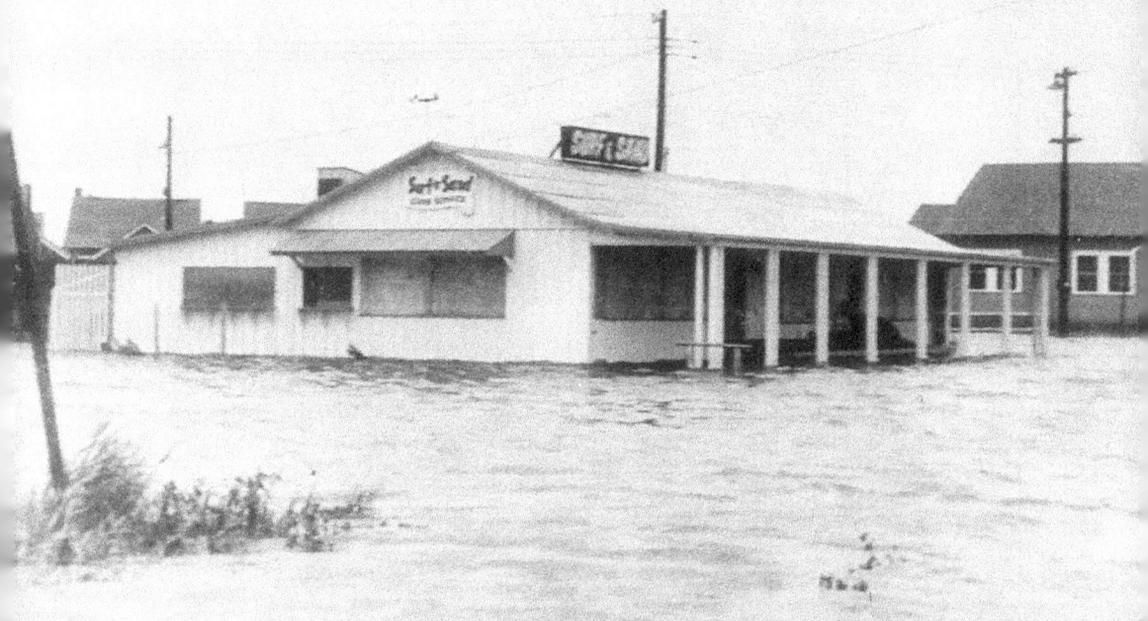

The Surf 'n' Sand, a seasonal restaurant, is surrounded by high saltwater tide in this scene taken after the famous storm of March 1962. The eatery was owned by Bankston and Hilda Brooman, who had purchased it from original owners Ward and Peggy Wight.

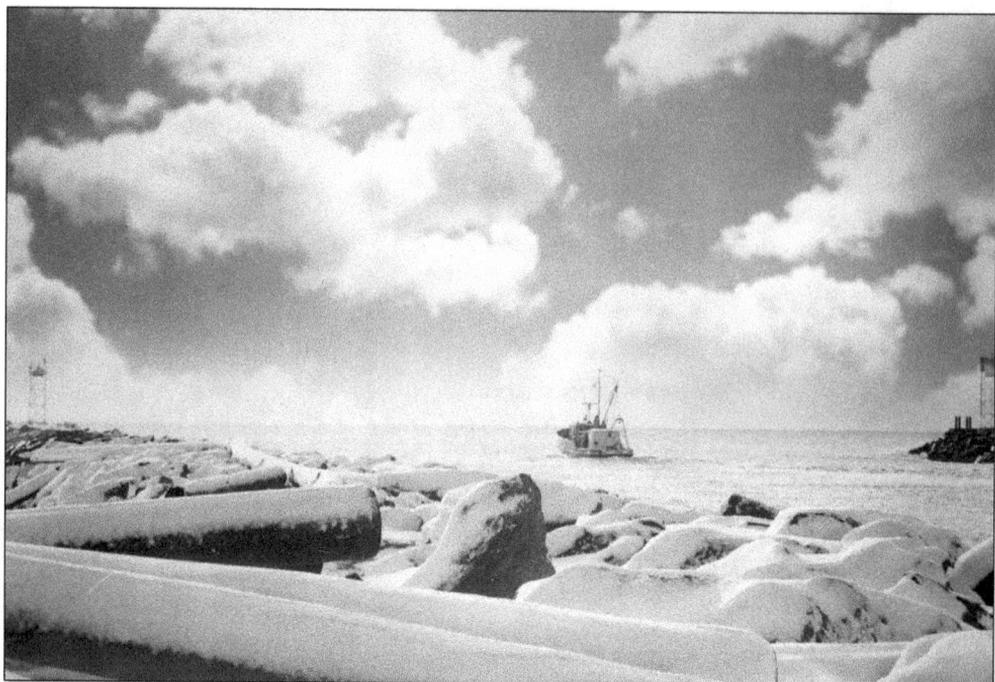

This trawler travels east out of the Manasquan Inlet following the early February 1967 snowstorm. Deep snow blanketed the area, causing local schools and businesses to close.

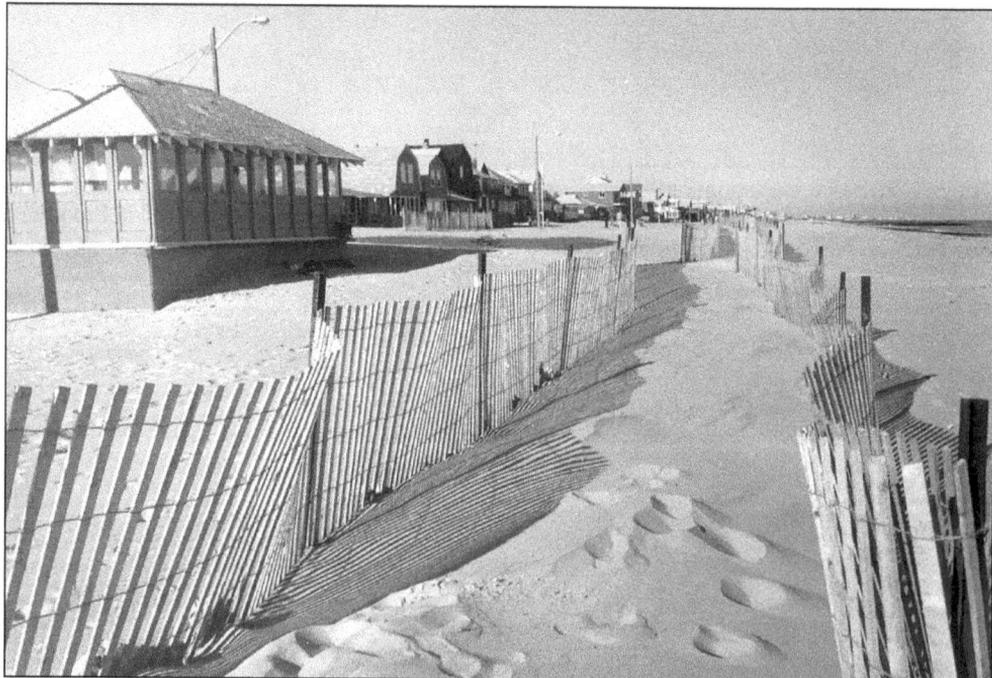

Temporary snow fences were used to keep sand from blowing off the beaches during the off-season. This 1960s view of the fences also depicts a different scene at the Manasquan Inlet beach: the summerhouse is enclosed so that visitors can enjoy the ocean view without the cold, biting winds of winter.

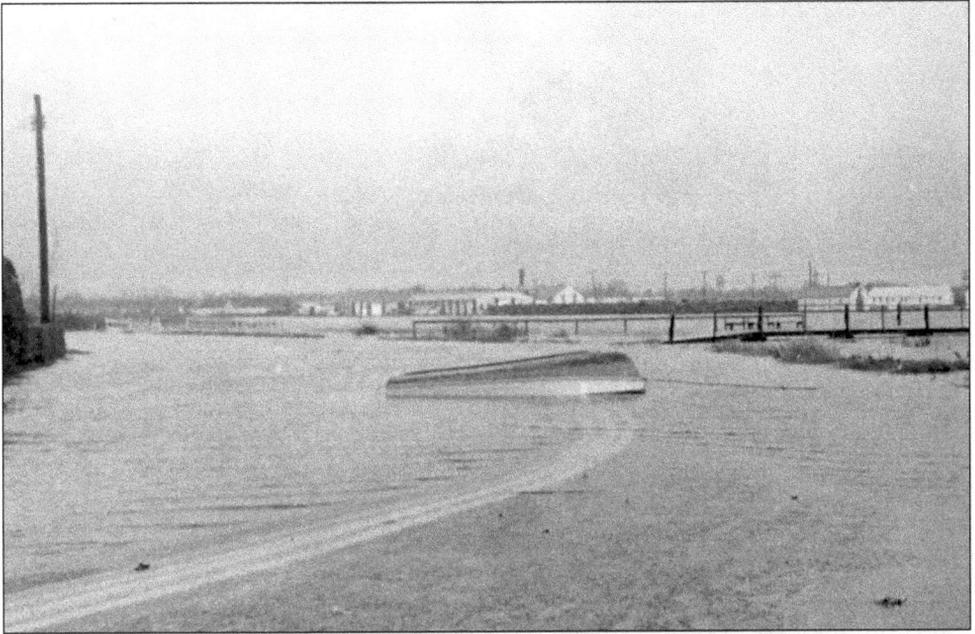

A wooden rowboat lies upside down on the center line of Stockton Lake Boulevard following a storm in November 1968. High tides and strong winds also caused considerable flooding on Brielle Road, Main Street, and Ocean Avenue. Some sections of the beach walkway were damaged, and debris was pushed into the street by the powerful waves.

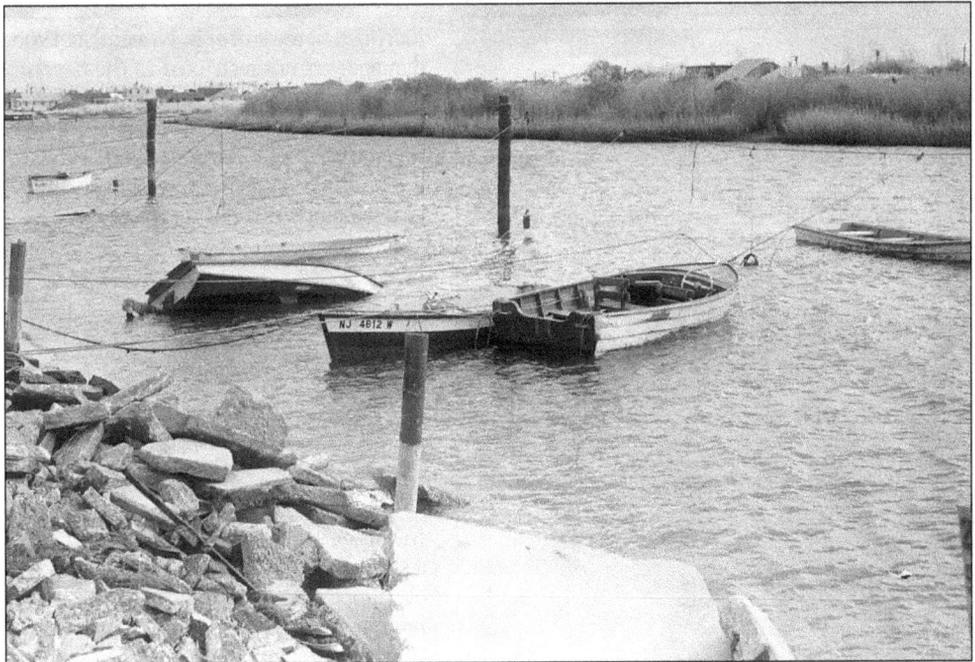

Some of the rowboats were overturned and partially submerged at the municipal docking area on Perrine Boulevard during the November 1968 storm. Residents of the beach area were evacuated, using borough vehicles, the Coast Guard, the National Guard, and the Marpal Company trash trucks.

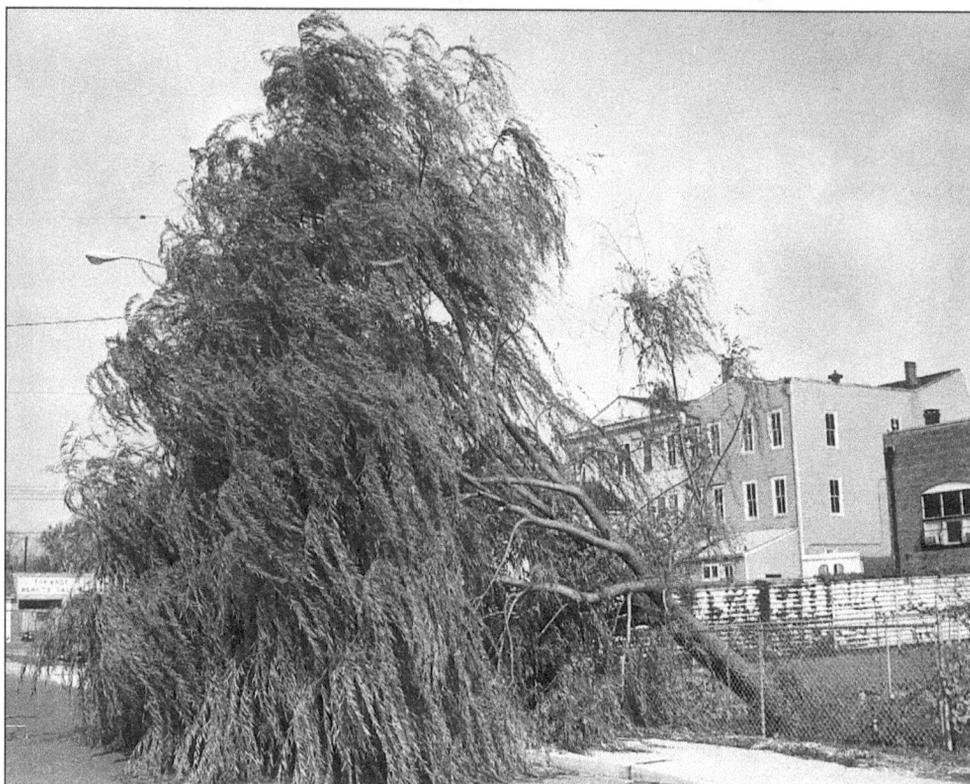

During a fierce storm in November 1968, damage was not restricted to the beach area of the community. This weeping willow tree in the backyard of a property on Main Street fell into the street in Old Squan Plaza. Power and telephone lines also were downed during the storm.

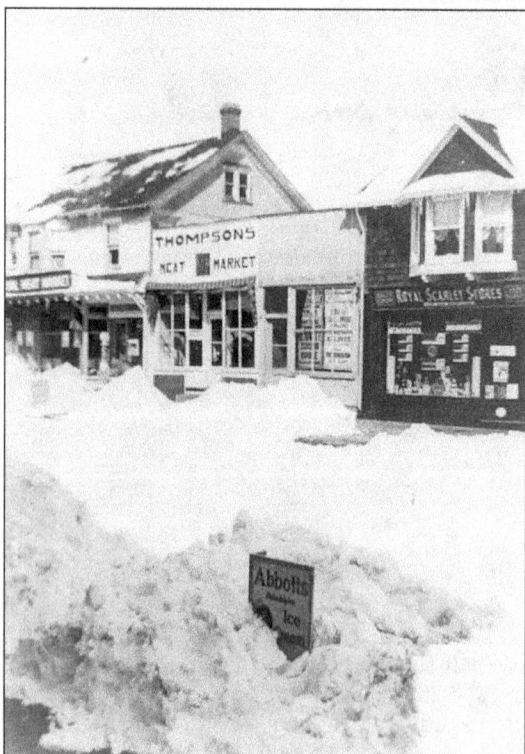

In this early-1930s scene following a snowstorm, Main Street is empty of shoppers, but the business district merchants have all cleared their sidewalks. Abbott's Philadelphia Ice Cream is advertised for sale at Tassini's on the opposite of the street, but customers have opted to stay home and drink cocoa instead.

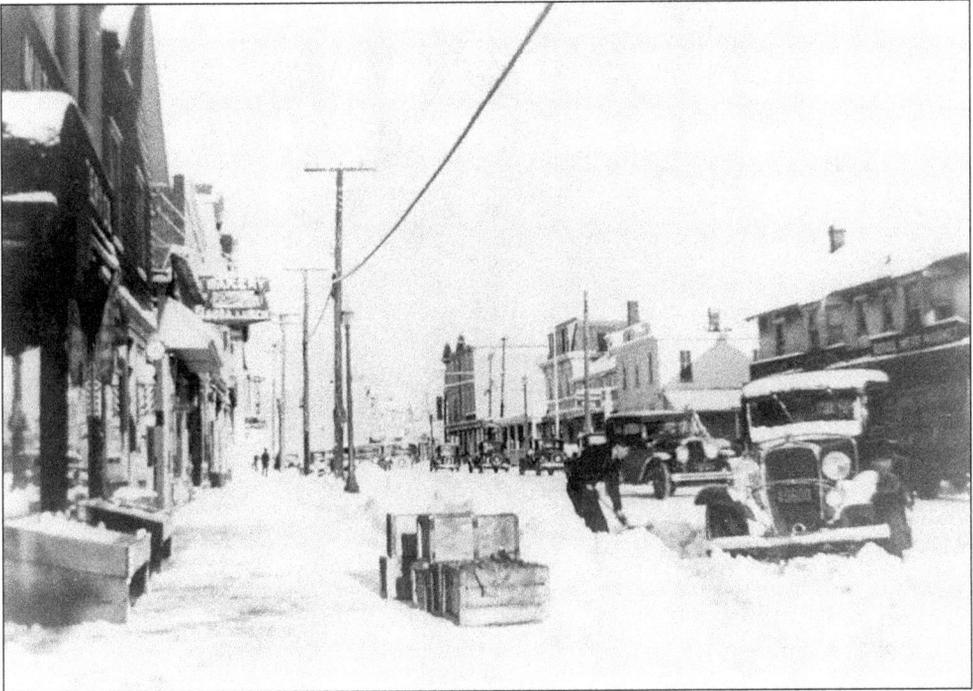

This view of the south side of Main Street was taken looking west after the early-1930s snowstorm. Main Street has been partially plowed, and further shoveling is under way. Meanwhile, more automobiles venture out and the business of the town resumes.

George Minier of Manasquan walks along Main Street in this winter scene in the late 1930s. This image illustrates not only the desolation of the season but also the sparsely developed area. The three-story home is located at 278 Main Street, and the home in the background is on the corner of Main Street and Minerva Avenue.

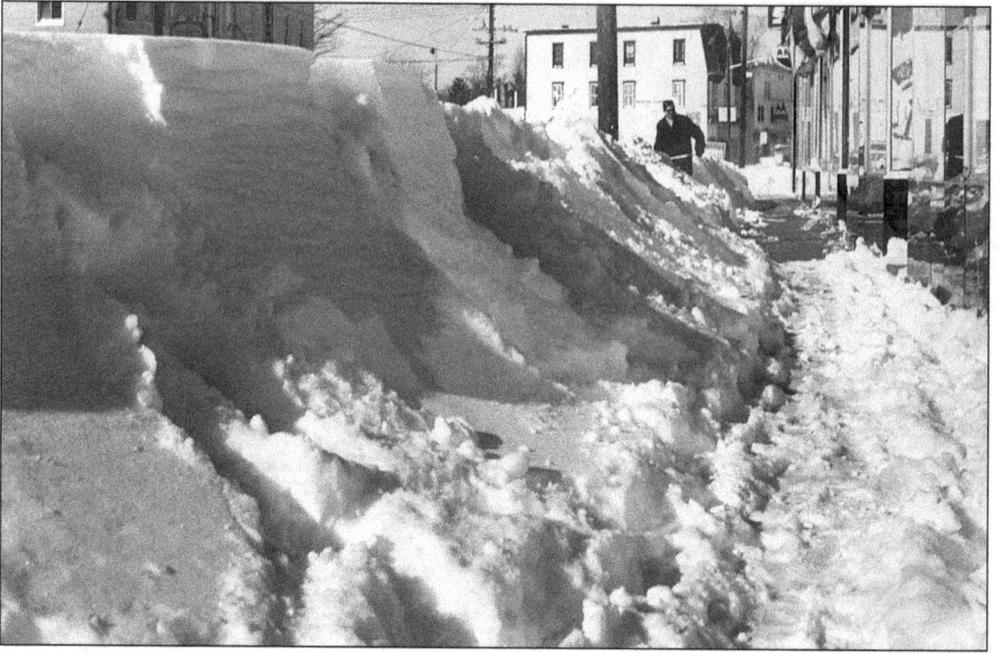

A shopkeeper digs out from the blizzard of January 1964. This view was taken on the north side of Main Street near the intersection of Broad Street. Gale force winds created these huge snowdrifts.

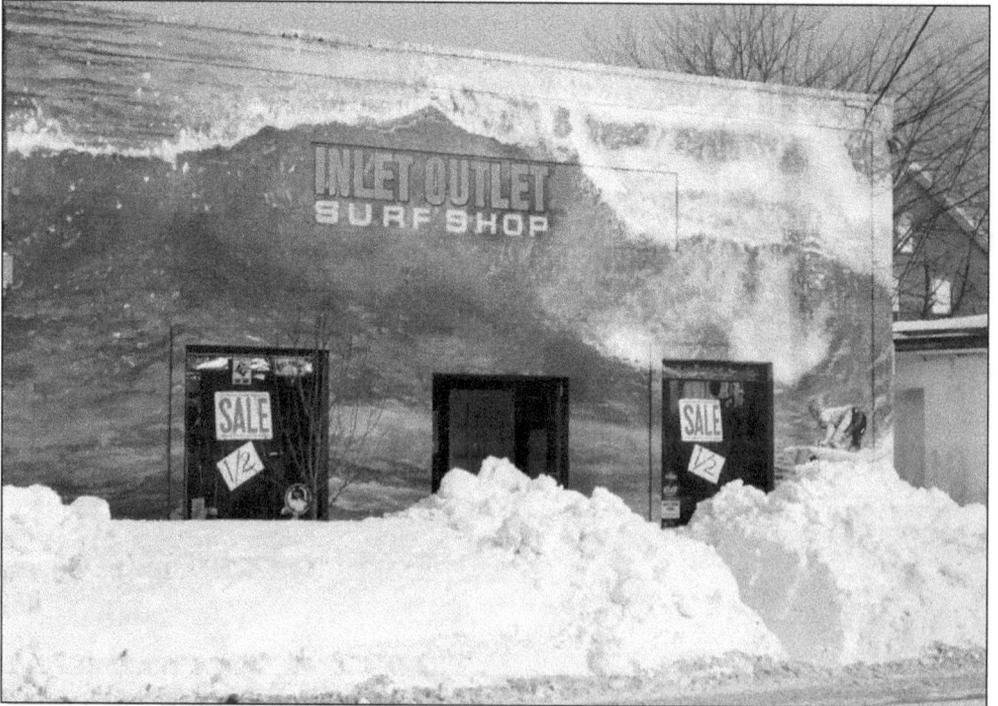

The Inlet Outlet Surf Shop at 146 Main Street features a half-price sale following the January 1994 blizzard, which closed some schools, shops, and businesses for three days. (Photograph courtesy of Holly Peterson.)

Six

A Day at the Beach

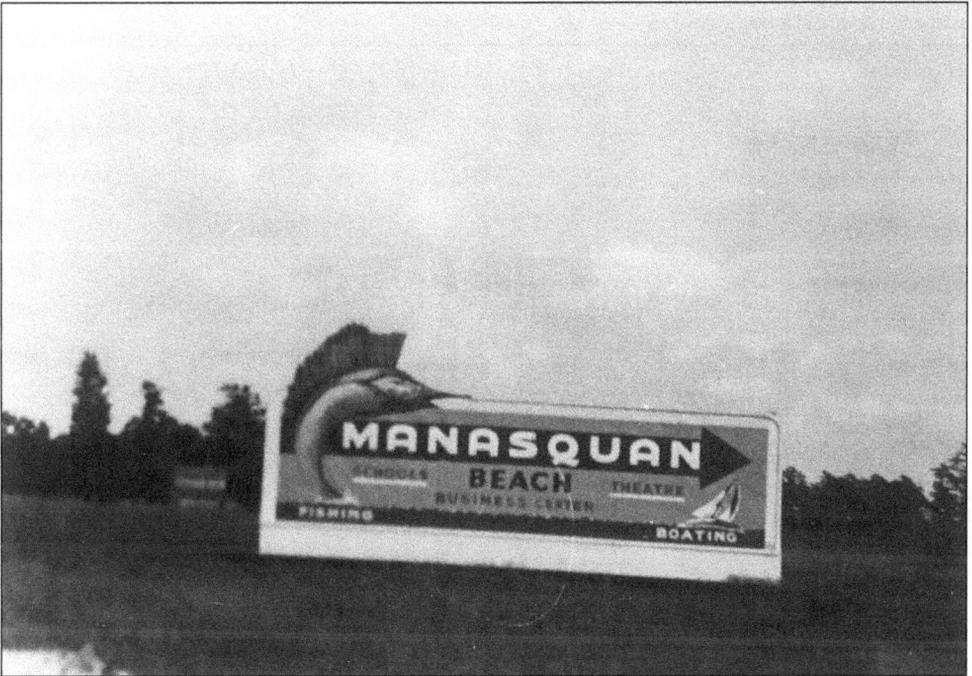

A larger-than-life swordfish on this highway sign at Brielle Circle welcomes visitors to Manasquan, c. the 1950s. More than 50 years later, Manasquan still draws summer crowds who swell the coastal community. The crowds come because the town continues to offer some of the greatest fishing off the Jersey Shore, recreational boating, swimming, and a thriving business district.

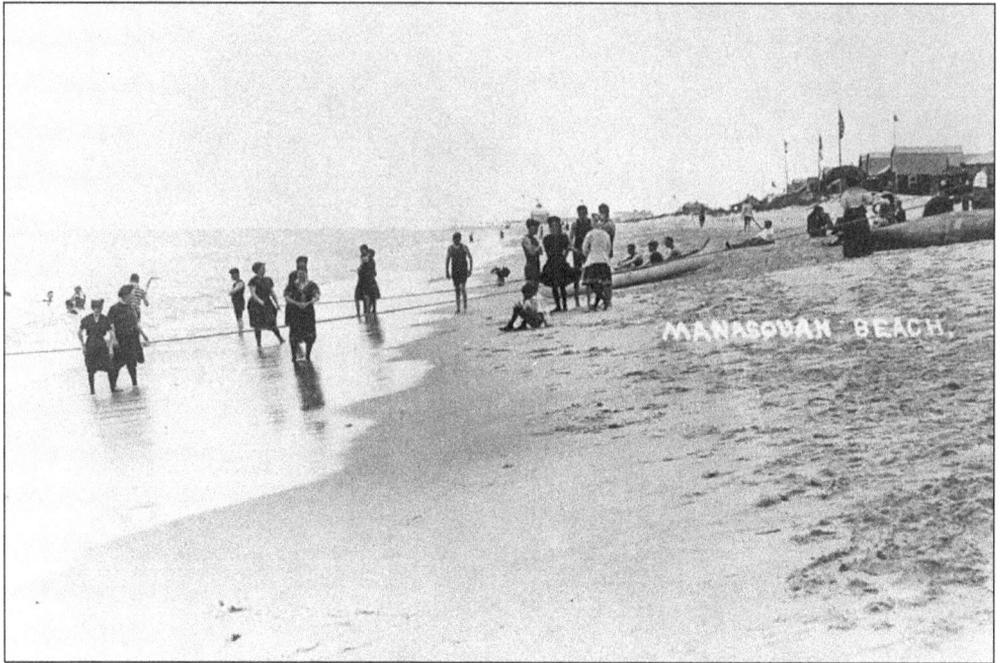

Beachgoers in the 1920s enjoy a day on the shores of Manasquan. Bathing costumes were made usually of dark wool and covered bathers from head to toe. Women wore knee-length bathing attire with wool tights.

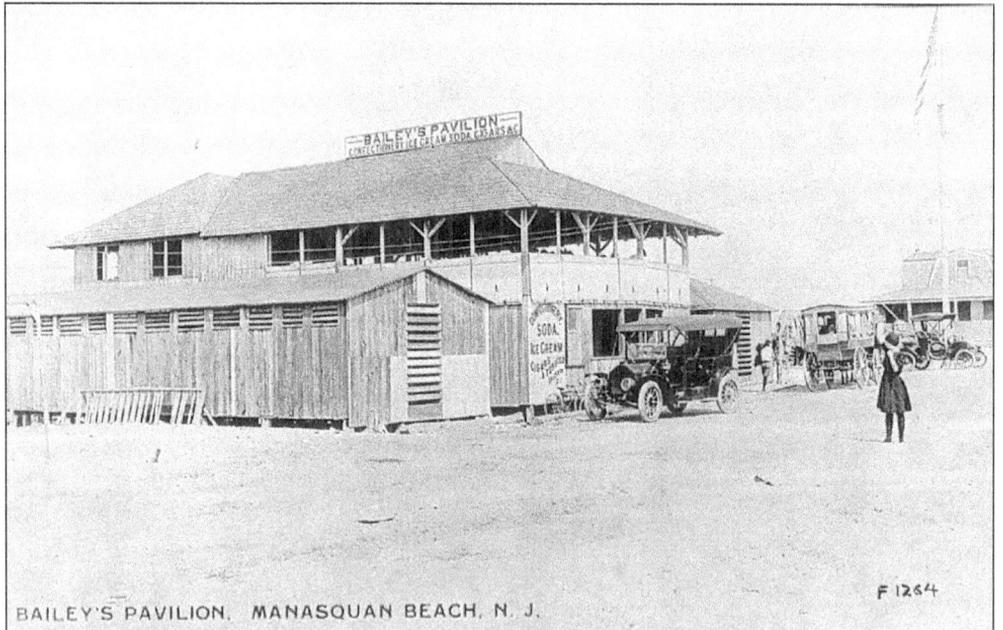

Located on the beachfront, Bailey's Pavilion, later Sweeting's Pavilion, was established by William H. Bailey, a sea captain who resided in the borough. After years at sea, Bailey stayed as close as he could to the salt air and ocean waves by operating this pavilion, which featured cold drinks, lunch, snacks, and bathhouses. The building was later owned by Dr. Edward S. Sweeting.

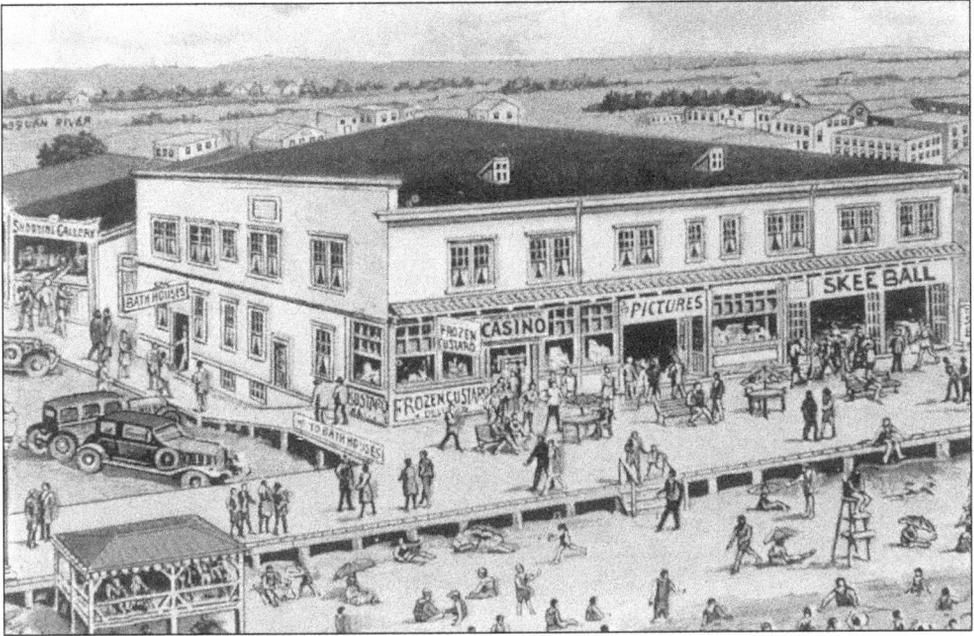

Day-trippers in this 1930s artist's rendering would have had to look no further than the Manasquan Casino and the Main Street beach for a day of merriment and relaxation. The building was owned and operated by members of the Seyfried family, who also built a similar structure—Frank's—in Point Pleasant Beach.

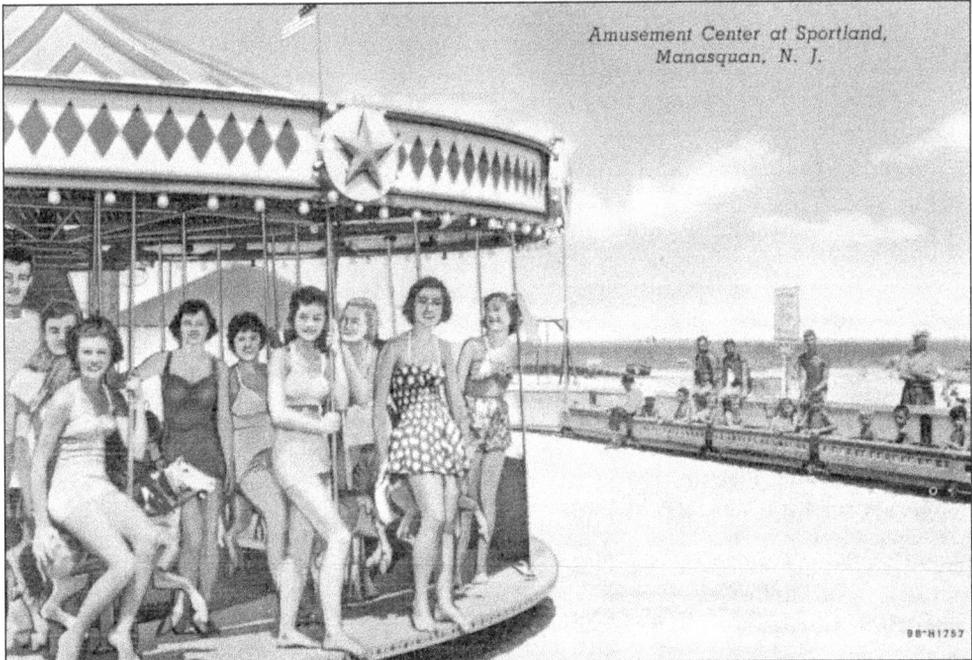

Amusement Center at Sportland, Manasquan, N. J.

No visit to Manasquan beach in the late 1940s was complete without a leisurely ride on the carousel. Other rides at the Main Street beach included the miniature train at the right, boats, and a ferris wheel. The roof of the beach registrar's office is visible in the background.

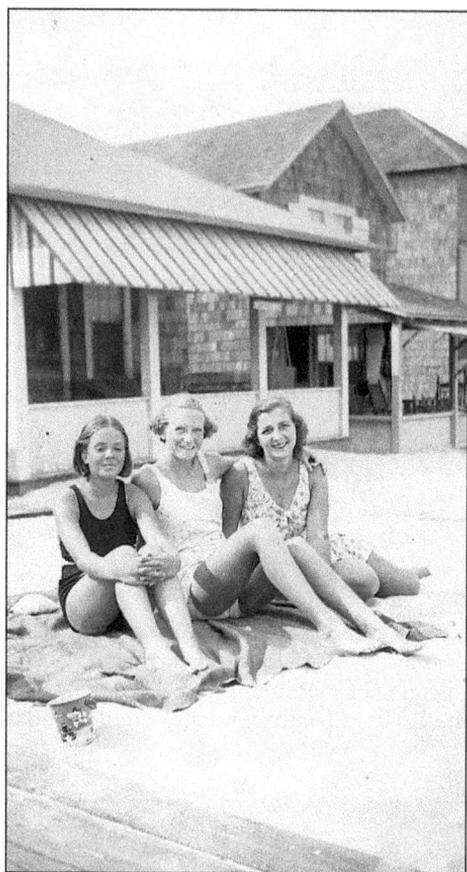

These teenagers are enjoying the beach, c. 1935. Seen here, from left to right, are Nila Schoen (Sutphen), Margaret Hartman, and Betty Schoen (Van Schoick), who lived in Manasquan from 1947 until her death in 1996.

Thomas S. Birckhead Jr., left, and Vernon A. Jackson enjoy a summer day on Manasquan beach in 1947. The childhood friends graduated from Manasquan Grammar School and then from Manasquan High School in 1942. The two are still friends, although Birckhead resides in his childhood home and Jackson lives in Washington state. Jackson's sister Irma is still a Manasquan resident.

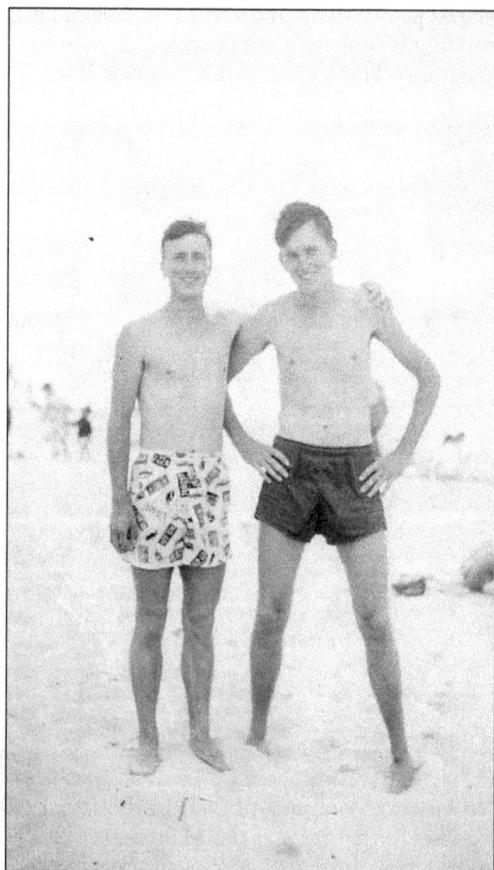

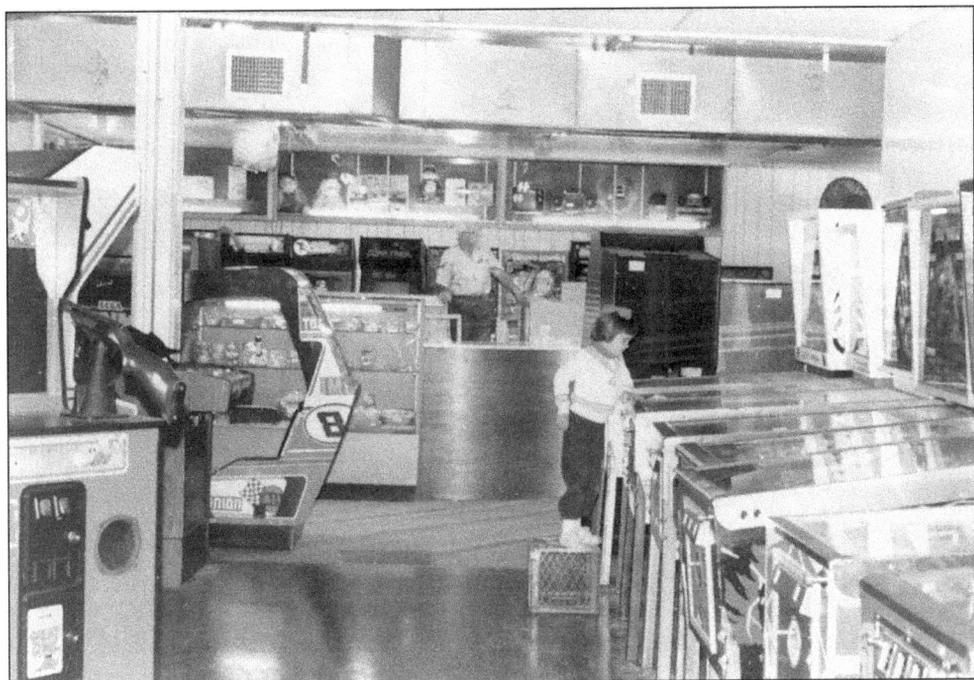

Manasquan native Abbey Dickson has no trouble reaching the pinball machines in Gee Gee's arcade at the beachfront. For decades, these machines, skeeball, and other games have provided hours of fun for area children and visitors.

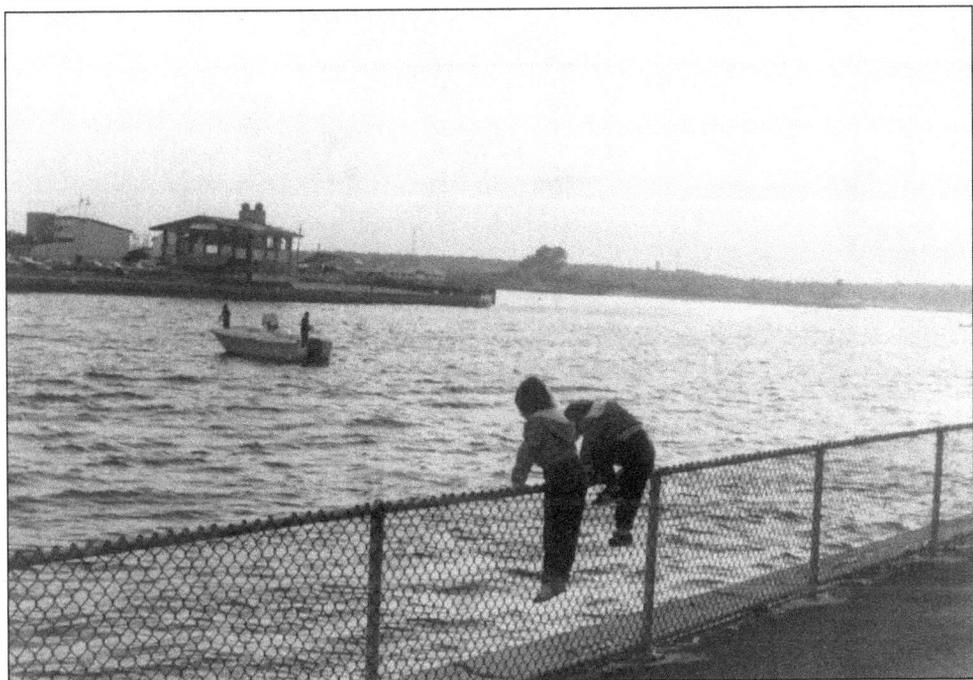

After enjoying the sights and sounds in the arcades, Abbey Dickson and her brother Trevor Dickson visit one of the beach area's other very popular destinations: Manasquan Inlet. This photograph captures the pair in 1984. Thank goodness they are great swimmers!

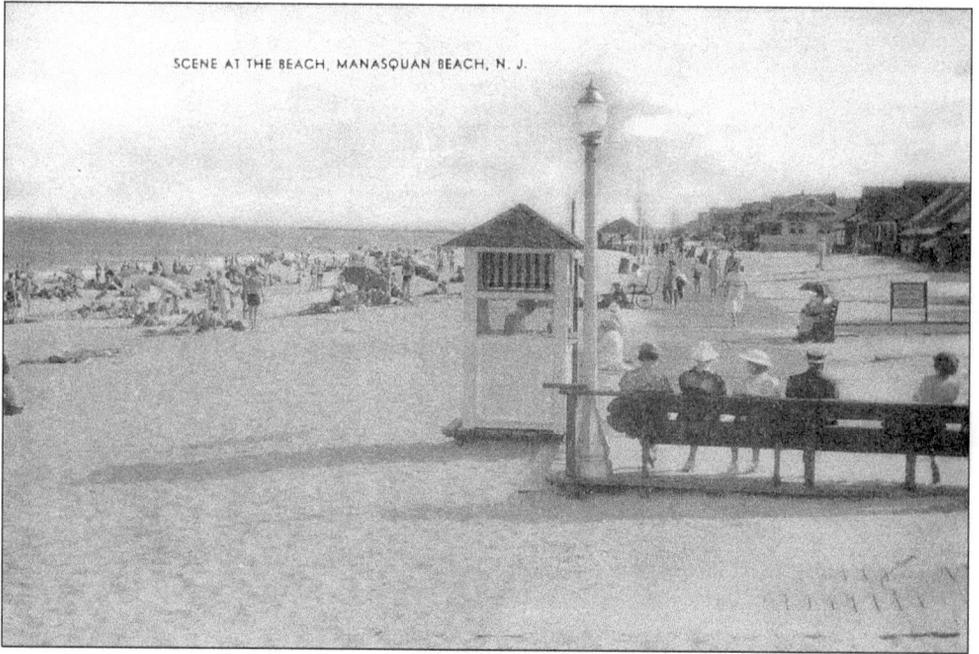

SCENE AT THE BEACH, MANASQUAN BEACH, N. J.

This 1950s postcard shows the asphalt walkway at Ocean Avenue beach, a popular recreational spot. Notice the booth for the person who sold daily beach passes. In 1934, the borough established beach fees: a daily pass cost 25¢.

This imposing edifice is the Beachcomber, near the corner of Second Avenue and Brielle Road. The Beachcomber advertised clean, airy rooms, by the day, the week, or the season.

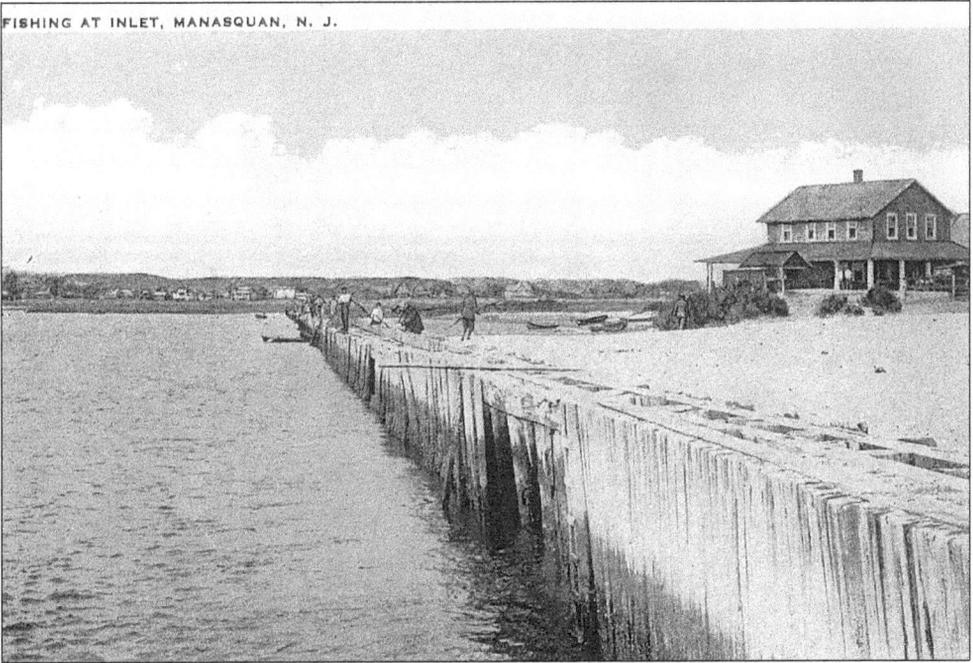

The Manasquan Inlet was under construction from 1929 to 1931. This view was taken looking west shortly after the waterway was completed. The Manasquan Fish and Gun Club is at the right. Just south of the club was Hap's Pond and a bait shack owned by Hap Naylor.

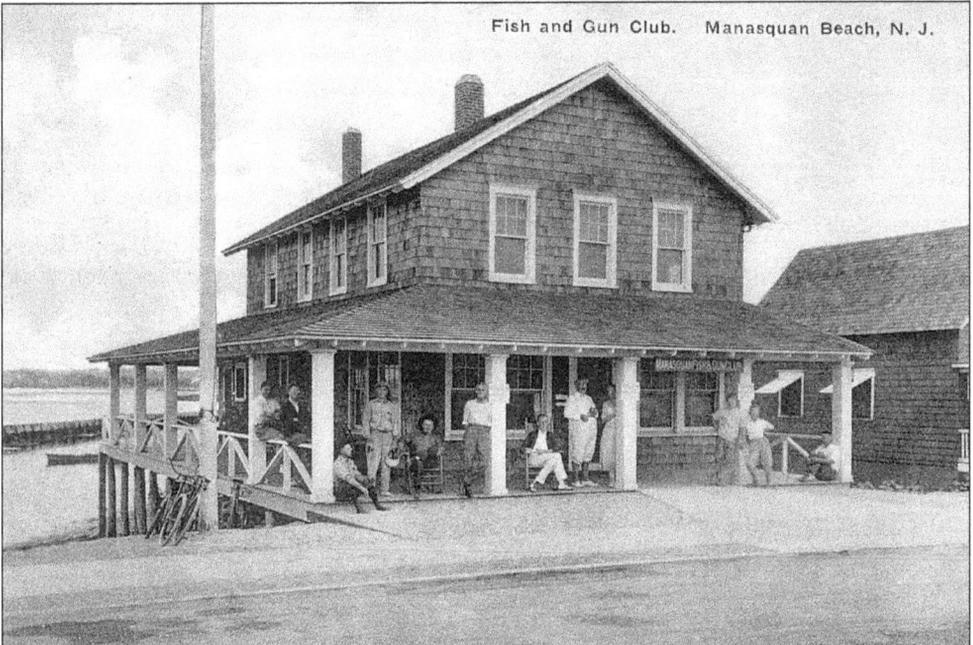

Fish and Gun Club. Manasquan Beach, N. J.

Members of the Manasquan Fish and Gun Club enjoyed restful days on the porch of the clubhouse, exchanging fish tales. In the early 1900s, businessmen came from New York and Philadelphia for the excellent fishing and hunting that they found along the Manasquan River.

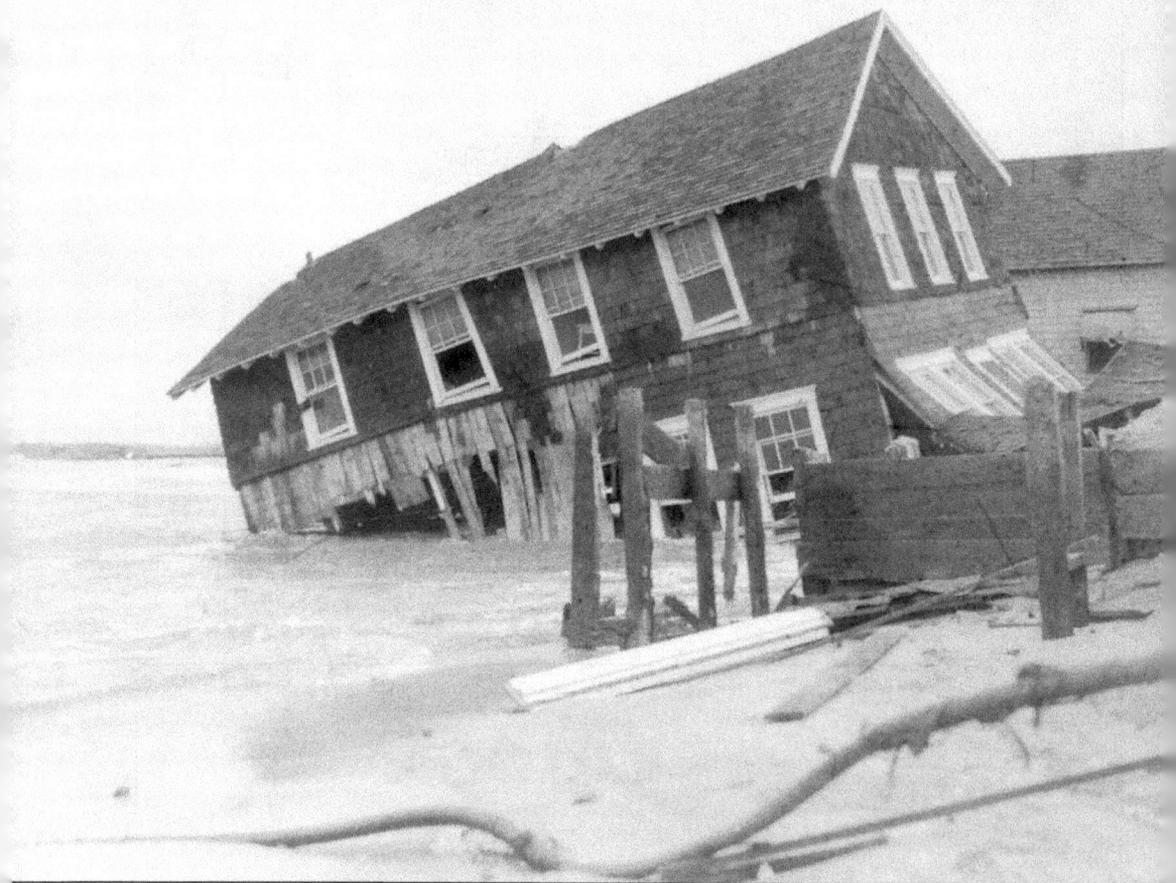

The foundation of the Manasquan Fish and Gun Club collapsed after several days of heavy rain, pounding surf, and strong winds; the ocean and the river met under the back porch of the clubhouse in September 1933. The club was not rebuilt.

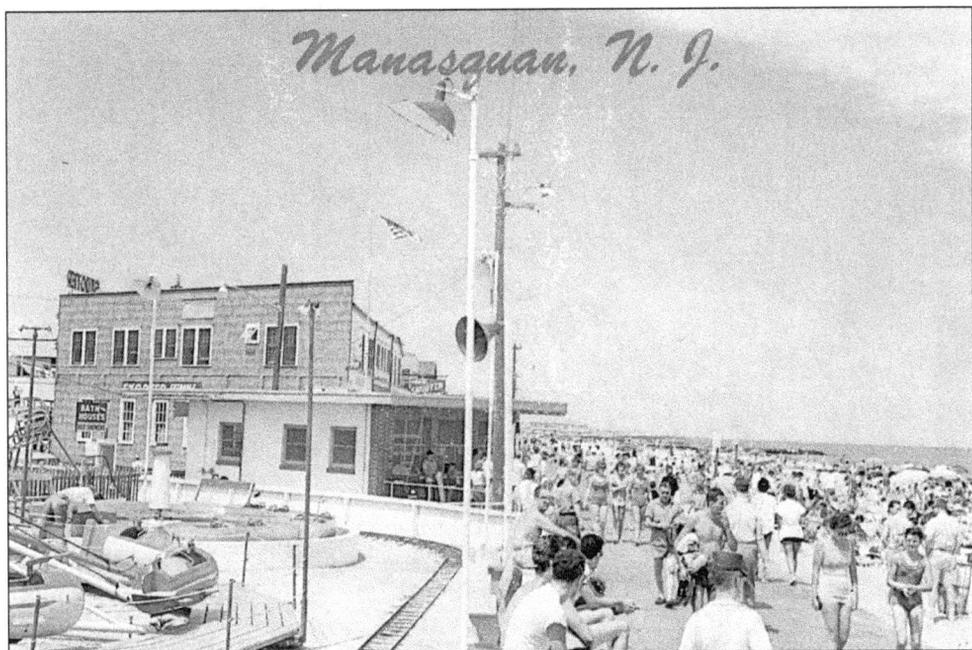

Amusements for children were a popular attraction at the Main Street beach. The miniature train, wooden boats, and airplanes provided children with hours of entertainment. The beach registrar's office at the end of Main Street was still only one story high in the early 1960s.

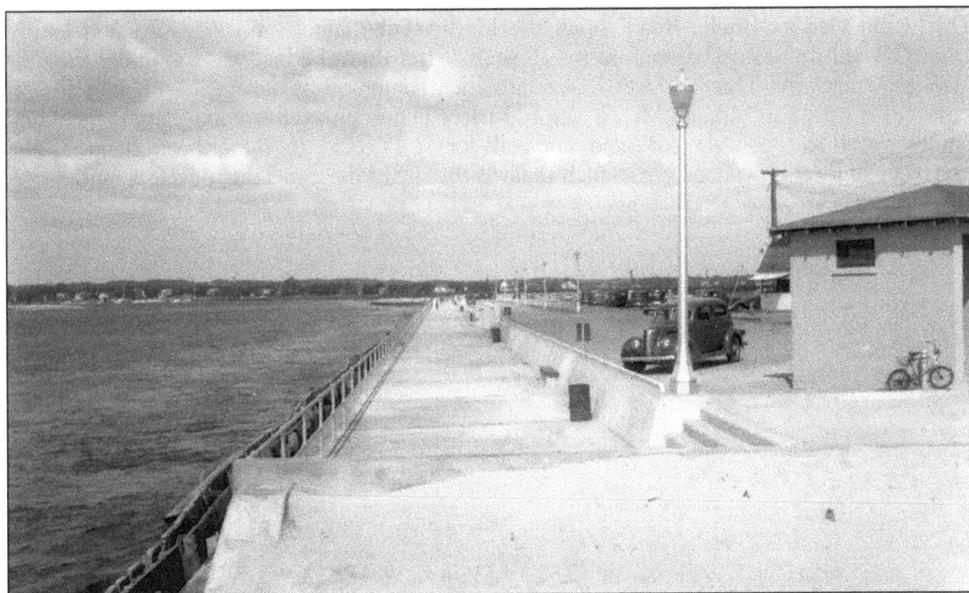

The esplanade at the Manasquan Inlet is nearly empty just days after Labor Day in 1939. Except for the removal of the median separating the lanes of traffic on Riverside Drive, the esplanade has not changed much since this photograph was taken more than 60 years ago.

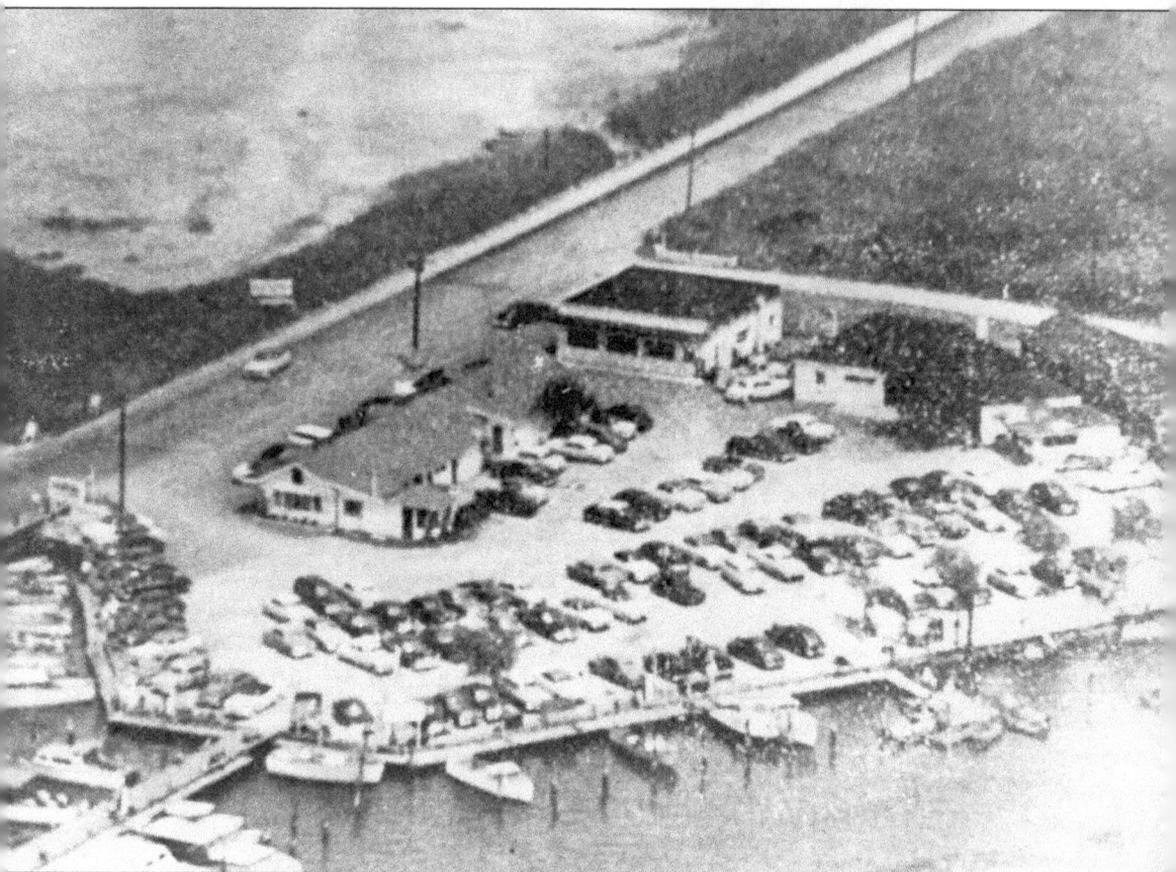

This aerial view of Brielle Road shows the Marlin Tuna Camp in 1963. Karl and Jennie Glaser owned the seafood restaurant for 18 years. After that, the business was under the new management of the Three Bridges Restaurant Inc., comprised of New York attorney Joseph Bolton, his wife, and Mr. and Mrs. Irving B. Kirsch. Diners enjoyed seafood platters including potato, vegetables, cole slaw or salad, and rolls for $2.25 to $5.75. Note the wetlands to the north across Brielle Road, an area which today is the site of the Sanctuary development.

Steven E. Phillips, a summer resident of the community, stands in front of his grandparents' home on Riverside Drive in this late 1950s image. His grandparents, Adrian and Mabel Phillips, were summer residents of the borough from 1954 to 1970. Carlson's Corner, established in 1934 as Randy's at the Inlet, is visible in the background.

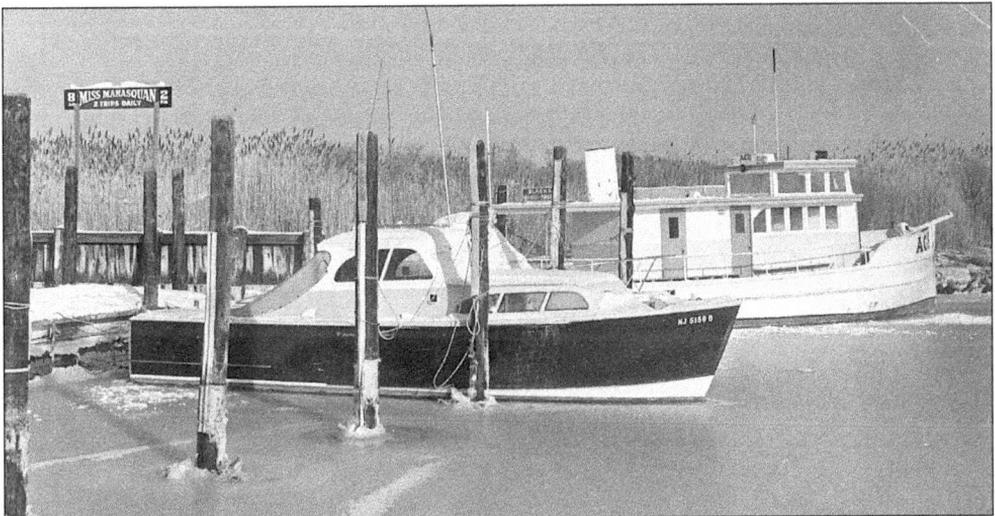

Boats docked at Sherman's Creek, a branch of Watson's Creek off Brielle Road, are surrounded by ice in January 1963. The dock was the home port of the Miss Manasquan, a 50-foot boat that took day-trippers on fishing excursions.

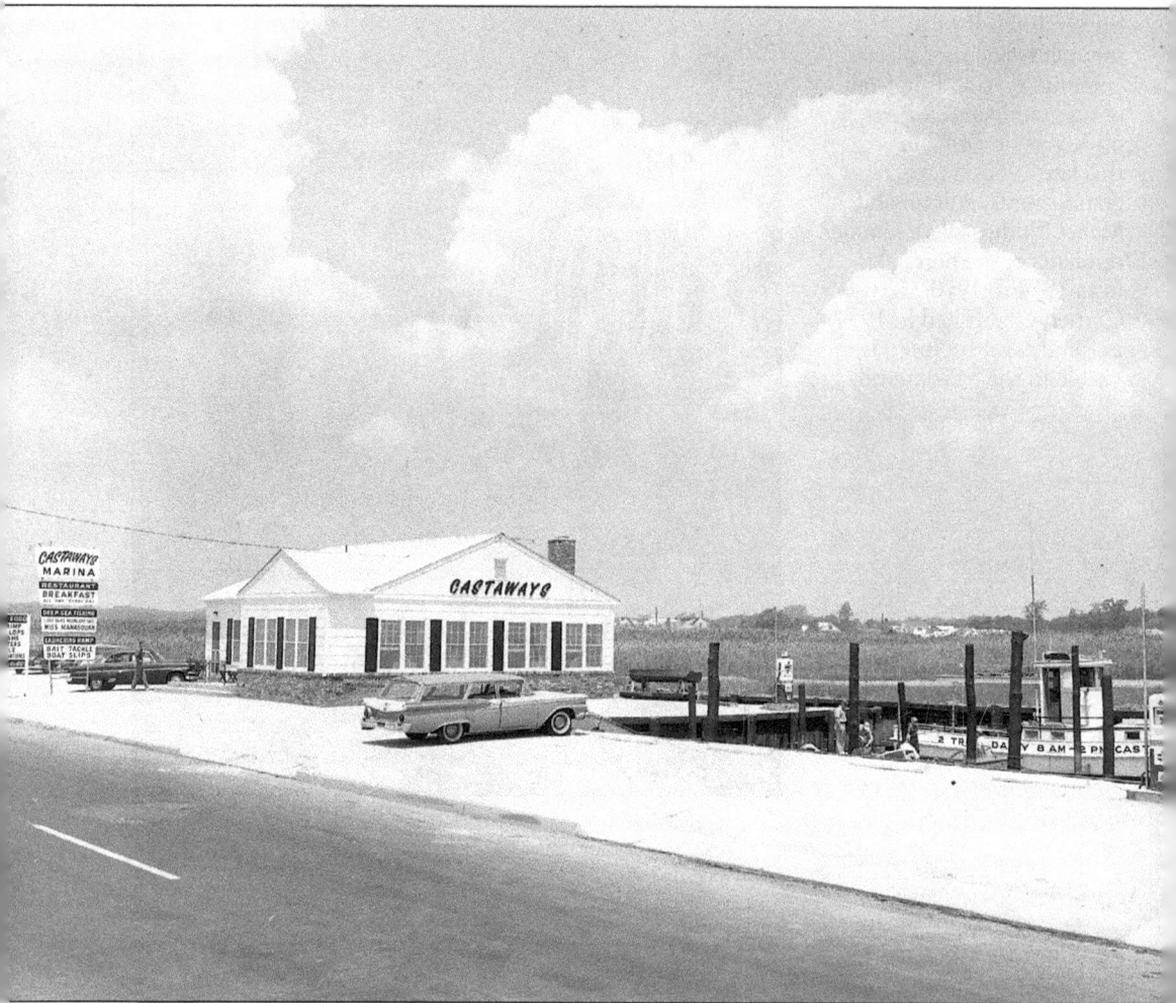

The Castaways on Brielle Road just east of the Brielle Road bridge has served visitors to the area since the early 1960s. The establishment initially featured a restaurant and later added rooms for overnight guests, making it the Castaways Motel. The motel was built before any development on the "isle of sedges" to the north and west had occurred.

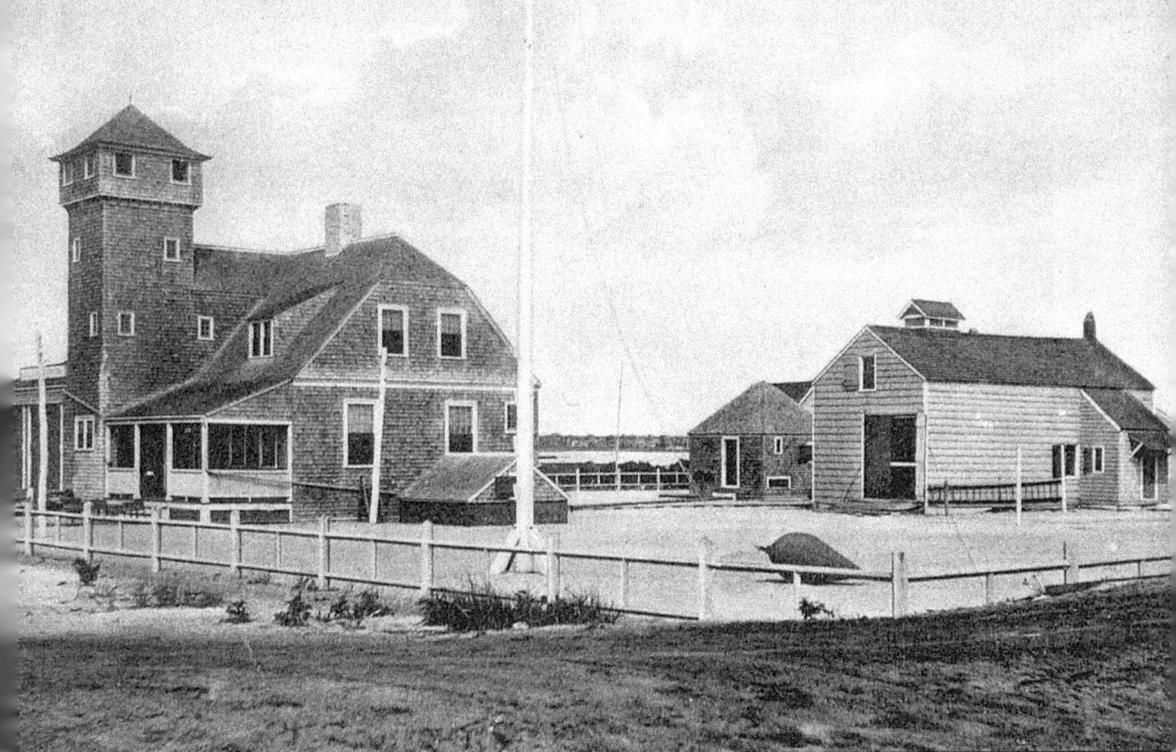

With heavy shipping traffic traveling along New Jersey's 127 miles of coastline, there was always a need for lifesaving. In 1848, Squan (Manasquan) Beach was one of the first eight lifesaving stations on the coast. The station was constructed on the north side of Ocean Avenue between First and Second Avenues. For a time the station served as an electronics facility, before it was decommissioned in the early 1990s.

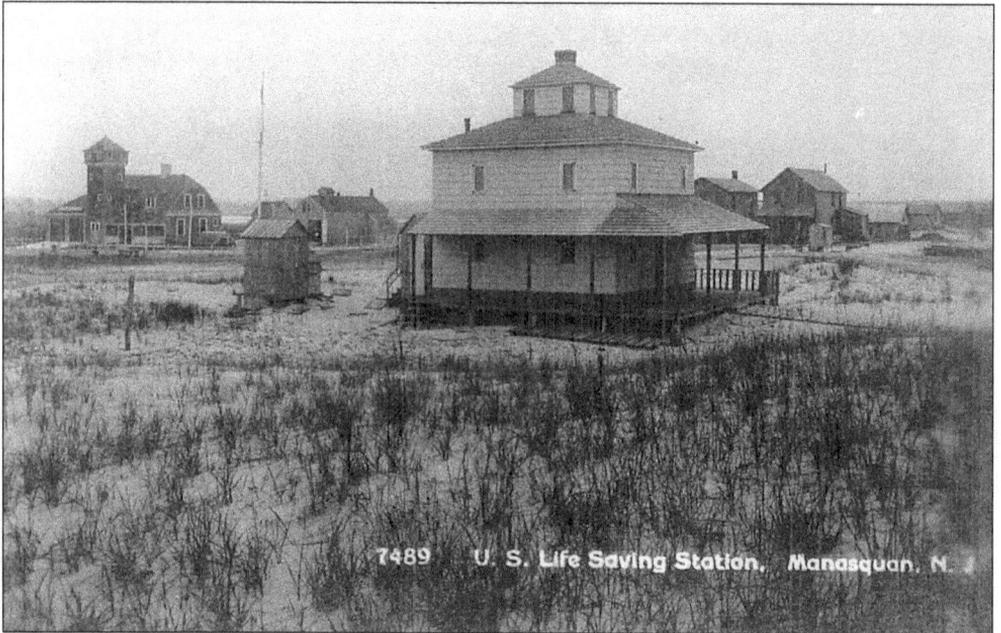

The crew's quarters of the U.S. Lifesaving Station at Squan was located on the beachfront. The structure, located at 107 Beachfront, has been the home of Joseph Gumienny for 20 years.

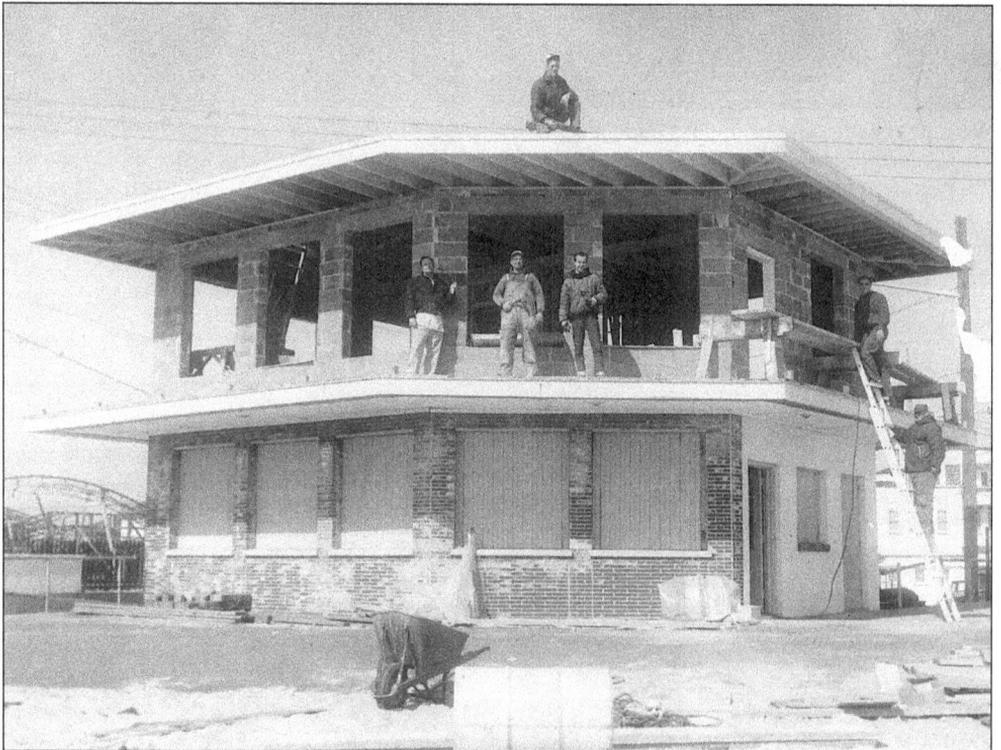

A second story is added to the beach registrar's office at the end of Main Street. Space also was provided for a substation of the police department. The addition, completed in 1965, cost $11,079.

110

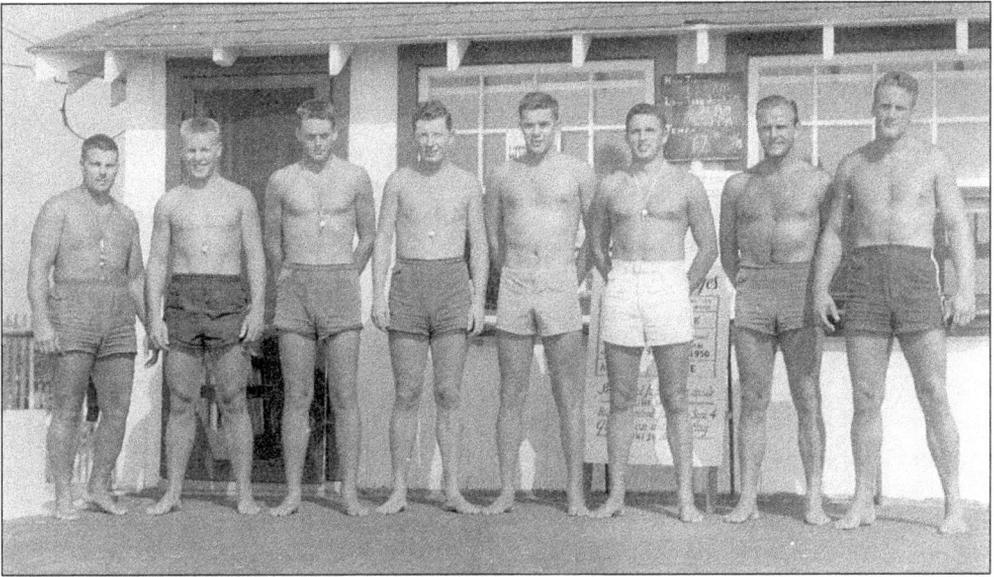

The borough's lifeguards in 1950, from left to right, are Jack Legg, Jim Walker, Webb Sherrel, Buster Thompson, Dan Wooley, Fred Murnane, Ed Poling, and Herb Stiefel, captain. The lifeguards made safety their top priority. (Photograph courtesy of Herb Stiefel.)

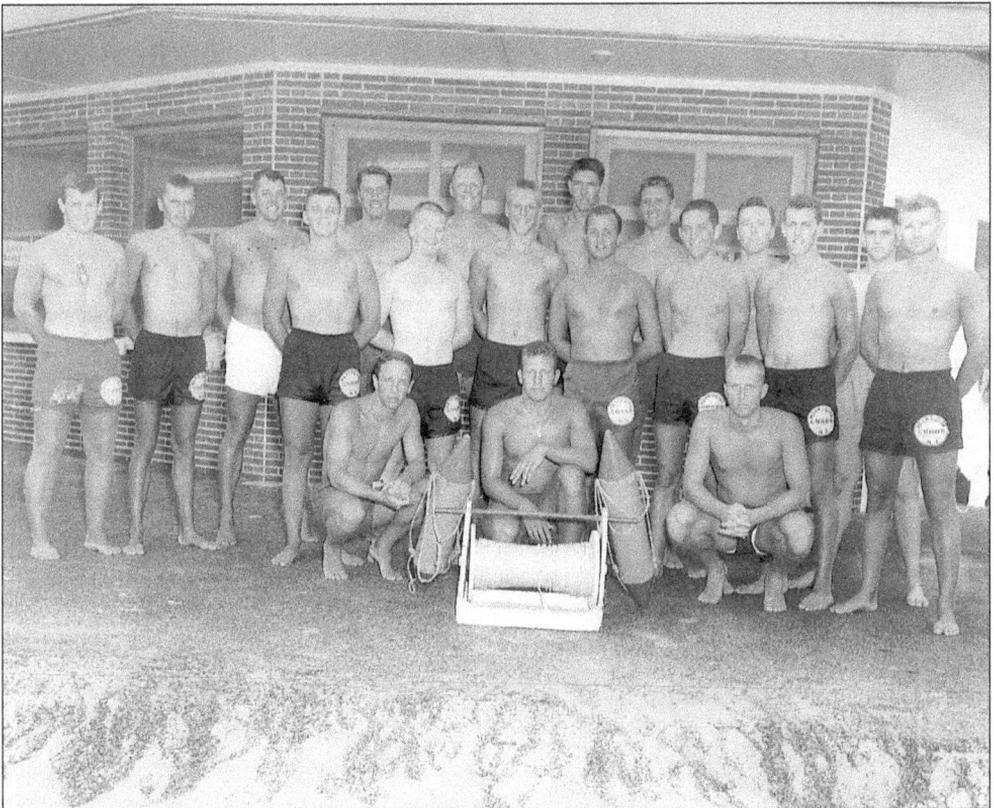

By 1956, the Manasquan Beach Patrol had more than doubled the size of its staff. Also, notice that the lifeguards are wearing uniform beach trunks.

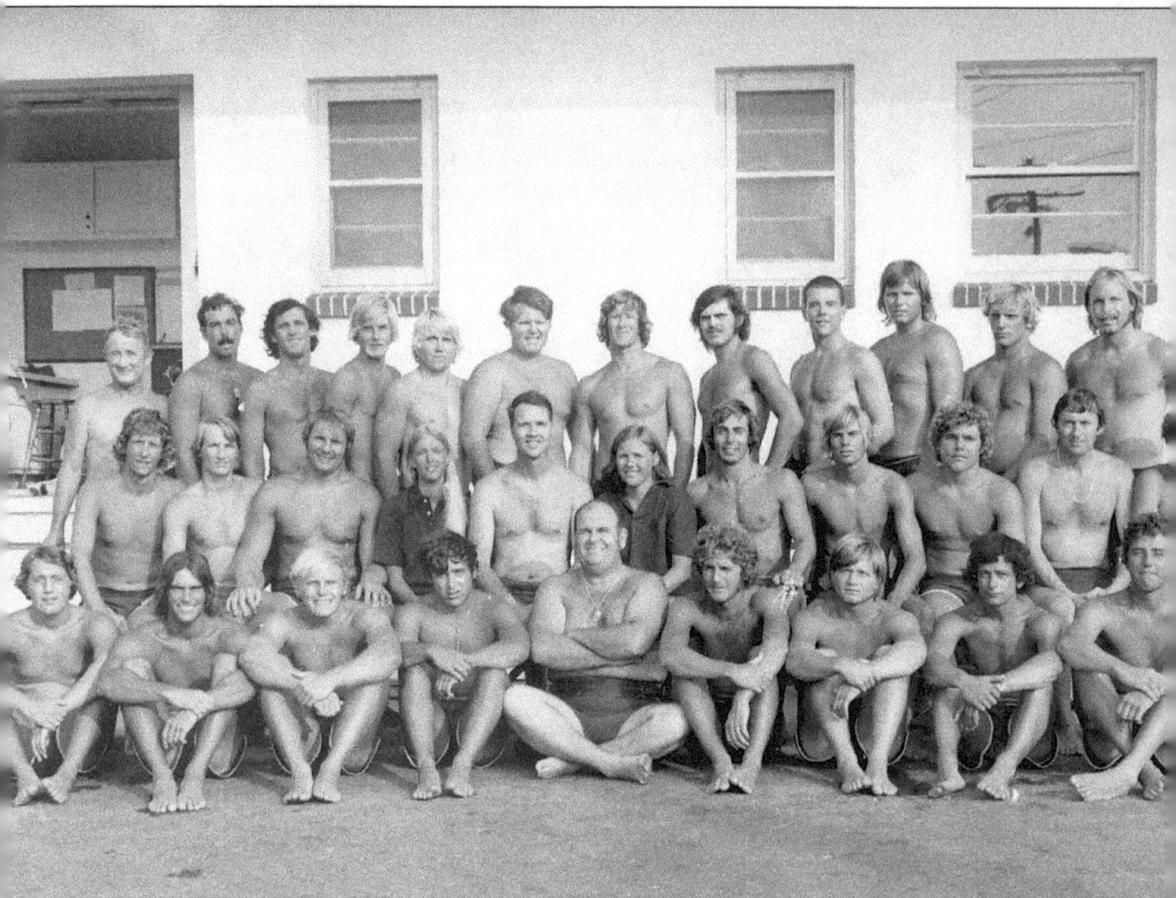

This photograph of the 1973 Manasquan Beach Patrol illustrates the growth of the staff, who worked toward making certain that beachgoers had a safe day. Members, from left to right, include the following: (front row) Scott Fischer, Bob Patterson, Mark Roberts, Tom Cantillo, Neil Lomax, Keith Carlson, Tim McCorkell, Ron DeLuca, and Bill Bateman; (middle row) Jeff Lee, Harry McCarthy Jr., Jim Hamley, Kathy Hancock, Miller Preston, Barbara King, Wayne Palmer, Jeff Mantak, Bill Mangan, Dick Marks, and unidentified; (back row) Harry McCarthy Sr., Alex Weiss, Jack Clausen, Craig Carlson, Rex Capro, John Cocce, Ken Fortier, Lucky McKelvey, Bill Roberts, Rob Hamley, Stu Whitman, and John Ervin. Other members of the beach patrol included Gary Walsh, Susan Patterson, and Diane Guiliano.

Workmen build a new bulkhead on the lagoon to accommodate more pleasure boats on the Manasquan River. Many such lagoons were built throughout the area in the 1950s and 1960s.

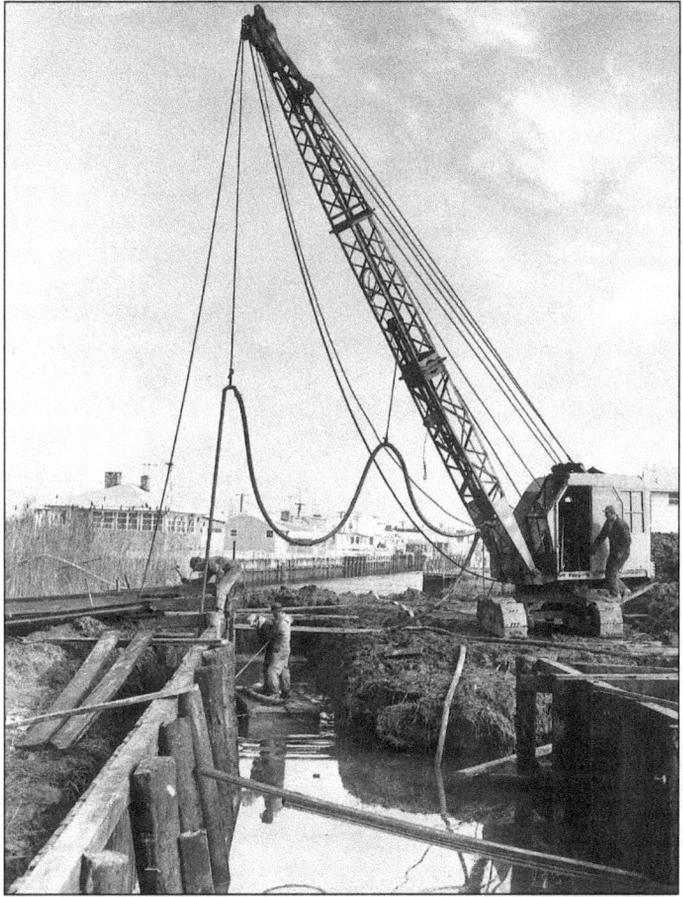

Paving the way to accommodate the growing number of day-trippers' automobiles that came to Manasquan beach, the Pompano Avenue municipal parking lot was constructed in the spring of 1966.

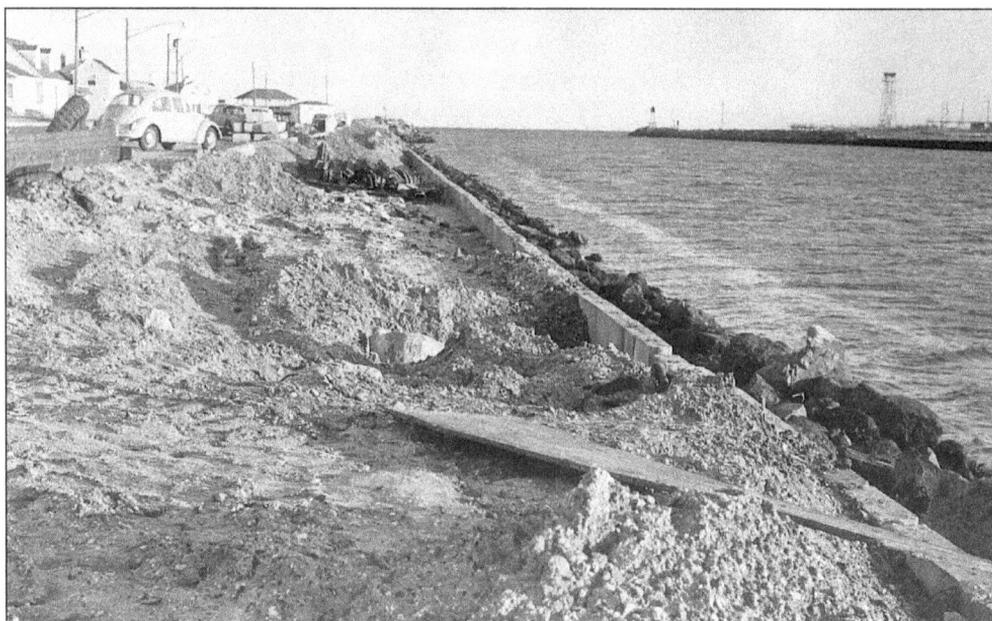

Employees from the DeLee Construction Company of Brooklyn, New York, replaced the deteriorating steel bulkhead at the Manasquan Inlet. The project, completed in the mid-1960s, was under direction of the U.S. Army Corps of Engineers.

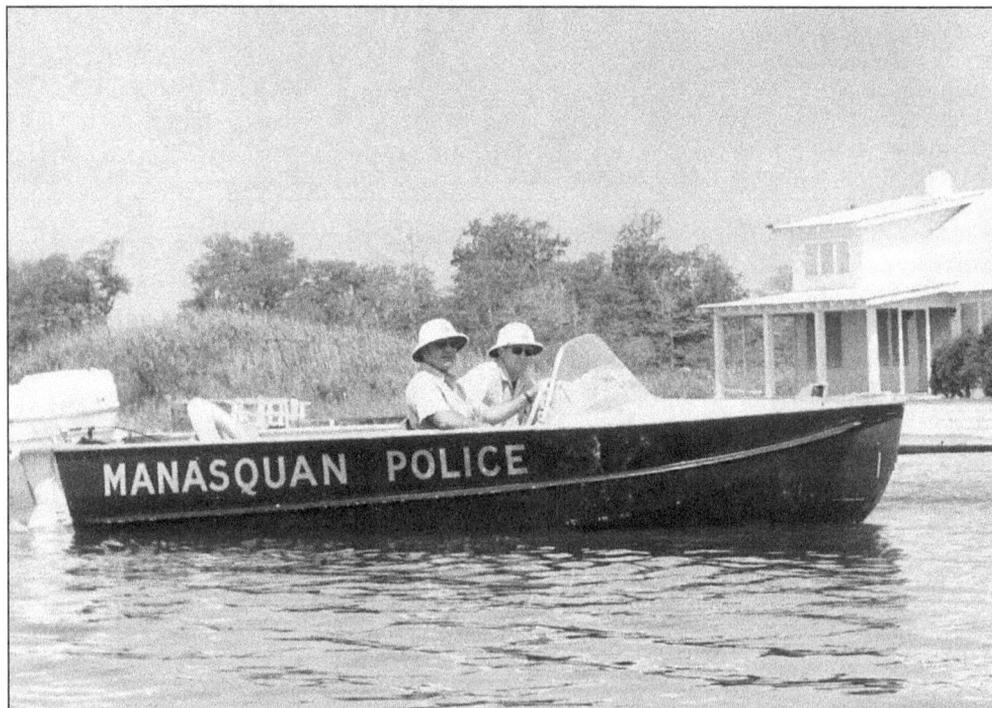

The police boat cruises on the borough waterway in July 1962. Rocco Luciano is at the wheel and Ralph Yersin is at his side. Law enforcement duties were preformed in this 16-foot Runabout, loaned to the borough by James M. Sigler, who operated Sigler's Marine in Allenwood for 37 years.

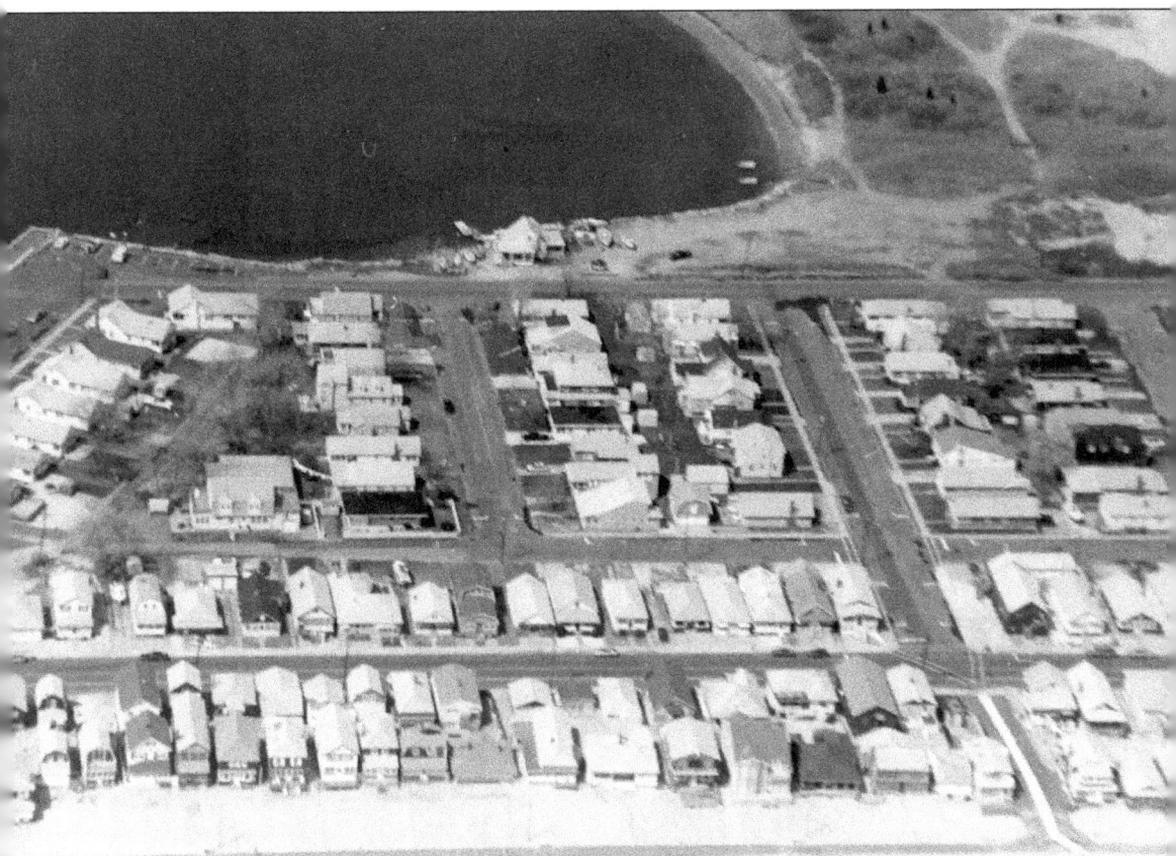

This aerial view of the south end of the beach area was taken *c.* 1950. Fisherman's Cove and the bait shop are visible in the top portion of the photograph.

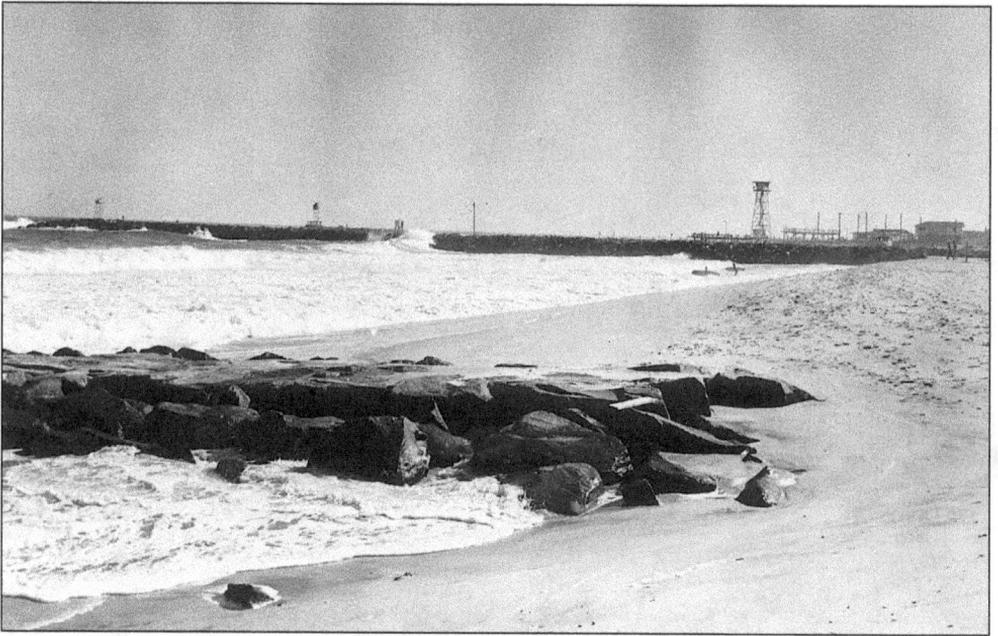

Surfing continues to be popular in Manasquan, particularly prior to or after a hurricane or northeaster. In this 1980s view, surfers are ready to enjoy the swells at the Manasquan Inlet beach.

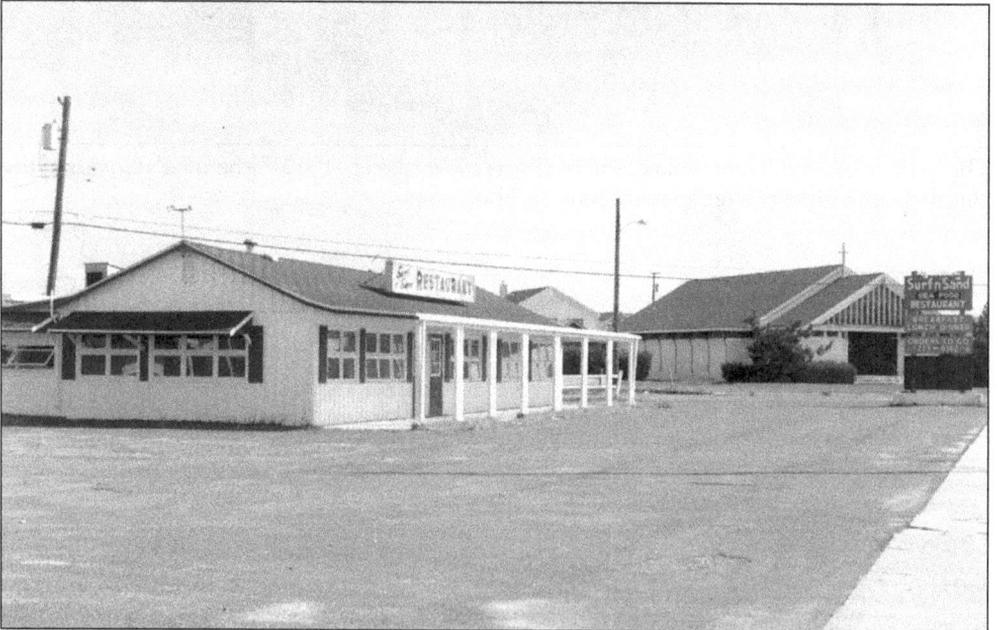

Fresh seafood, hamburgers, hot dogs, fried chicken, French fries, and garden salads with Jersey tomatoes were the favorites at the Surf 'n' Sand Restaurant, located on Main Street between Second Avenue and Pickell Alley. The seasonal eatery— at one time operated 24 hours a day— was established in 1948 by Ward and Peggy Wight. In 1952, Bankston and Hilda Brooman purchased the building. Employing their children as well as many area teenagers, the Brooman's operated the Surf 'n' Sand until 1980.

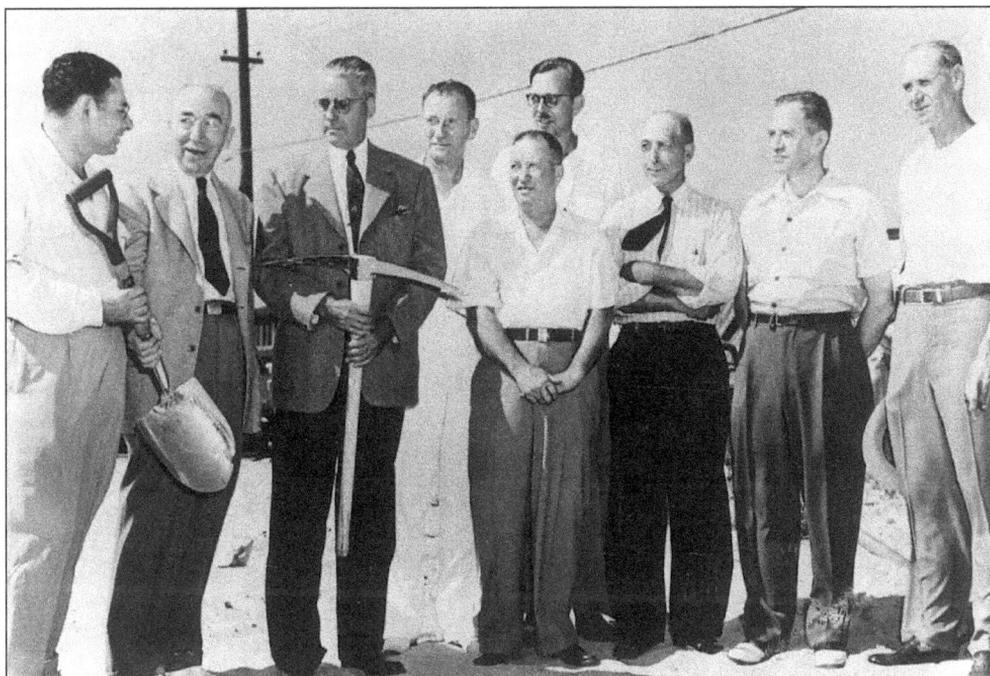

Members of the community participate in ground-breaking ceremonies for the Osprey Hotel in 1946. They are, from left to right, Joe Crisanti, John Vogel, Ed Emmons, unidentified, Joseph LaVance, Jim Van Nuys, Forman Estelle, Ray Baker, and Abe Voorhees. Located at the corner of Main Street and First Avenue, the Osprey Hotel featured accommodations, a restaurant, and a bar.

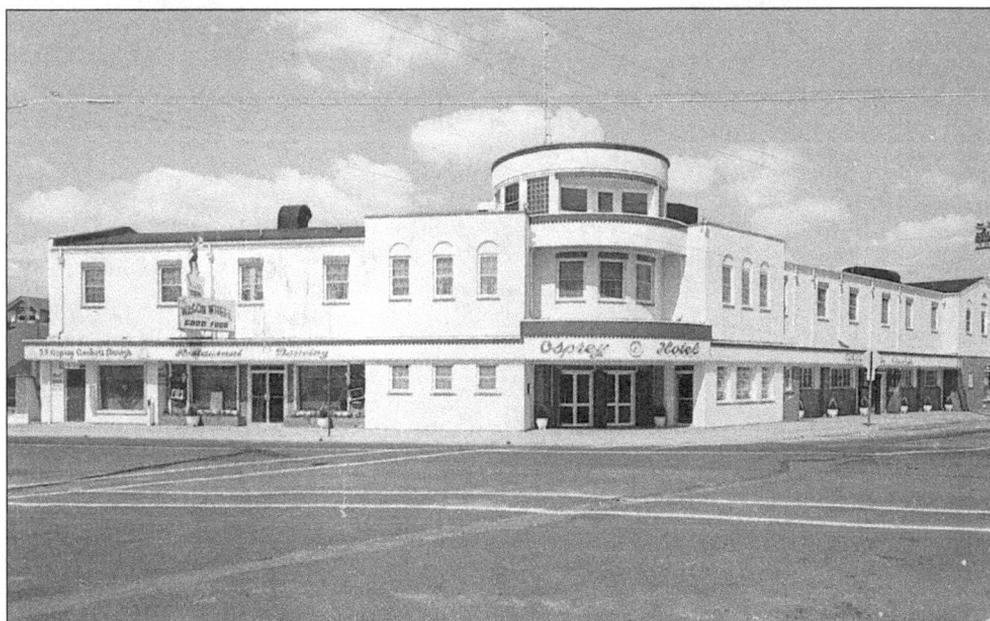

This postcard view of the Osprey Hotel was taken in the 1950s, when crowds, after enjoying a great day at the beach across the street, relaxed at the S.S. Osprey Boat Bar or Beachcomber Bar with a cold drink before dinner.

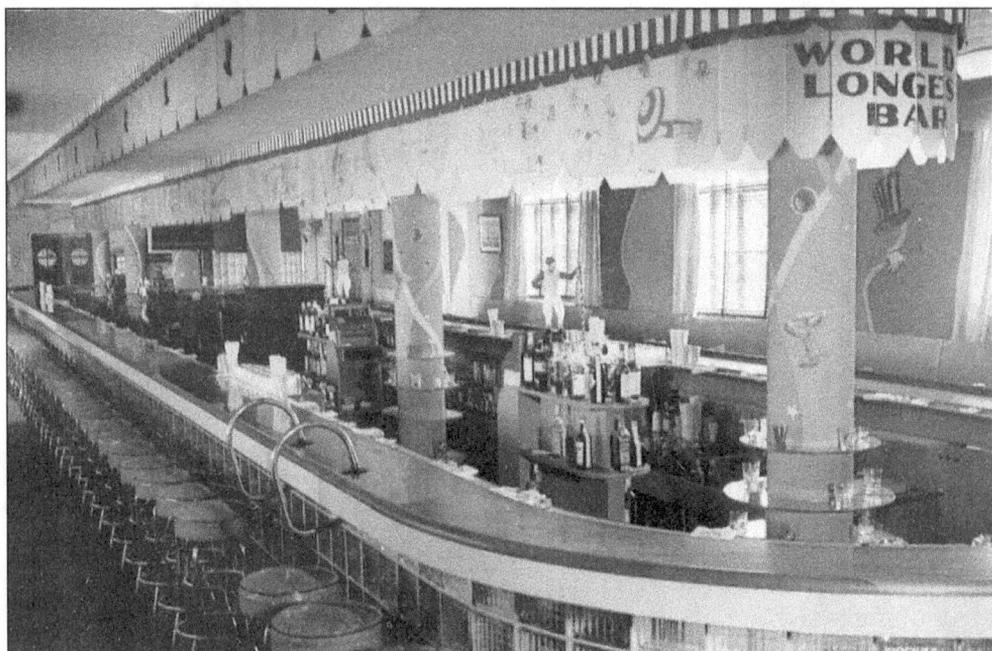

The Crisantis, who owned and operated the Osprey for many years, remodeled it for the 1958 season, calling it "one of the top hotels in the country." Touted as having the "world's longest bar," it could accommodate 700 patrons, served by "12 courteous mixologists," according to a brochure circulated by the owners.

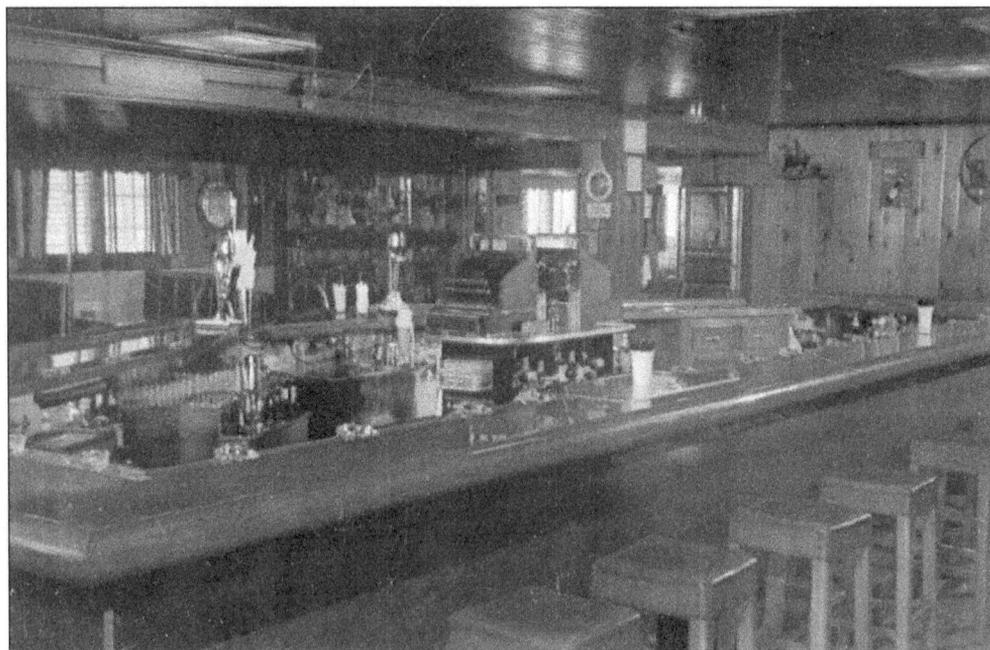

Leggett's Sand Bar at 217 First Avenue has been a part of the community since 1935, when it was opened by Edward "Ned" and Lillian Leggett. In 1969, Frederick W. Leggett purchased the bar and restaurant from his parents, razed it, and constructed a two-story building—doubling the size of the establishment. It remained in the Leggett family until 1986.

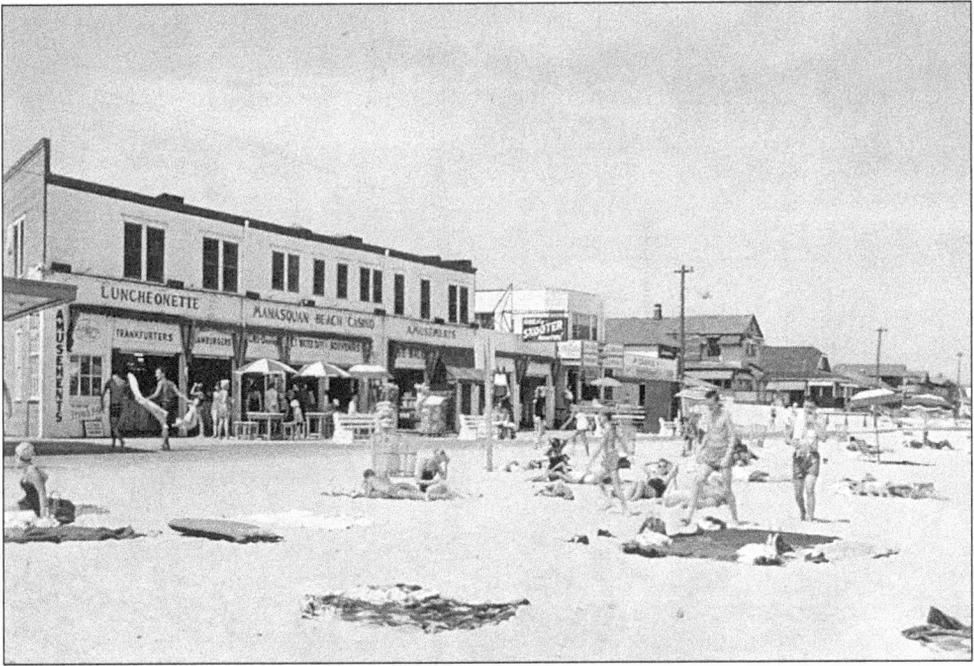

Fun in the sun has always been the rule at Manasquan beach. The Main Street beach in particular, with its casino, rides, amusements, and food stands, was very busy when this photograph was taken during the 1956 summer season.

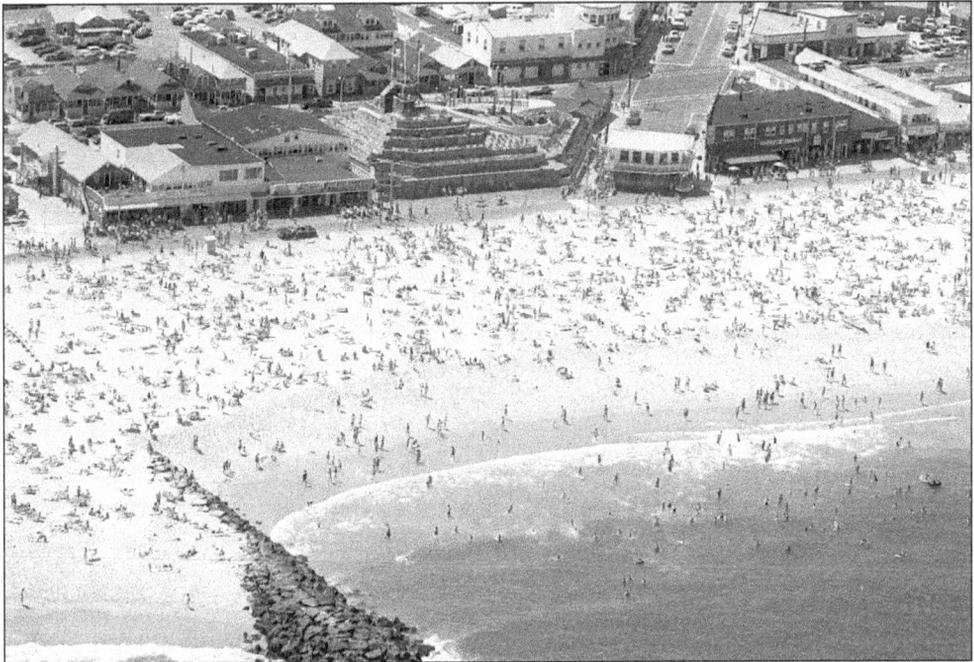

This aerial view shows the water slide at Main Street—a popular attraction during the late 1970s. After only a few years, however, the slide was demolished and was replaced with a parking lot.

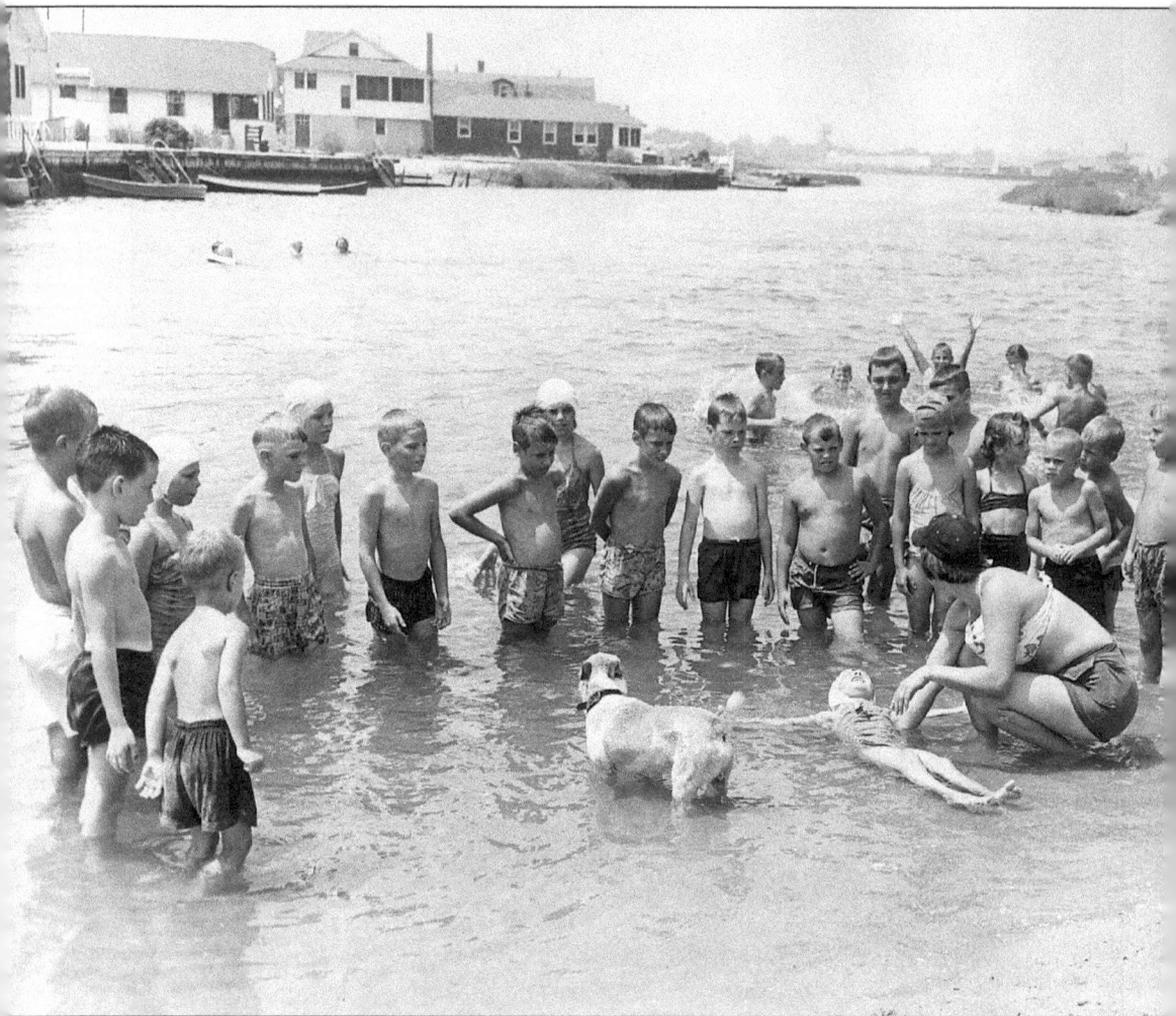

Everyone—including the family dog—learned to swim in Watson's Creek. In 1958, female lifeguards started working at the Kiddie Beach on Second Avenue. In addition to guard duties, they worked for the borough's swimming program and taught area children the finer techniques of the sport. The borough provided lifeguards and swimming lessons at the beach until 1974.

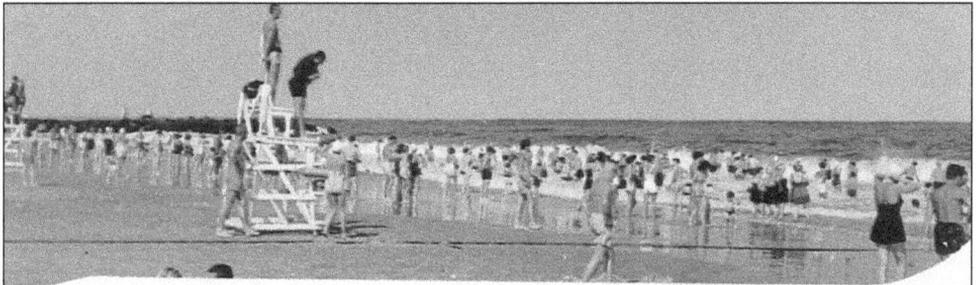

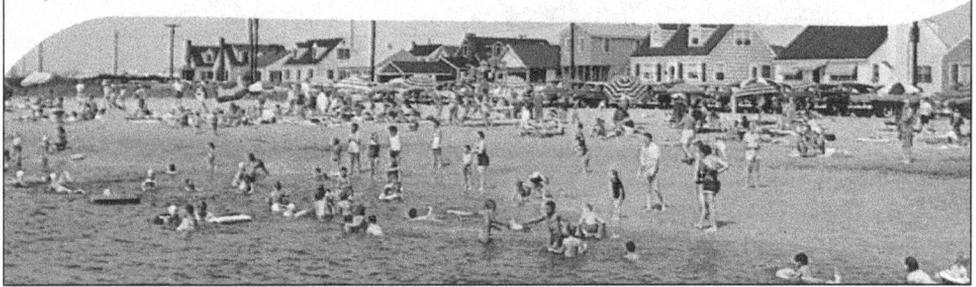

This early 1960s postcard view illustrates the activity at the Atlantic Ocean beaches in the upper half and the activity at Watson's Creek on Second Avenue in the lower half. Later, the Kiddie Beach, as it was commonly known, was moved farther north on Second Avenue to Stockton Lake.

Volunteers prepare the Manasquan-Brielle Little League field on Second Avenue for the start of the 1964 baseball season. The first baseball tryouts were held in April 1953.

In 1964, the area adjacent to Stockton Lake near the Manasquan-Brielle Little League field was cleared for the relocation of the Kiddie Beach. The beach was moved from an area south of this site on Watson's Creek.

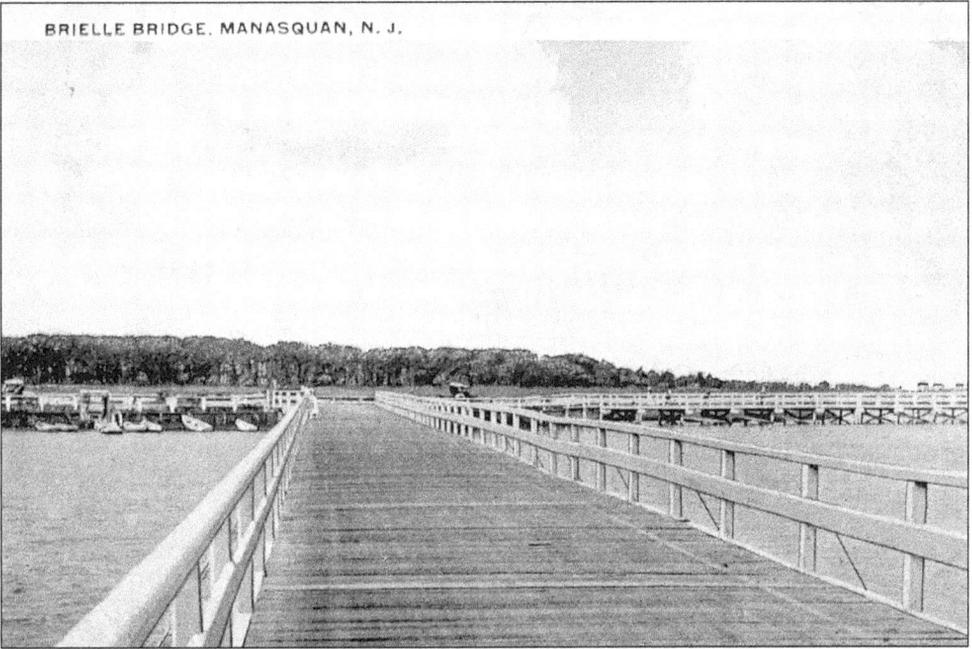

The Brielle Road bridge, on the right, is one of three that has provided access from Brielle to the Manasquan beach area for roughly a century. In keeping with the times—and to allow boats passage beneath it—the bridge has been altered.

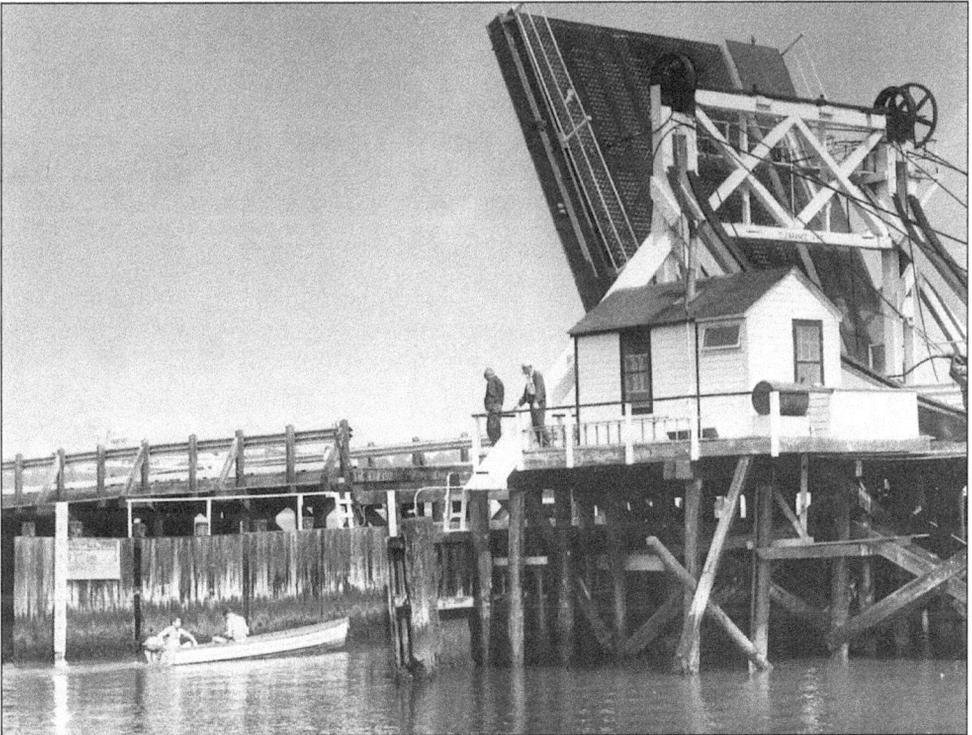

The picturesque drawbridge at Brielle Road has provided boat owners access to the Manasquan River, the Atlantic Ocean, and Barnegat Bay. A bridge tender maintains activity at the site.

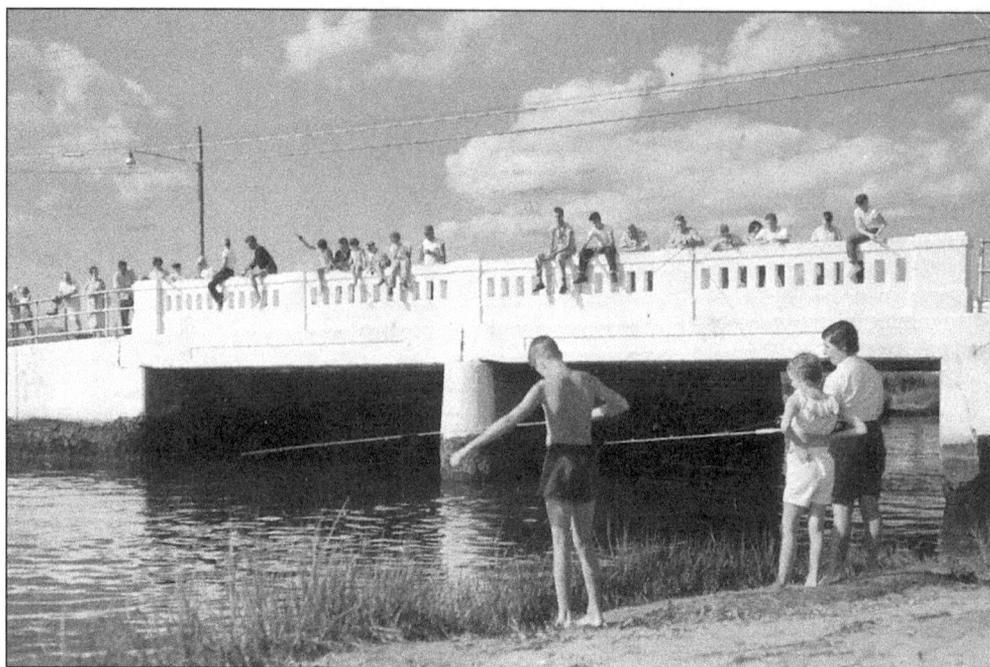

In earlier times, the white concrete bridge on Main Street offered area residents and visitors hours of fishing on sunny summer afternoons. This view was taken in the early 1960s. Today, fishing and diving are prohibited from the bridge.

For decades, the owners of small watercraft have docked their boats in the lagoon at Watson's Creek. The white concrete bridge, one of three bridges with access to the beach area, was reconstructed from 1999 to 2000. This view was taken in the early 1960s.

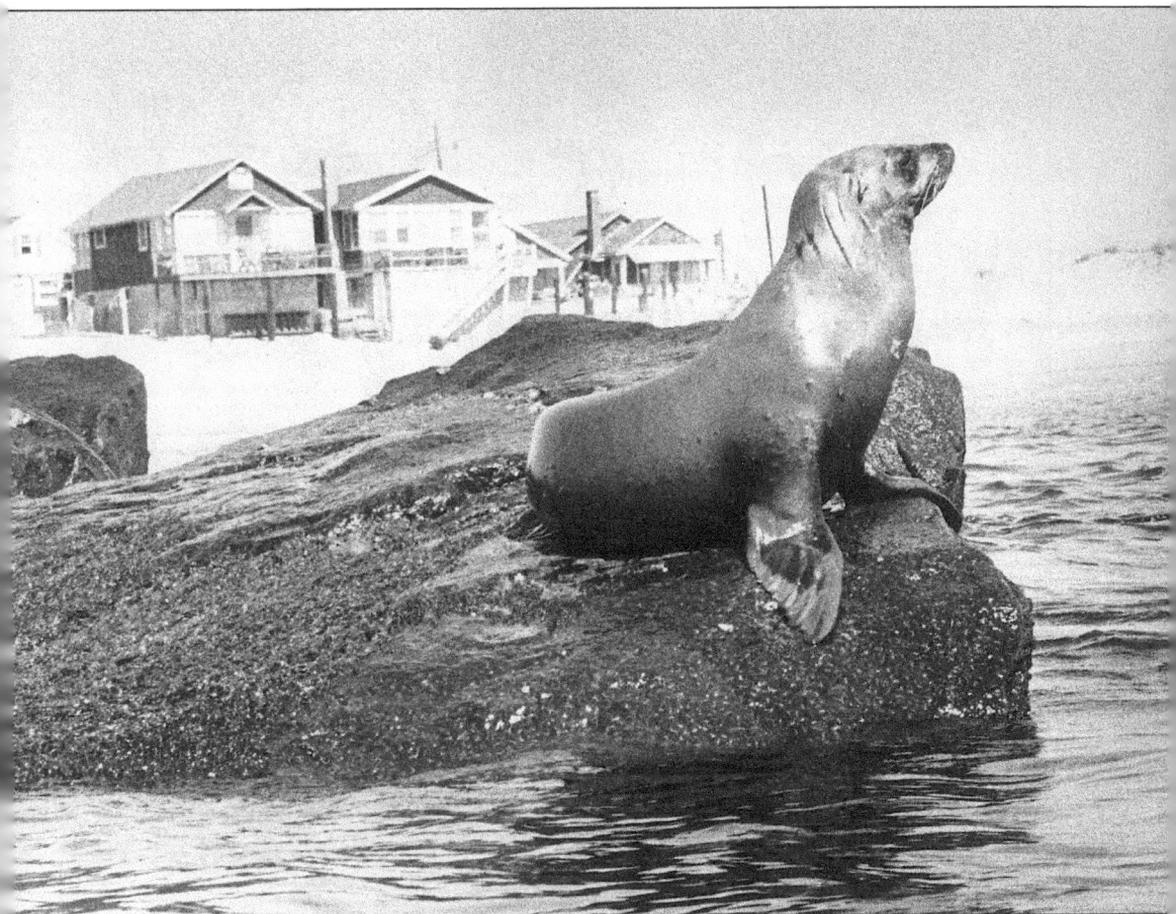

Manasquan has been a vacation destination for many, but this seal, who found a sunny spot on the jetty rocks at the northern end of the beachfront, was one of the community's most enchanting. His visit on July 29, 1968, attracted large crowds. At day's end, he slid into the sea to continue his travels.

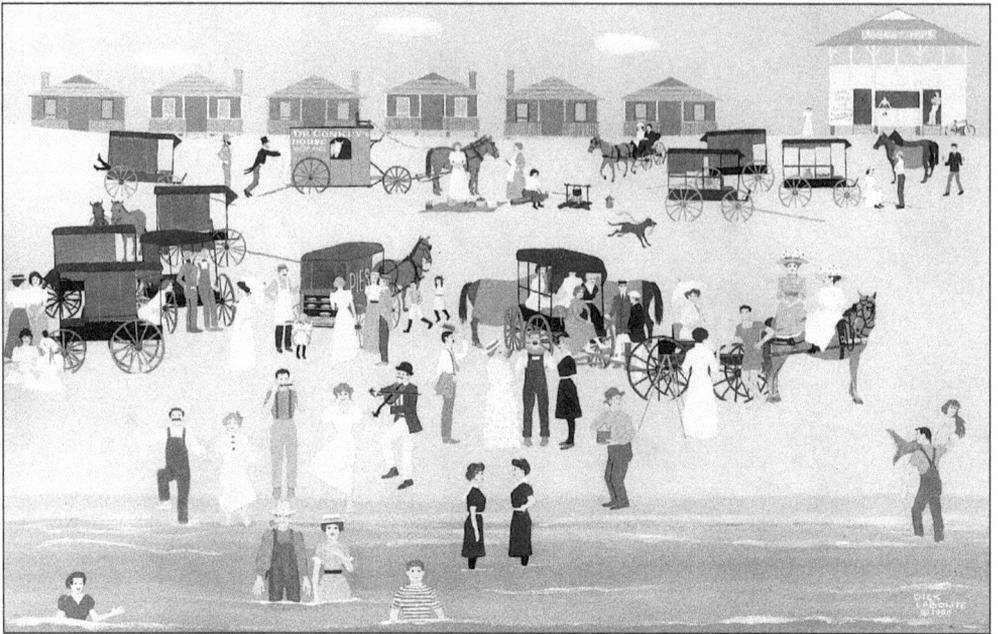

Dick La Bonte of Bay Head illustrated *Big Sea Day in Manasquan*, c. 1887, for a fund-raiser to benefit the Squan Village Historical Society in 1988. Two hundred signed, limited edition prints of the original acrylic painting were sold to raise funds for society activities. The original, which was framed free of charge at the Main Street Gallery, was donated to the Manasquan Public Library for permanent display.

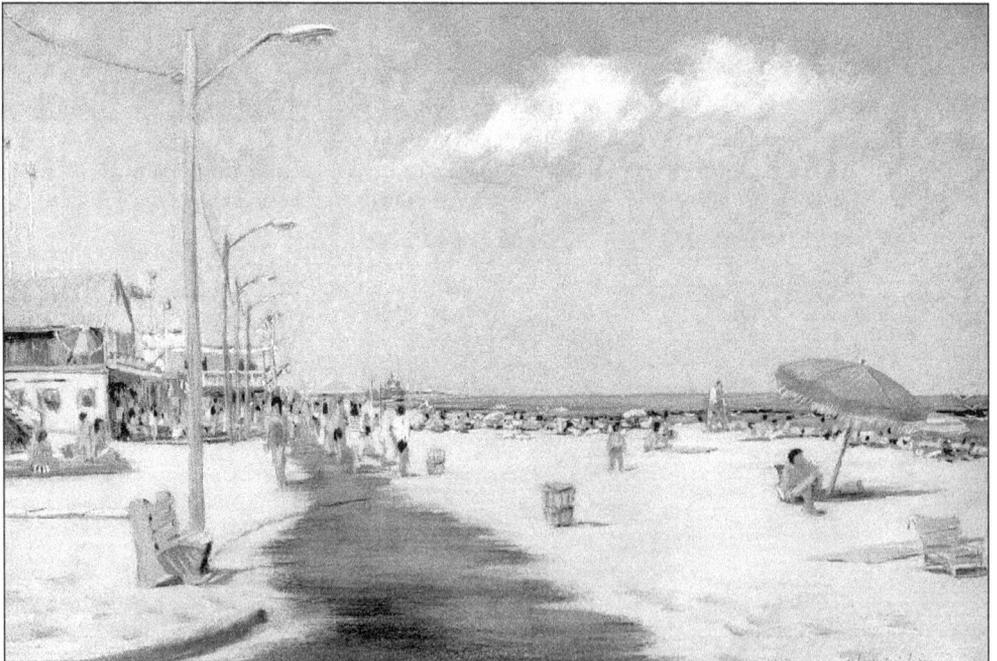

This familiar scene at the Main Street beach was painted by artist Paula Kolojeski in 1987. Dunes were not yet planted along the macadam walkway. The artist has been illustrating the beauty of Manasquan and the shore area for more than two decades and continues to do so.

126

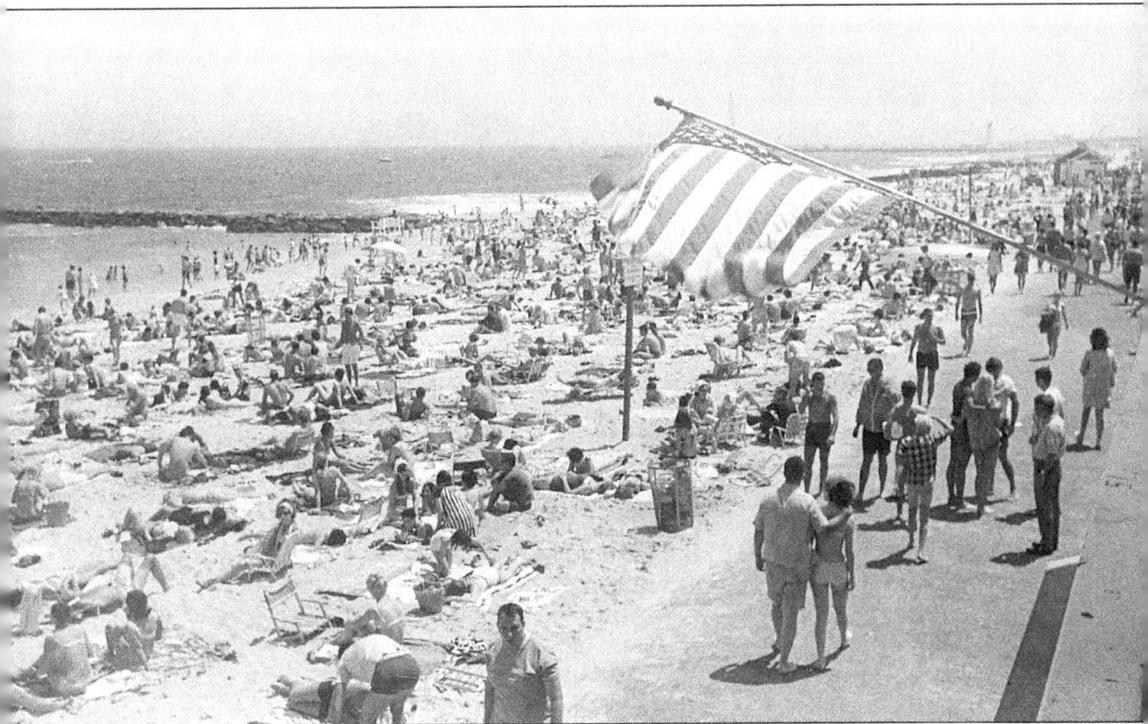

The U.S. flag is flown proudly from the second floor of the Main Street beach office on June 15, 1968, opening day. Season passes for the beach cost $6. According to newspaper accounts, revenue from the sale of beach badges was higher than the previous year because the weather had been warm and sunny. Judging from the crowds in this scene, no one visiting the beach on opening day would dispute the beautiful weather.

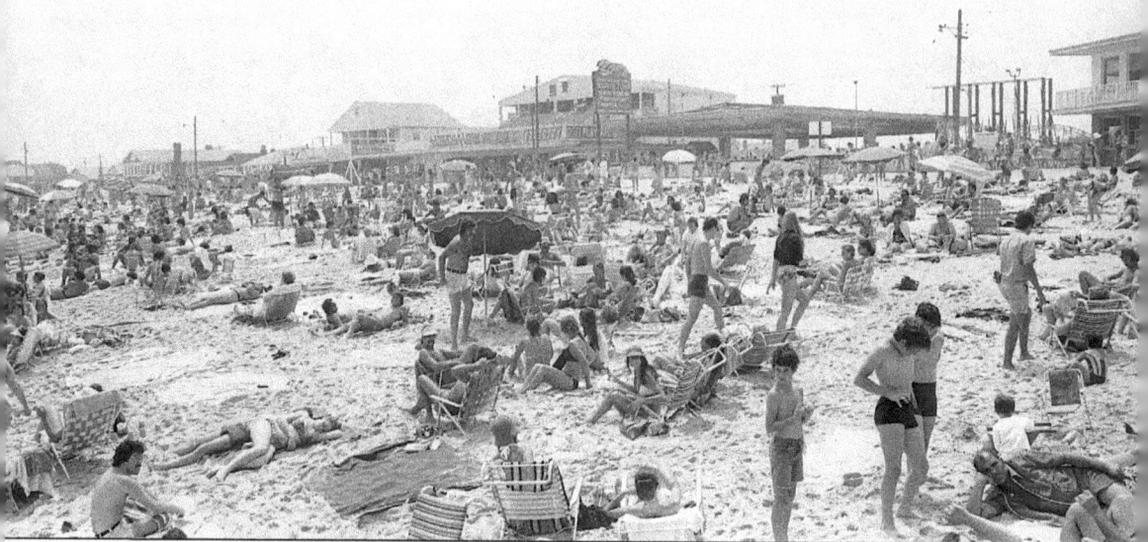

Local residents and visitors enjoy the Main Street beach in this photograph taken on July 4, 1974. Season passes for the beach were $8.50 each for persons 14 years of age or older. A new senior citizen rate of $5 was introduced in 1974. Notice the borough employee on the right whose job it was to check whether beachgoers had badges. At the time this image was taken, the family-oriented beach had amusement rides for youngsters.

www.ingramcontent.com/pod-product-compliance
Lightning Source LLC
Chambersburg PA
CBHW080901100426

42812CB00007B/2116